Off the Beaten Track
Three Centuries of Women Travellers

VISAS

Also valid for:- Iraq.
Syria Palestine. Egypt
Persia Ethiopia French
Possessions Transjordan
Spanish Possessions Italian
Possessions Portuguese
Possessions. ⸺

Valid for
Saudi Arabia (not
valid for Nejd or the
interior of Arabia ⸺

ISSUED TOURIST
BOOKLET No. 8762
ON Jan 15 1937
BY
THE AMERICAN EXPRESS Co. Inc.
6, HAYMARKET
LONDON, S.W.1.

TWO SHILLINGS
2
PASSPORT

COMMISSARIAT SPÉCIAL
PORT AÉRIEN DU
2 SEPT. 1937
DÉPART

FOREIGN OFFICE
13 - 6 NOV 1934 13
NO FEE
CHARGED

Seen at
London
Visa Go
months

Trans

Chief
Date

COMMISSARIAT SPÉCIAL DE DIGN
Poste Frontière
15 JUIL 193
Le
ENTRÉE

Deutsche Paßkontrolle
10 OKT. 1935

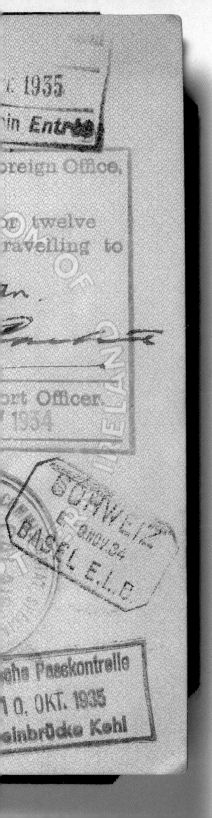

Off the Beaten Track
Three Centuries of Women Travellers

Dea Birkett

Foreword by Jan Morris

National Portrait Gallery

Published in Great Britain by National Portrait Gallery Publications,
National Portrait Gallery, St Martin's Place, London WC2H 0HE

Published to accompany the exhibition *Off the Beaten Track: Three Centuries of Women Travellers*
held at the National Portrait Gallery, London, from 7 July to 31 October 2004.

For a complete catalogue of current publications please write to the address above,
or visit our website at www.npg.org.uk/publications

ISBN 1 85514 526 X

A catalogue record for this book is available from the British Library.

Publishing Manager: Celia Joicey
Editor: Susie Foster
Copy Editor: Arianne Burnette
Design: Chrissie Charlton & Company
Production: Ruth Müller-Wirth
Printed by Conti Tipocolor, Italy

The publisher would like to thank the copyright holders for granting permission to reproduce
works illustrated in this book. Every effort has been made to contact the holders of copyright
material, and any omissions will be corrected in future editions if the publisher is notified
in writing.

Front cover:
Sunset from Nananu, looking to Viti Levu, Fiji (detail), Constance Gordon Cumming, 1876
University of Cambridge Museum of Archaeology and Anthropology (1998.46)

Back cover:
Dame Freya Stark, Herbert Olivier, 1923
National Portrait Gallery, London (NPG 5465)

Frontispiece:
One of Freya Stark's passports, issued 26 November 1934
John Murray Archive

Contents

Acknowledgements

This book is based on an exhibition celebrating the exploits of women travellers from the 1660s to the 1960s. All the women's portraits (except for Miss Benham and Marianne North) come from the National Portrait Gallery's own extensive collections. However, they were not necessarily acquired systematically as 'travellers'. The result is a fortuitous cross section of extremely well-known women and lesser known, but equally fascinating, female travellers. I am exceedingly grateful to Dea Birkett for accepting with such enthusiasm the challenge of writing the main text of this book, weaving them together by exploring key themes running through their lives. My thanks also go to Jan Morris for contributing her foreword.

I owe a substantial debt to Caroline Bressey who helped shape the exhibition with her research into the Black and Asian presence in the National Portrait Gallery's collections, funded by the Hollick Trust. She kindly has written the epilogue for this book. Many people made helpful suggestions about possible British women travellers to search for in the collections. In particular, members of ASTENE, the Association for the Study of Travel in Egypt and the Near East, were most generous with their interest and expertise. I am also very grateful to all the lenders to the exhibition who have allowed their items to be reproduced here. My particular thanks go to the many curators and archivists who have guided me both in finding and in interpreting the wide variety of objects brought back by women travellers. Dea Birkett would like to thank Fiona Pitt, Curator at Plymouth City Museums and Art Gallery, for the information on Gertrude Benham. I am also grateful to the staffs of the London Library and the British Library, as well as in the Heinz Archive and Library at the National Portrait Gallery. Responsibility for any mistakes in the captions, both to the women's portraits and to their various possessions, rests with me alone. Picture credits and copyright permission to quote are given in the back of the book. Many people supplied me with encouragement and help of various kinds including Mike Hitchcock, Carole Mahoney, Tom Sutherland, Susanna Hoe, John Gittings, Rosie Mills, Terri Sabatos and my companion in life and many travels, Malcolm Ramsay.

I am extremely grateful to my colleagues at the National Portrait Gallery who have made this book possible. These include the curatorial staff, especially Terence Pepper and Clare Freestone in the Photography Collection; Claire Everitt and Rosie Wilson in the Exhibitions Department; Annabel Dalziel and Jude Simmons in the Design Department; Pim Baxter, Naomi Conway, Hazel Sutherland and John Haywood in the Communications and Development Department; and, in the Publications Department, Denny Hemming, Johanna Stephenson and, above all, Susie Foster for her editorial skills and endless patience. I am also most grateful to Arianne Burnette both for picture research and for meticulous copy editing, and to Chrissie Charlton for designing the book.

Clare Gittings
Exhibition Curator

Director's Foreword

This is a book about determination. It celebrates people so determined to explore other places and countries that they overcame enormous barriers – whether physical or social – to pursue the excitement of discovery. Their initial motivations and circumstances were various but, whether in the 18th century or the 20th, they all relished the fascination of meeting strangers, of speaking new languages, of walking in places that had not previously been written about or of advancing knowledge through research and exploration.

The idea for this book, and the exhibition to which it relates, came from Clare Gittings, and I am most grateful to her for the exemplary way in which she has energetically pursued the project, from selection of images to the writing of captions and biographical material and the organising of events. I am equally grateful to Dea Birkett for her work on the text of the book, where she has brought these exceptional people to life for contemporary readers and given an invaluable overview of the scale of their achievements. Jan Morris has given us a delightful foreword derived from her own outstanding achievements as a traveller and writer. I am also grateful to the many Gallery staff who have worked on the project, particularly Claire Everitt, Jude Simmons, Susie Foster, Denny Hemming, Johanna Stephenson, and other colleagues in education, communications and development, and publishing.

For many living now in Western countries foreign travel is not only a mass activity, but also a means of regularly exploring the more distant and remote parts of the globe through specialist companies offering organised trips. This clearly has inherent dangers in terms of cultural convergence and globalisation, but equally it may encourage an appreciation of cultural difference and mutual respect that counters the complacent assumptions of our media-saturated society. Certainly, a greater respect for those women travellers who overcame real challenges relating to prejudice and innate suspicion should encourage a more complex understanding of the world.

Sandy Nairne
Director
National Portrait Gallery, London

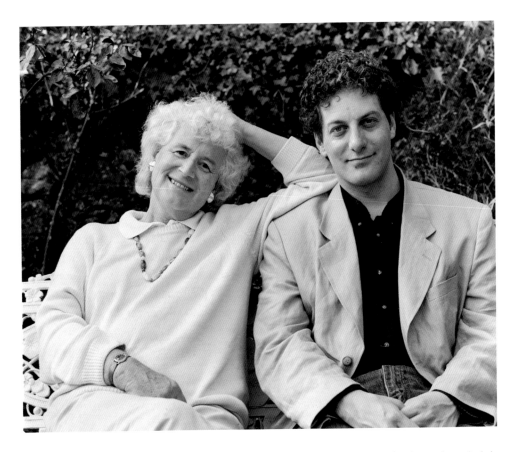

Jan Morris (b.1926) with her son Twm Morys (b.1961)
Richard Whitehead, 1994
Selenium-toned bromide print,
267 x 324mm (10½ x 12¾")
National Portrait Gallery, London
(NPG x76899)

Jan Morris, who is half Welsh, half English, lived and wrote as James Morris until she completed a change of sexual role in Casablanca in 1972. Between 1956 and 2003 she published some forty books of travel, history, fiction, biography and autobiography, including the major *Pax Britannica* trilogy and studies of Wales, Oxford, Venice, Manhattan, Sydney and Hong Kong. Her final book was an unclassifiable work about the city of Trieste, which she characterises being 'on a fold in the map' – a phrase she feels also describes herself. Her youngest son Twm is a distinguished poet in the Welsh language, winner of the coveted Chair at the Welsh National Eisteddfod of 2003, and author of several poetry collections.

Foreword

Jan Morris

It is a happy fact that anachronism is beginning to attend exhibitions of all-women achievement, or for that matter all-women anything else. In Western society the sexes really are approaching equality, in reputation as in life (if not just yet in hard cash). Sexual complexes of superiority or inferiority are recognisably fading, and the fact that something was done by a woman rather than by a man is becoming increasingly irrelevant. Humankind did it, whatever it was!

This was certainly not true until the sexual revolution of our own times, which will doubtless be seen by future generations as the most important revolution of them all. The deadening restrictions imposed upon most women down the centuries, confining them to domestic duties, not only denied them chances of fulfilment but also deprived them of confidence. Everyone knows now that except in matters of brute strength women are potentially the equals of men – in brain-power of course, but also in courage, in fortitude and in endurance. It was not so obvious in the old days, least of all to women themselves, who had been educated to opposite conclusions. For every Brontë sister who was published, we can surmise, a thousand other women writers never even dared to try: it took genius for a woman to publish *Wuthering Heights*, but it also took chutzpah.

Most of all, perhaps, even into the twentieth century, terrific resolution was required of women who wanted to travel – not just on the Grand Tour, or the holiday visit to Cannes, but in the more distant, dangerous and mysteriously compelling corners of the world. Most of the women who are represented in this book were people of the upper and middle classes, which of course gave them advantages of privilege but did not make adventures any easier for them, and may even have made it more difficult to escape from social convention at home. In any case, for duchess as for lady's maid, women's travel in the pre-modern world was beset with barriers.

First there was the often unarticulated prejudice of men, all too many of whom viewed adventurous women at best patronisingly, at worst with scheming hostility: time and again we read of women travellers being thwarted by male officialdom simply because they were women, often through the agency of bureaucrats too timid to admit it. More orthodox expatriate women, too, and women of other cultures altogether, were not invariably pleased by encounters with dashingly libertarian females from the other

half of the world, who made the consulate tea-party or the gossip of the seraglio seem sadly fustian. When somebody like Gertrude Bell appeared in Iraqi society in the 1900s it must have seemed like a visitation from another planet; when the Algonquin princess Pocahontas arrived in London in 1616 some of the natives assumed it actually was.

And of course there was the matter of Islam. It was through the lands of Islam that many of these women journeyed, and the local peoples were not generally welcoming to emancipated females. Some women simply brazened it out – the astonishing Lady Hester Stanhope, for instance, who defied all taboos in the 1800s and swaggered among the Lebanese Muslims with mighty bravado. Others, like Rosita Forbes in 1920, disguised themselves as believers, and even the indomitable Freya Stark, in the 1940s, sometimes found it expedient to don the veil (which she quite enjoyed, as a matter of fact, because it made her feel comfortably private, and because she was not proud of her face).

Stark was one of the great women travellers who made use of her femininity. Not all these heroines did. Some preferred to dress and behave as men, sometimes so absolutely that the bemused indigenes thought they *were* men. Others found it advantageous to flaunt their female qualifications, and took pretty dresses and flirtatious hats with them into howling deserts or steaming jungle glades – edging sometimes, it must be said, towards the poor brave little woman syndrome ...

Sometimes they took conventional female attitudes, too. The intrepid West African explorer Mary Kingsley insisted that she 'did not do anything without the assistance of the superior sex'. When the alarmingly macho Victorian adventurer Richard Burton set off on another of his journeys, all he habitually told his wife Isabel was 'Pay, pack and follow' – and obediently (but fearlessly) Isabel obeyed.

They were all sorts, really, these extraordinary women – bourgeois and aristocrat, scholar and hedonist, botanists and big game hunters and missionaries and reckless aviators and imperialists. Some travelled on official duty of one kind or another, some were spectacularly freelance. There were married mothers among them, there were determinedly spinsterish spinsters, there were doubtless some lesbians. Some were sexually, or at least sensually excited by their travels, some were austerely dispassionate. What they all had in common was their gender and their guts.

How different it is for women now! I have had the peculiar experience of travelling both as a man and as a woman, and I have reached the conclusion, on the whole, that during my own travelling years the female traveller has had it easier than the male. Women have generally offered no threat to anyone, women are still more likely to be helped, women retain their own immemorial methods of persuasion, and most importantly women are more likely to fall among friends, allies or colleagues wherever they go – to this day the human sorority is stronger by far than the fraternity.

I have been lucky in my timing. It may be that as the world gets used to the idea of absolute equality between the sexes, and as women willy-nilly acquire more male attitudes, these female advantages will fade. In the meantime the world's women can only look back with astonishment at all their predecessors achieved against such formidable odds, with gun, veil or flowered hat, with butterfly net or theodolite, pursuing anthropology, ruling empires, flirting, organising, or simply paying, packing and following into the far unknown.

Introduction The Mysterious Miss Benham

I t was a warm and humid December, 1916, as 34-year-old colonial officer Selwyn Grier sat down to write a long letter home to his mother, Grace, from his posting at the Northern Nigerian station of Bauchi. For once, he had something to tell her: he'd had an unexpected visitor. 'I have just had Miss Benham here – the experienced lady traveller – she really is rather a wonderful person and I was most agreeably surprised with her,' he wrote. 'She became very friendly last night here and told me the reasons which led her to take to wandering about the world.'

I stumbled across this letter in Rhodes House Library, Oxford, while I was searching for the letters of Mary Kingsley, the well-known Victorian traveller, writer and political agitator. Like Grier, I had not expected to come across Miss Benham. I had never heard of her, but Grier had. She had, he wrote with shared national pride, 'done two climbs in the Alps only once done before; is the only Britisher to get to the top of Kilimanjaro; has done climbing in the Himalayas, Rockies, Andes, Mexico, Japan, making several first attempts.' She had stumbled into Bauchi on the way to India, across Africa, on foot.

Grier told his mother why Miss Benham travelled:

To put it boldly, it was sheer loneliness – she said she had no relations who took the slightest interest in her – that she had spent most of her time looking after a brother who used to leave her to spend all her evenings as well as her days alone and finally, having a small income of her own, she started wandering, got bitten with it, and for eight years has been wandering all over the world.

She was 'fifty if she was a day', 'has absolutely no nerves at all', and was 'violently anti-suffrage'. 'Altogether quite different to what I expected,' he summed up. Then, like an apparition, Miss Benham left Bauchi. 'This morning she trudged out of the station with one servant and seven carriers to go to Yorla – some 200 odd miles – from there she goes into German Territory, then the Congo, then up into Nyasaland ... It sounds perfectly mad,' said Grier. As far as we know, Grier and Miss Benham never met again.

Her journeys were pioneering, her ambition huge, her achievements remarkable, but Miss Benham has left scant trace of her paths through the world. The little I later

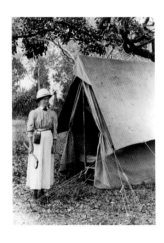

Gertrude Benham
Photograph taken outside her tent in
Blantyne, Nyasaland, 1913
Plymouth City Museums & Art Gallery
collection

found out about her came from the local museum near Lyme Regis. She settled in the area in her later years, and bequeathed her large collection of artefacts and curios to the museum. I discovered that her first name was Gertrude, and that this trans-African journey was one of three she made during her lifetime, all on foot, and none lasting less than a year. She would have been forty-five years old (not fifty) when she met Grier.

She shunned publicity. She did not write a book nor did she lecture before the Royal Geographical Society, and she probably never penned an article but, in her sixties, she agreed to be interviewed by the *Daily News*. There we gain the first glimpse of how she must have looked on her travels. Describing herself as a 'lone wanderer', she said, 'I wear just an ordinary khaki skirt, puttees, strong shoes, and a pith helmet. In addition I have a sunshade and an umbrella – not very warlike weapons.' She carried her Bible, a pocket edition of Shakespeare, Blackmore's *Lorna Doone*, Kipling's *Kim* and her knitting. She also took calico and needles, which she bartered for food.

Although a photograph of her matching this description survives, there is no formal portrait of her. Unlike the other women travellers illustrated here, her image is not to be found in the National Portrait Gallery's collections. Yet she is, in a sense, an archetype for all the women in this book. Even Grier's brief glimpse reveals a fearless, fiercely independent woman, with any ties she had long broken. She feels forced out into the world, and at the same time proudly declares she travels through her own free choice. Like the women who stepped out before and after her, she is unique – eccentric even. That doesn't mean she isn't rooted in her time, a part of and a creator of history. Almost all the women in this book, including Miss Benham, shifted attitudes and challenged stereotypes both of themselves and of the people they encountered on their travels.

Grier was surprised; Miss Benham was, indeed, 'quite different to what I expected'. Throughout the centuries, this has been the most commonly expressed sentiment when discovering, and continually rediscovering, women travellers. They are rarely as we expect them to be. They surprise us still.

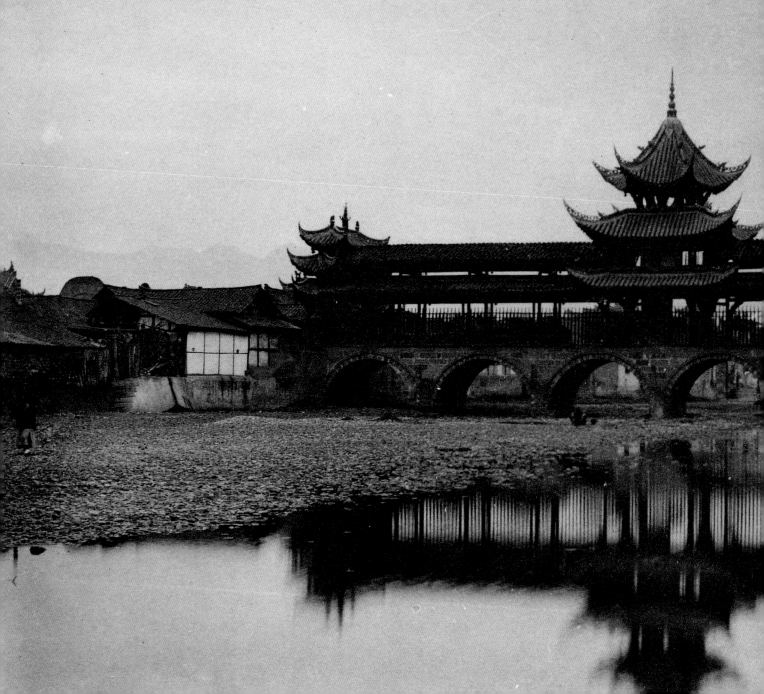

Stepping Out

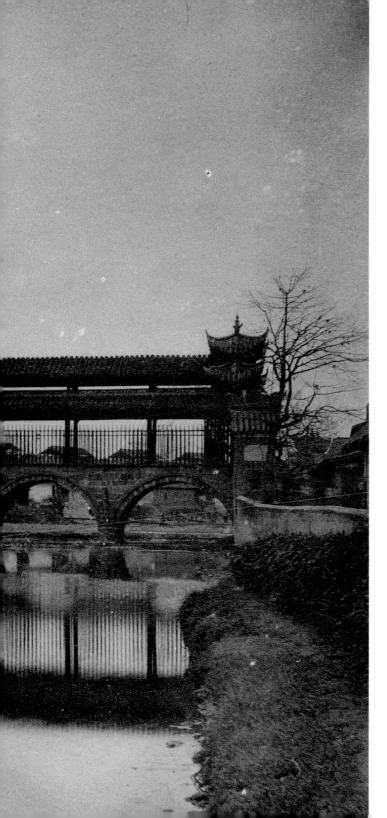

The beckoning counts, and not the clicking latch behind you: and all through life the actual moment of emancipation still holds that delight, of the whole world coming to meet you like a wave.

Freya Stark, *Traveller's Prelude* (1950)

In 1663 – or thereabouts, we cannot be certain of the date – Aphra Behn, a young woman in her early twenties, set sail for Surinam. When she arrived at this colony on the northern coast of South America, a small English settlement had been established for about twenty years, served by a large slave population working the sugar plantations. These exotic people and their land astonished and delighted the young woman. 'These countries do, in all things, so far differ from ours that they produce inconceivable wonders,' she says in *Oroonoko, or The Royal Slave* (1688), a fictionalised account of her journey written twenty years after her return. We do not know why Aphra Behn chose to make the hazardous voyage to Surinam. Later, in her writing, she encouraged the belief that she had been accompanying her family, but this could be fiction, and she is just as likely to have been chasing a reprobate lover.

Other women had already ventured far from home. As early as 381AD an abbess called Egeria had made a three-year pilgrimage from France to the Holy Lands of Palestine and Egypt, using her Bible as a guidebook. 'Nothing could hold her back, whether it was the labour of travelling the whole world ... the perils of the sea and rivers ... the dread crags and fearsome mountains,' wrote Valerius, a seventh-century monk who commented upon

Bridge at Mien-Chuh, Sichuan, China
Isabella Bird, 1896
Gelatin silver print
John Murray Archive

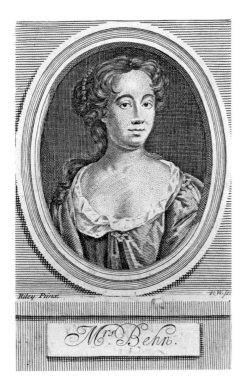

Aphra Behn (1640?–89)
Robert White after John Riley, published 1716
Line engraving, 130 x 86mm (5⅛ x 3⅜")
National Portrait Gallery, London (NPG D9483)

Details of Aphra Behn's early life are uncertain. She seems to have journeyed to South America in 1663–4 with her mother, her sisters and a relative she called her father, who had been appointed Lieutenant General of Surinam. He probably died at sea, but the women of the family lived in Surinam for some time. In 1688, Aphra Behn published her novel *Oroonoko*, named after its hero, a wrongfully enslaved African prince. She claimed she was 'an eyewitness' to his story. The novel is remarkable not only because of the author's gender, but also because slavery was then so unthinkingly accepted. On her return to England, Aphra was briefly married to a Mr Behn, a London merchant, and from 1667 she went to Antwerp as a spy for Charles II. She was stranded in Antwerp without money and was threatened with imprisonment when she could not repay the funds she borrowed to return to England. She turned to writing in the hope of earning a living. The most successful female writer of the age, she produced a string of plays, as well as novels based on her exotic life. She was buried in Westminster Abbey.

the journal Egeria had kept for her sisters. This account of her journey is the first known travel book by a woman. By the time Margery Kempe, the wife of a Norfolk merchant and the mother of fourteen children, left her family and set sail for Jerusalem in 1413, the pilgrim route was so well established that she did not need to rely on her Bible for directions. Books, with titles such as *Information for Pilgrims* and *Description of the Holy Land*, could be bought as guides, giving recommendations on where to stay and what to see. The account of her wanderings, *The Book of Margery Kempe* (1432–8), taken down by a scribe, is the first known travel book in English.

Aphra Behn could not have known about either of these pioneering women. The abbess Egeria's account – *The Pilgrimage of St Silvia of Aquitania to the Holy Places* c.385AD – was not rediscovered until 1884, nor Margery Kempe's book until the 1930s. If she had known about these women, would the seventeenth-century writer have felt any connection to or sympathy with them? Would she have seen herself as a link in a long, if intermittent, line of women venturing abroad?

Lady Hester Stanhope

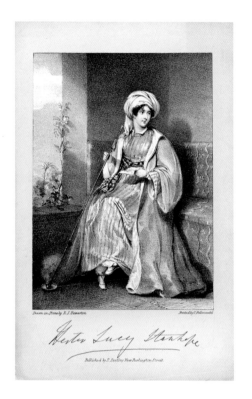

Lady Hester Stanhope (1776–1839)
R.J. Hammerton
Lithograph, 230 x 144mm (9 x 5⅝")
National Portrait Gallery, London (NPG D5409)

Lady Hester was the lively daughter of Charles, 3rd Earl Stanhope (1753–1816). Her mother died when she was only four, condemning her to a peripatetic childhood. She finally, and most happily, kept house for her uncle, the Prime Minister, William Pitt the Younger (1759–1806). After his death, she left Britain for Turkey, ostensibly to make her money go further and for her health; she never returned. In this romanticised image of her with her ubiquitous pipe, she is shown in the Turkish dress she adopted after losing her entire wardrobe in a shipwreck. Myths quickly accumulated around her as she travelled the Middle East, making a spectacular entry into Palmyra in 1813, calling herself 'Queen of the Desert'. Her remaining decades were spent in a ruined Lebanese monastery, initially admired but living increasingly in destitution. Her memoirs, written by her doctor, were published in 1845 after her death.

Letter from Lady Hester Stanhope to Mary Rich, July 1813 (extract)
The British Library (MSS Eur C740)

Lady Hester Stanhope writes from Latakia, in Syria, with advice about travelling through the desert. She begins: 'Madam: I will allow you to laugh at the little details I shall enter into [but] they may prove useful to you upon your intended journey.' After discussing horses and grooms, she suggests 'a small tent five or six feet in diameter', a sack containing 'a milk kettle … very useful when you meet some Arab flocks', and a chamber pot. She continues: 'Imagine, Madam, a plain which never seems to end' where you 'travel eight or nine hours together. It will be in vain to seek a bush or tree for any little purpose' and anyway you cannot 'stray from the party'. The solution? 'Pitch y[ou]r tent … saying you wish to repose, or eat' and retire with the chamber pot, ordering 'coffee for the people'. Lady Hester recommends 'shabby' dress with a veil and having an 'aba', a warm Syrian camelhair cloak. She also suggests carrying 'nearly twice of what you generally consume', as it will be 'spoilt or stolen' – advice based on her own practical experience.

Lucie, Lady Duff Gordon (1821–69)
Henry Wyndham Phillips, 1851
Oil on canvas, 917 x 711mm
(36⅛ x 28")
National Portrait Gallery, London
(NPG 5584)

Born into a radical family, as a child Lucie Austin played with her cousin, the social philosopher John Stuart Mill (1806–73). In 1826, her parents spent some time in Germany, where she became fluent in German; she later made numerous translations into English. In 1840, she married a Scottish baronet, Sir Alexander Duff Gordon (d.1872), and lived in London. In this portrait she looks in good health, but by its completion she was already wasted by the consumption that was to kill her: 'I look thin, ill and old, and my hair is going grey. This I consider hard upon a woman just over her thirtieth birthday' (quoted in 'Memoir' in *Last Letters from Egypt*, 1875). She sought a cure in southern Africa, before eventually making a new home in Egypt in 1862. During the last seven years of her life she rarely saw her husband and children, although she missed them terribly. The Egyptians described her as 'the great lady' who 'was just and had a heart that loved the Arabs'. Her vivid letters home, revealing the close relationships she established in Egypt (unlike the majority of Western travellers of her day), were published in 1865 and 1875. She was buried in Cairo.

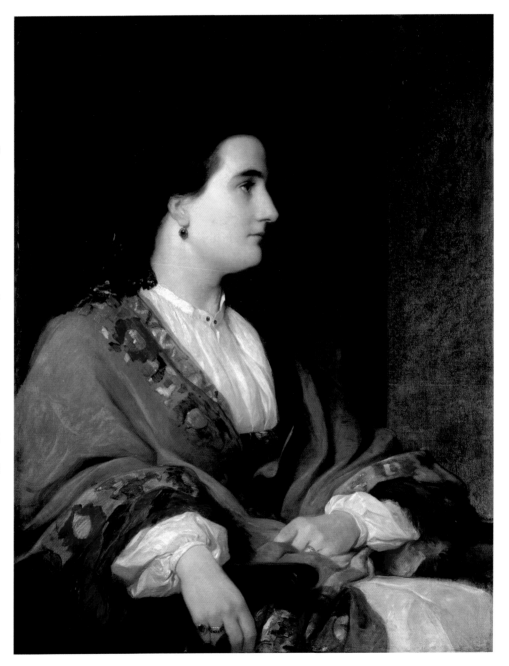

Even if Aphra Behn did not regard herself as part of a trend or tradition, we enjoy doing so with the help of hindsight. From the moment our gallery of women travellers step out – from the 1660s to the 1960s – we can trace common paths along their different routes. All but the most recent women travellers' journeys begin at sea. It is remarkable how many of their ships set sail in a storm. The departure of Lady Hester Stanhope was so blustery that, after the ship set sail from Constantinople for its final call at Cairo, it was wrecked off Rhodes. Lady Hester and her small party – her doctor, Charles Meryon, her maid, Anne Fry, and a young man called Michael Bruce, who was to become her lover – lost all their clothes and were forced to borrow Turkish costumes. Lady Hester, refusing to wear a veil, dressed as a Turkish man in robe, turban and slippers. She enjoyed her new image so much that when another ship took her on to Cairo, she bought a more elaborate version of the same outfit, with an outer garment of purple velvet, embroidered trousers and waistcoat, and added the dash of a sabre.

As the women travellers describe their tempestuous departures, the launch into a new life takes on the style of a baptism, washing away what had come before and committing them to what lay ahead. On 24 July 1862, Lucie, Lady Duff Gordon wrote: 'We put our pilot on shore and went down Channel. It soon came on to blow, and pitched so, and had to call doctor to help me into cot; slept sound. The gale continues. My cabin is watertight as to big splashes, but damp and dribbling. I am almost ashamed to like such miseries so much.' Lucie had made this voyage down the English Channel once before. In 1860, on doctor's orders, the established hostess had left her London home and sailed for Cape Town. She suffered from tuberculosis, for which the only known cure was warmth and rest. South Africa was believed to provide a healthier climate, in which she might recover her lost strength. The remedy seemed to work – but only temporarily. Returning from her recuperation the following year, she settled back into Queen's Square, Westminster, entertaining Charles Dickens, William Makepeace Thackeray, George Meredith, George Eliot and other literary luminaries, as well as many foreign visitors. Surrounded by London's drizzle and smog, her health began to deteriorate again. Leaving behind her husband and young children, she set sail for the dry, warm lands of Egypt in July 1862. The choice of destination had been suggested by her eldest daughter, recently married to a bank official working in Alexandria. The billowy voyage down the English Channel did, indeed, prove to be the start of a new life for Lucie. Apart from two short trips abroad, she would remain in Egypt until her death.

Lucie Duff Gordon parted from her family with reluctance; only the very real threat of death had driven her away from the comfortable circle of the drawing room in

Isabella Bird

Isabella Bird (1831–1904)
Sir Benjamin Stone, 1899
Platinum print, 198 x 150mm (7¾ x 5⅞")
National Portrait Gallery, London (NPG x36474)

With the encouragement of her father, Isabella Bird started travelling in her early twenties. Her first journeys, to North America, were undertaken to relieve her spinal problems and other illnesses. These mysteriously vanished when she went abroad, but reappeared each time she returned. After her parents died, she made trips around the world gathering material for a series of travel books. The year after her sister Henrietta ('Hennie') died in 1880, Isabella, aged fifty, married her sister's doctor, Dr John Bishop, ten years her junior. He claimed he had 'only one rival in Isabella's heart, … the high table-land of Central Asia' (quoted in *A Curious Life for a Lady: The Story of Isabella Bird*, 1970). He died five years later. With no ties to bind her, Isabella set off again for two years, travelling to India, Tibet, Persia (now Iran) and elsewhere. In 1891, she visited the House of Commons (where Benjamin Stone later took this photograph) to speak on 'the Armenian question', having travelled through those areas of the Turkish Empire inhabited by Christian Armenians. A year later she was among the first women to be elected Fellows of the Royal Geographical Society. After learning photography in 1893, she recorded her three-year journey to Japan, China and Korea in pictures as well as words.

Photographs of China
Isabella Bird, 1896
Gelatin silver prints
John Murray Archive

1

2

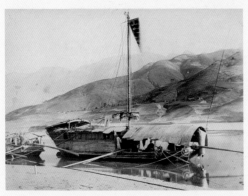

3

4

These photographs, printed from glass-plate negatives, were taken by Isabella Bird to illustrate her book *The Yangtze Valley and Beyond* (1899). She described how she developed negatives on her boat: 'Night supplied me with a dark room … a box served for a table.' She cleaned the chemicals from the glass plates by leaning over the side to hold them 'in the wash of the great river' (the Yangtze), although its muddy waters left 'a fine even veil on the negative', requiring filtered water at the end. 'Printing was a great difficulty … When these rough arrangements were successful, each print was a joy and a triumph, nor was there disgrace in failure.'

Bridges caught her eye. She described the 'Bridge at Mien-Chuh' (Mianzhu, in western Sichuan) as 'a beautiful modern bridge of six stone arches, a fine roof, iron balustrades, and a central roofed tower' (see pp.14–15). Photographs 1 and 2 were not good enough for publication. On the back of the first she wrote, 'Spoilt alas! Monastery … with last sunset gleam on woods'. Taking the other caused a frightening incident. She had climbed on to a stage built for a Buddhist ceremony to photograph her companion, the missionary Mr Williams. This offended local people, who threatened them, shouting 'foreign devils'.

Photograph 3 shows the boat in which she travelled – 'a small houseboat of about twenty tons, flat-bottomed, with a tall mast'. Her cabin was 'the width of the boat with a removable front … my "furniture" consisted only of a carrying chair.' Photograph 4 is of the 'Author's trackers at dinner' – 'inferior' rice, vegetables, occasionally pork or fish – 'on three such meals a day the poor fellows hauled with all their strength for twelve hours daily, never shirking their work.' They would tow her boat from pathways cut in the rock face of the gorges, dragging it with ropes up the rapids. After dinner, the trackers smoked opium, 'their nightly Elysium'.

Queen's Square, and she regarded her life in Egypt as exile. For other women, with no family or emotional ties, abroad – warm, dry and smog-free – could cure just about anything.

Isabella Bird, a clergyman's daughter, suffered from an undiagnosed spinal complaint. Continual operations and a plethora of remedies, including being sucked by leeches, had provided no respite. Young Isabella was far from robust, and very small – 'four foot eleven and a half inches,' she boasted. In 1881, the painter Marianne North wrote that a friend with whom Isabella had stayed in Ceylon – quite probably Julia Margaret Cameron's husband – had described her as 'so fragile and small that when he put up his hands to lift her down from a dog-cart they met in the middle as if he were lifting a bag loosely filled with fluff'. Isabella suffered from insomnia, numerous vague aches and pains, and was prone to bouts of 'restlessness'. She described 'shivering in our own foggy, murky islands … depressed by sunless gloom.'

In 1854, the same year in which Coventry Patmore began his sequence of poems about female domestic responsibility, *The Angel in the House*, a far-sighted local doctor prescribed a long sea voyage for the 23-year-old Isabella. Her father gave her £100 spending money and permission to stay away as long as necessary. Isabella chose to travel to North America, and returned to write up an account of her experiences, *The Englishwoman in America*, published anonymously in 1856. Soon, she was setting out on a second American journey for her health. The result was a second book, *The Aspects of Religion in the United States of America* (1859).

The prescription to travel may have been a panacea, but it worked – and continued to work. Following her parents' deaths, Isabella travelled first to Australia and Hawaii, then to the Rocky Mountains, Japan (for her neuralgia), India, Persia, Korea, China and Morocco. She insisted that she had no choice but to keep travelling. In her preface to *The Hawaiian Archipelago: Six Months among the Palm Groves, Coral Reefs and Volcanoes of the Sandwich Islands* (1875), she explained: 'During that time the necessity of leading a life of open air and exercise as a means of recovery, led me to travel on horseback to and fro through the islands, exploring the interior, ascending the highest mountains, visiting the active volcanoes, and remote regions … and otherwise seeing Hawaiian life in all its phases.' Like Lucie Duff Gordon, Isabella insisted that returning to home ground would be a rash step and that her health would inevitably suffer. She had written to a friend from the Rockies, 'I am well as long as I live on horseback, go to bed at eight, sleep out-of-doors, or in a log cabin, and lead in all respects a completely unconventional life. But each time that for a few days at Honolulu or San Francisco

I have become civilized, I have found myself rapidly going down again.' Isabella's contemporary and acquaintance Constance Gordon Cumming remarked, while dutifully seeing friends and relatives in Scotland before setting out for Fiji, how she found 'such visiting involves more wear and tear of mind and body, than any amount of travelling in distant lands.' For many of these Victorian women, nothing was as dangerous as being stationary. The best cure for illness – whether emotional or physical – was a good dose of foreign travel.

By the late nineteenth century, the benefits of warm, dry foreign air were in doubt. Diseases that had been prevalent in Britain, including cholera, scarlet fever, typhus, typhoid and malaria, were in decline due to better sanitation, less crowded living conditions, improved diets and medical advances. In 1895, X-rays were discovered. By the turn of the century, fatalities from previously common diseases, including Britain's biggest killer, tuberculosis, were declining dramatically. Britain was becoming a healthier place to live.

In Africa and Asia, however, diseases that were beginning to be eradicated in Europe continued to exact a fatal toll, mainly on the local populations but, inevitably, also on travellers. No longer would someone write, as Florence Dixie had in 1880, that she was going to South America to be 'free from fevers'. By 1893, Mary Kingsley was joking how the shipping line that took her to West Africa, a region known as the 'white man's grave', did not issue return tickets. The London School of Tropical Medicine was founded six years later, with Kingsley's support, in recognition of the health threats associated with foreign travel. By the 1920s, going to a faraway land was not being recommended as a cure but perceived as a risk; it was considered far better to recuperate by taking plenty of rest at home.

Many women, finding claustrophobia induced by domestic responsibilities just as severe a condition as any threatened tropical disease, rebelled against such stay-at-home advice. The side effects of enforced immobility would, many said, be far worse than the cure. In the summer of 1921, Lilian Brown, Lady Richmond (d.1949), convalescing after a serious operation, found herself 'condemned by my medical attendant to months of inactivity, combined with the endless though kindly exhortations of my companions to "be careful". My whole soul revolted at the idea ... It simply could not be done. Everything under such conditions would be abhorrent to me, and I declined to visualise myself becoming a disagreeable, disgruntled and chronic invalid. Flight was my only salvation.' Lilian Brown was a woman of considerable wealth, so she agreed to make a large donation to her friend Frederick Mitchell-Hedges' expedition to explore the San

Dame Rebecca West (1892–1983)
Wyndham Lewis, 1932
Pencil, 430 x 310mm (17 x 12¼")
National Portrait Gallery, London
(NPG 5693)

Cicily Isabel Fairfield took her
pseudonym Rebecca West from a heroine
in one of Ibsen's plays, signalling her
admiration for strong women. In 1913, she
had a passionate affair with the novelist
H.G. Wells (1866–1946), her greatest love,
and had a son. Her marriage, in 1930, to
Henry Maxwell Andrews (d.1968) brought
more order to her chaotic life. Wyndham
Lewis drew her for an exhibition in London
in 1932 called *Thirty Personalities*. He
described her as bursting into a dinner
party like a thunderbolt. Although
successful as a novelist, she is best
remembered for her journalism. She
produced several notable books of her
reporting, of which *Black Lamb and Grey
Falcon* (1941) is the finest. This powerful
account of her travels with her husband in
Yugoslavia describes the many underlying
tensions within the Balkans that have
shaped its history to this day.

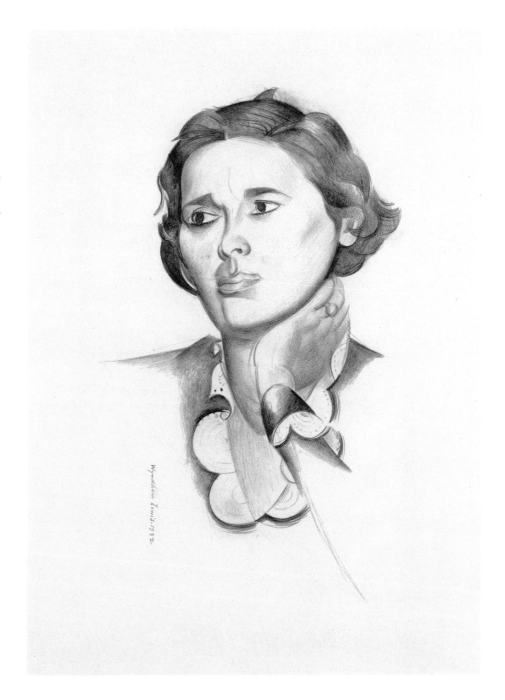

Blas archipelago and undertake deep-sea research off the coast of Belize – as long as she could join him.

Illness as the propulsion behind a journey was so entrenched that when Rebecca West wrote about setting off for war-torn Yugoslavia in the mid 1930s, her post-operative nursing home bed became the launch pad for her departure.

> My operation wound left me an illusion that I had a load of ice strapped to my body. So, to distract me, I had a radio brought into my room ... I heard the announcer relate how the King of Yugoslavia had been assassinated in the streets of Marseille that morning ... It appeared to me inevitable that war must follow ... so I rang for my nurse, and when she came I cried to her, 'Switch on the telephone! I must speak to my husband at once. A most terrible thing has happened' ... So, that evening in 1934, I lay in bed and looked at my radio fearfully ... and later on the telephone talked to my husband ... In a panic I said, 'I must go back to Yugoslavia.'

What had begun, a century earlier, as a medical reason for travelling had become a metaphor. Travel made you whole again.

Women travellers often felt their young lives had been incomplete. Many women, almost always in private, would bemoan their lack of education. Mary Kingsley remembered the hurdles she had faced in the 1870s and 1880s when she attempted to give herself a rudimentary scientific education. She stole her father's copy of *Solar Physics* and, relying on the practical how-to instructions of a popular magazine, used domestic objects – kettles and rags – to perform experiments.

When women did receive a formal education, it was often on different terms to the male students. Gertrude Bell, from an influential industrial family, attended Queen's College, a pioneering girls' school in Harley Street, London. She was an excellent student with insatiable energy and threw herself equally into intellectual and physical pursuits – reading, riding, sailing and tennis. But soon she became bored, sitting in class twisting her fingers round and round her auburn fringe. In January 1886, she scribbled at her school desk to her mother, 'I am writing to you in English Literature. Mr Mabey thinks I am taking copious notes!'

That spring, aged eighteen, Gertrude gained a place at Lady Margaret Hall, Oxford, from where she again wrote to her mother, 'The attendance of women at the lectures is very small. We think ourselves a very large contingent when there are nine of us, and

generally there are about three. This is in classes of between one and two hundred men.' She excelled here, too, completing her papers in only five terms rather than the customary nine, and passing with First Class Honours, but she was not awarded a degree. Although a handful of women had been admitted since October 1879, they were not permitted to graduate.

With a lack of opportunities for formal education, many women would-be travellers, naturally curious, turned to those closest to them for illumination. Their parents, in particular their better educated and well-read fathers, were an inspiration. After her mother's death in 1842, Constance Gordon Cumming, twelfth of sixteen children in a noble Scottish clan and then just five years old, was taken to sleep in her father's room, under his protection and guidance. In her sixties, she remembered the large, illustrated editions of Captain Cook's *Voyage to the South Sea* she had discovered among the books on travel in his dressing room. But Victorian fathers, while often the greatest influence in the home, were frequently, at the same time, physically absent. Mary Kingsley's young life was dominated by the desires and interests of her itinerant father, even though he was so fitfully and briefly with her. Dr George Kingsley was employed as private physician to wealthy families on their world tours, and he rarely spent more than a month or two of the year at home. All the young Mary had left of him were the books in his library, such as James Barbot's *Description of the Coasts of North and South Guinea* (1732). She resented her father's adventures, taken at her and her mother's emotional expense, but she also envied them. The exotic lands depicted in his travellers' tomes seemed a better place to live – even if only in her imagination – than her stifling Cambridge home.

Forty years later, just before the outbreak of the Great War, young Ethel Mannin was being raised to follow in the footsteps of her father, a post office clerk. But even as a child she had broader ambitions. Although she had a basic education at a local school, with few aspirations, this did not prevent her from constructing images of a wider world from any source available. Aged twelve, she began writing to travel agents requesting copies of their brochures. She received booklets with pictures of sailing boats on the Nile and the Temple of Luxor, in the shadow of which Lucie Duff Gordon had lived half a century earlier. She bought an atlas of Europe and, in the margin, made a list of places she hoped to visit – Barcelona, Paris, Berlin, Rome. Her teacher awarded colour picture postcards of foreign countries for 'good composition'. Ethel Mannin, who was top of the class when it came to writing essays, began a collection of the postcards, adding them to pages torn from the travel brochures. She wrote in her first

Lady Florence Dixie (1857–1905)
Andrew Maclure, published 1877
Lithograph, 304 x 213mm (12 x 8⅜")
National Portrait Gallery, London (NPG D16189)

From an early age, Florence showed a fondness for sport and travel together with a facility for writing. After marrying Sir Alexander Dixie (b.1851), she combined these talents in a journey from 1878 to 1879 to Patagonia, where she hunted big game and ate it with great relish. She published *Across Patagonia* in 1880. In 1879, she was the war correspondent for the *Morning Post*, covering the Zulu War in southern Africa. She had strong views on African politics, which she expressed in *In the Land of Misfortune* (1882). In Britain, she was a keen writer of letters to newspapers on a range of liberal issues, including Home Rule for Ireland. She had forthright views on the position of women, proposing equality of the sexes in marriage and divorce, identical male and female clothing, and reform of the royal succession to allow the oldest child of either sex to inherit the throne. In the 1890s, in a distinct about-turn, she condemned as cruel the blood sports she had once so greatly enjoyed, publishing *The Horrors of Sport* in 1891.

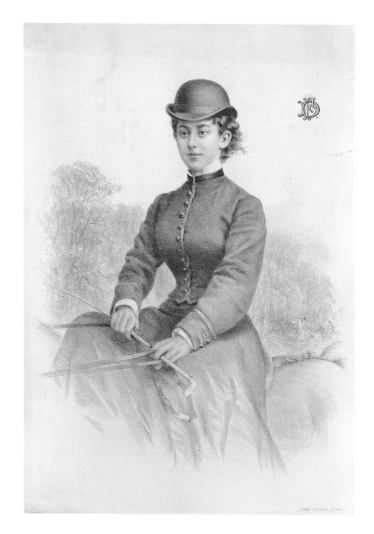

Lady Florence Dixie

travel book, *All Experience* (1932), how she 'never tired of looking at them, so blue were the depicted skies, such sunset hues stained the Alpine snows'.

Her imagination filled in any blanks on the map. She would pretend her own street was in Marseilles, 'with red and white striped awnings over cafés and shops, and the pavements crowded with all kinds of people – sailors, and coloured soldiers in bright uniforms, brown-faced men from the East selling shawls and rugs, dark-haired women without hats ... It would torment me to think of it all actually there whilst I dreamed of it, of it all going on without me.' When, aged fourteen, she started commercial college in London to train as an office worker, she used to walk past the windows of the travel agencies she had written to a few years before and think, 'One day I will walk into one of those offices and buy a ticket for abroad.'

Abroad – from a distance – could take on any shape and provide countless opportunities. In *Safar Nameh: Persian Pictures* (1894), Gertrude Bell noted how 'by the light of our earliest readings we look upon that other world as upon a fairy region full of wild and magical possibilities.' The more blank a spot on the map, the better a woman's ideas and ambitions could be projected on to it. At first, Rebecca West had thought of travelling to Finland, and even learned Finnish in preparation, but the small nation failed to meet her needs. So, knowing already what she wanted to do and say, only ignorant of where she wanted to do and say it, she turned elsewhere. Commentator Felicity Rosslyn has written that West was 'looking for Yugoslavia before she found it'.

In a similar spirit, Lady Florence Dixie, the Marquess of Queensberry's youngest daughter, had set her mind on Patagonia – 'an outlandish place' – because of all she could attribute to it. Patagonia, believed the eager horsewoman and hunter, was '100,000 square miles which you may gallop over', to which she 'added the thought, always alluring to an active mind, that there too I should be able to penetrate into vast wilds, virgin as yet to the foot of man. Scenes of infinite beauty and grandeur might be lying hidden in the silent solitude of the mountains which bound the barren plains of the Pampas, into whose mysterious recesses no one as yet had ever ventured.' So she set out to venture into the land of her imaginings.

Imagination was not always enough; women also needed opportunity. For many, it came late in life, as in their youth they became entrapped by the failing health of their parents and their responsibility, as spinster daughters, to nurse them. Mary Kingsley's mother suffered mental illness, leading to madness. While her feckless younger brother Charley attended Mr Barber's school in Bexley Heath and went on to Christ's College,

Cambridge, to study law, Mary Kingsley cared for her increasingly paranoiac and, eventually, paralysed mother, keeping all the curtains closed so the light outside would not disturb her and she would not disturb the outside world. From behind this screen, Mary peeked out at the society of academics and intellectuals surrounding her Cambridge home. Only after her mother's death did she escape 'the dreadful gloom of all my life' for West Africa.

The death of an ailing parent did not automatically set a daughter free. When the parent passed away, an unattached spinster could be shuttled from brother to married sister, cousin or anyone who might find them useful, rather like a practical piece of family furniture. Lucy Broad, author of *A Woman's Wanderings the World Over* (1909), who, from 1898 to 1908, enthusiastically covered 100,000 miles in ten years as a Methodist missionary for the Women's Christian Temperance Union (even though she could have committed herself to the same evangelical work at home), wrote how, after her mother died, 'There came the blackness of darkness to our home in the death of our loved father, and a while after I moved out of it to successively mother three of my brothers, until each got established with home ties of his own. But all this time I had been fighting a burning desire in my own heart that craved for the whole world.'

Mary Kingsley, who had spent her young womanhood buried in the books of adventure she had found in her absent father's library, set sail for the mysterious recesses of West Africa in 1893, aged thirty. Ten days later, seeing the city of Freetown perched magnificently on the coast of Sierra Leone, she declared from the deck of the *Lagos*, 'It was with a thrill of joy that I looked on Freetown harbour for the first time in my life. I knew the place so well.'

The women travellers had stepped out into these strange, yet familiar, lands.

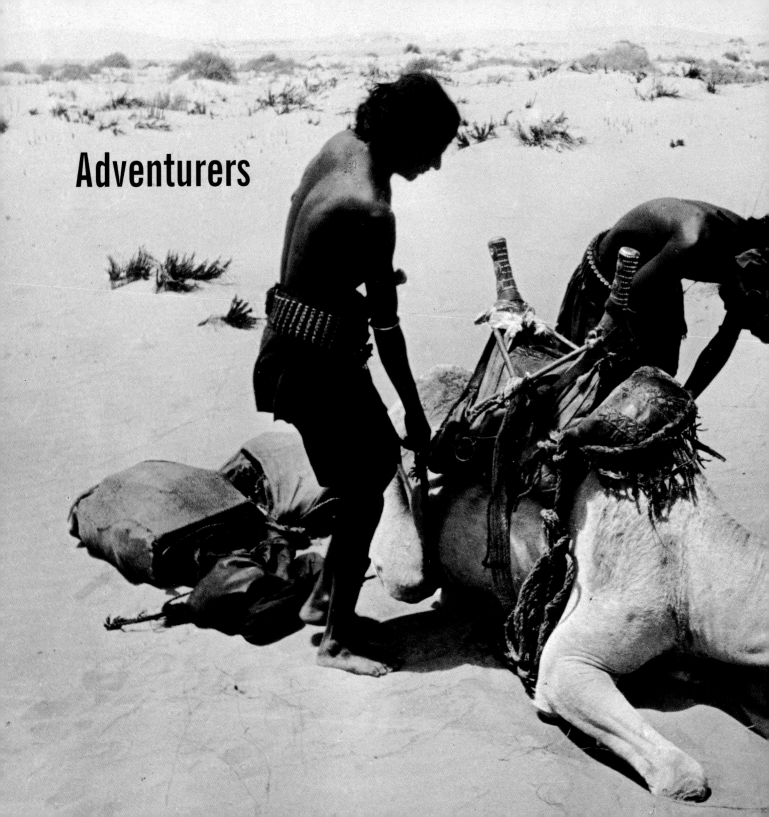

Adventurers

Oh! Isn't it jolly
To cast away folly
And cut all one's clothes a peg shorter
(A good many pegs)
And rejoice in one's legs
Like a free-minded Albion's daughter.

Barbara Bodichon, 'Ode on the Cash Clothes Club', written on the eve of an unchaperoned European walking tour with her friend Bessie Parkes, 1850

First, they noticed the colours. 'The shades are perpetual,' wrote Aphra Behn. 'The trees appearing all like nosegays adorned with flowers of different kind; some are all white, some purple, some scarlet, some blue, some yellow; bearing, at the same time, ripe fruit and blooming young or producing every day new.'

Britain had been grey, full of gloom, murky, cloudy, drab. There Isabella Bird said she felt constantly 'dil', her shorthand for dull and inactive. Abroad, on the other hand – almost anywhere abroad – was vibrant, glowing, luminous and golden-hued, with an 'enlivening sun'.

For Constance Gordon Cumming, landing in India was 'a new revelation'. When she boarded the *Pera* bound for Calcutta, at Southampton on 14 November 1868, she had never been at sea before, apart from a few days yachting around the Hebrides. The husband of her younger half-sister, Jane Eliza, had been posted to India with his regiment, but on inheriting the family estate, was suddenly able to retire from the army and wanted to stay on for a little while to tour the subcontinent. The couple needed a nanny for their young son, Charlie, and asked Aunt Eka (as Constance, whose middle name was

Freya Stark's camel being loaded by a Bedouin
Freya Stark, 1937–8
Gelatin silver print
John Murray Archive

Constance Gordon Cumming

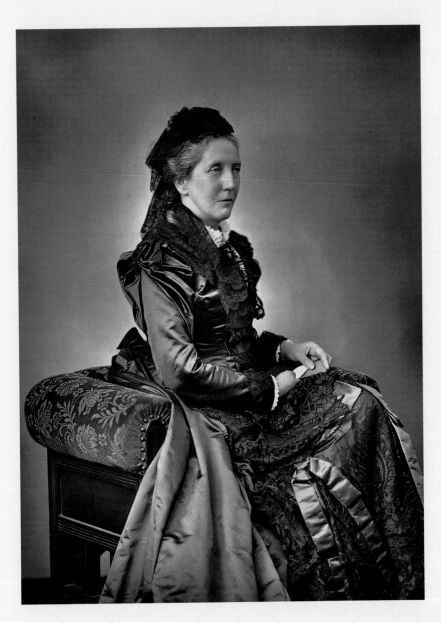

Constance Frederica 'Eka' Gordon Cumming (1837–1924)
Barraud, published in *Men and Women of the Day*, 1893
Sepia-toned carbon print, 250 x 185mm (9⅞ x 7¼")
National Portrait Gallery, London (NPG Ax27649)

Constance was born into a large, wealthy Scottish family.
She was almost self-taught as an artist, although she
had a few lessons from one of Queen Victoria's favourite
painters, Sir Edwin Landseer. Her first journey, in 1868,
was to Egypt and India with relatives and to Ceylon (now
Sri Lanka), where she knew the bishop. Family
connections then took her to the Pacific. In the 1870s,
another relative, Sir Arthur Hamilton Gordon (1829–
1912), was appointed the first Governor of the Crown
Colony of Fiji, and Constance accompanied Lady
Hamilton Gordon as her companion. There she painted
watercolours, less flamboyant than the oil paintings of
her friend Marianne North, and wrote *At Home in Fiji*
(1881). *A Lady's Cruise in a French Man-of-War* (1882)
records her trip with the Bishop of Samoa around his
far-flung diocese. She also travelled to Australia, New
Zealand, North America, Hawaii, China and Japan, writing
travel books and memoirs. She became particularly
interested in the education of Chinese people who were
blind. In old age, she returned to Scotland.

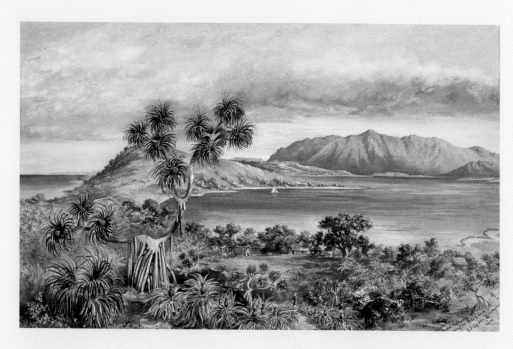

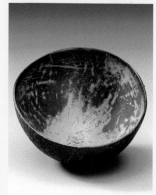

Sunset from Nananu, looking to Viti Levu, Fiji
Constance Gordon Cumming, 1876
Watercolour, 593 x 371mm (23⅜ x 14⅝")
University of Cambridge Museum of Archaeology and Anthropology

Kava Cup from Fiji
Collected by Constance Gordon Cumming, 1870s
Coconut shell
University of Cambridge Museum of Archaeology and Anthropology

Constance Gordon Cumming visited the small Fijian island of Nananu in September 1876, as she records in *At Home in Fiji*, and found 'the Robinson Crusoe home [of my] visions of romance … Imagine the charm of walking straight out of your bedroom … and plunging into the very clearest' sea: 'You are tempted to bathe at every turn.' She found the island shaped 'something like a starfish' and described 'an immense horseshoe of purest white sand … shaded by noble old trees'. 'Morning and evening' she sat on 'the raised centre of the island … watching for the rare appearance of a sail … The screwpine … makes an odd sketchable bit of foreground, with its long prickly leaves set screw-wise, and its roots like a cluster of white pillars, making the tree look as if it were walking on stilts.' The much bigger island of Viti Levu in the distance struck her as 'a fine rugged land, with narrow valleys hemmed in by great cliffs, and running down to the shore where little villages nestle beneath great trees.' Her watercolours of Fiji were displayed in an exhibition of her work at the Royal Pavilion in Brighton in the early 1890s.

The kava cup is a central feature of an important Fijian social ritual described by Constance Gordon Cumming in *At Home in Fiji*. Kava is a narcotic drink, made from the roots of the yangona plant, and is still consumed at ceremonial occasions today. Constance describes how the root was 'cut into small pieces and distributed to a … circle of young men to chew', creating 'finely chewed white fibres'. These are mixed with water in a kava bowl, 'a great wooden bowl with four legs … beautifully polished from long use, [with] a purple bloom like that on a grape'. The result is 'a turbid yellowish fluid … in taste resembling rhubarb and magnesia, flavoured by sal-volatile'. She adds that 'the operation is not *quite* so nasty as might be supposed.' It is drunk from coconut shell cups like this one 'while all the onlookers join in a peculiar measured handclapping'. She also says that while 'no one pretends to like the taste … its after effects are said to be pleasantly stimulating … Drunkenness from [it] … does not affect the brain, but paralyses the muscles so that a man lies helpless on the ground, perfectly aware of all that is going on.'

Frederica, had always been known, as if irredeemably and forever a maiden aunt) if she would act as the nanny's chaperone on the voyage out.

At first, Constance, always a doer of odd jobs for others, took on the task for her sister's sake. But almost immediately, from 'the never-to-be-forgotten sensation of a first glimpse of the real tropics', she was intoxicated. Forgetting her initial reluctance, she was soon proudly claiming that, wherever she went in India, she was the first woman who hadn't gone as 'a wife or sister of some official' or 'under compulsion'.

In fact, Constance rarely left British shores unaccompanied, but these offers and invitations provided the best excuses for her to strike out. In 1874, she travelled to Fiji as a companion for Lady Hamilton Gordon, wife of the first Governor, although later she wrote in her autobiography that she had gone there 'simply because that was the most absolutely improbable idea that could suggest itself.' Once she arrived at her destination, her itinerary was her own. By Christmas, she was living alone in a Fijian hut.

Sitting outside writing and painting, Constance was trespassing in forbidden territory. Indoors was the natural habitat of women in Britain; outdoors was not only deemed inappropriate, but also dangerous to a woman's physical and moral well-being. Horace Woodward, President of the Geologists' Association, warned that there were still areas of his discipline that were 'unsuitable'. 'Even in England,' he told the 1894 annual general meeting, 'in the process of field-survey one must spend many hours of a long period of time in spots the most lonely and desert [sic] ... the time has not yet come ... when lady geologists could ... wander at will unattended over the country.'

Women travellers sought to wander freely and for long periods of time in Asia, Africa and the Americas instead. Being in the open air was invigorating. In August 1892, Gertrude Bell wrote to her mother from an expedition in the Middle East, 'I shall be sorry to leave this wonderful Freedom and to be back within walls and gardens.' Abroad, being outdoors was doubly exhilarating for the novelty of the wide open spaces and the rampant foreignness. It was what Vita Sackville-West, when she first saw the Persian landscape in 1926, dubbed 'this question of horizon'. The views were, quite simply, 'enormous'. In *Persian Pictures*, her first book on the East, her friend Gertrude Bell had shared the adventurer's attraction to 'the boundless plain stretching before him, the nights when the dome of the sky was his ceiling, when he was awakened by the cold kisses of the wind'. Twenty years earlier, Isabella Bird had experienced the same feeling of her heart opening up to fill the vast land stretched out in front of her. On 28 September 1873, she wrote to her sister in tiny Tobermory in the Scottish

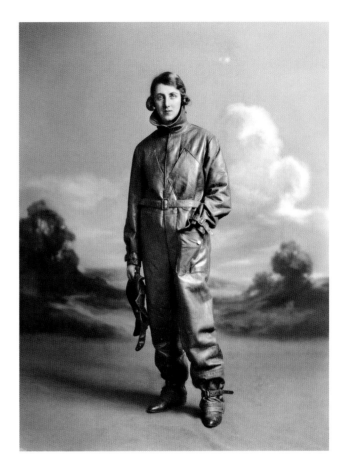

Violet Cressy-Marcks (1895–1970)
Lafayette, 7 August 1926
Modern print from an original whole-plate negative
National Portrait Gallery, London (NPG x69133)

Violet Cressy-Marcks's journeys took her round the world many times. She used all means of transport, from sleigh to canoe, and various four-footed creatures, as well as wheels and her own feet. This photograph, despite her active appearance, was taken in a London studio. Although married, she principally travelled alone taking photographs and shooting film. Her extensive interests encompassed archaeology, zoology, ethnology and geography. She wrote only two books about her journeys: the first was *Up the Amazon and Over the Andes* (1932). In north-west China in 1937, she interviewed Mao Tse-tung (1893–1976) for five hours at the remote cave dwellings that housed the wartime Communist headquarters, recorded in her book *Journey into China* (1940). From 1943–5 she was a war reporter in Chungking (Chongqing) for the *Daily Express*. She continued to travel after the war but her journeys became slightly less strenuous.

Highlands that the Rocky Mountains meant 'everything that is rapturous and delightful – grandeur, cheerfulness, health, enjoyment, novelty, freedom, etc, etc. I have just dropped into the very place I have been seeking, but in everything it exceeds all my dreams.'

Isabella Bird was a keen camper, and liked nothing better than to roll out her muslin-lined blanket sleeping bag in a fresh spot each night. Always precise, even in her speech (Marianne North observed that Isabella talked very slowly and methodically, as if 'she were reciting from one of her books'), she had a thoroughly tested routine that she observed on her travels. In the morning, she would rise and have a cup of tea accompanied by 'stir-about', boiled water thickened with local flour. She then travelled

until midday, when she halted for two hours for her carriers, who transported the load of her heavy camera kit and other equipment, to rest and eat. Isabella lunched on chocolate and raisins. She aimed to reach her new camp before six in the evening. Her men would pitch her folding bed, and she would take another cup of tea before sitting down to record the day's events in her notebook. For supper, she had curry, 'always appetising', made with her own curry powder and cayenne pepper.

Even small, everyday activities could be transformed into sensual pleasures. In April 1876, Constance Gordon Cumming wrote from 'The Teacher's House at Limiti, Isle Ngau', how a bath was no longer a 'humdrum tub, filled by a commonplace housemaid' but was taken in the open air, in an 'exquisite stream ... just deep enough to lie down full length', overarched by great tree ferns and palm fronds 'through which you see peeps of the bluest skies'. She confessed that, stumbling across such spots when alone, she simply undressed and waded in, her long blonde ringlets, usually so formally and old-fashionedly arranged, becoming damp and unkempt. After she had bathed, she picked ripe oranges from the tree, peeled and ate them. Being alone like this in the Fijian forest was far from frightening. Ten years later she was boasting in her book *Wanderings in China* (1886), 'physical fear is a sensation which I have never experienced.'

A determined fearlessness when faced with a physical threat was shared by many women travellers. Violet Cressy-Marcks had already trekked the Cape to Cairo route and sleighed across the frozen north to Murmansk before tackling the rivers and swamps of South America in 1929. She was sleeping on the ground in the Amazon when she was woken by a snake slithering over her. She grabbed it just below the head, crawled out from under her mosquito net and walked until she found a rock to smash the snake's head against. 'I was afraid I should cause too much commotion if I fired,' she explained in *Up the Amazon and Over the Andes* (1932). She had been bitten below the knee. Not knowing whether the snake was poisonous or not, but taking no chances, she used her scalpel and cut across the bite, pushing in two halves of a tablet of permanganate of potash. She examined her face in a mirror ('I hadn't used one for months') to see if she were turning grey or her lips were a strange colour. Apart from being thinner than when she had last looked, 'nothing seemed to be amiss.' Anyway, she mused, 'if I was going to die it was a fine spot for it.'

The sense of freedom (Gertrude Bell always spelt it with a capital 'F') was so exhilarating that any terror turned to rapture. 'Travellers talk of danger when surrounded by hungry jackals. I have always found that they flew away if a pocket-handkerchief were shaken at them,' wrote Isabel Burton from the Syrian desert. 'Their

yell is unearthly as it sweeps down upon you, passes, and dies away in the distance. I love the sound, because it reminds me of camp life, by far the most delightful form of existence.' Before setting out for the Middle East, Freya Stark described how, in 1913, in the French Alps, she had climbed with a rope for the first time. 'The happiness was almost frightening, for it seemed more than one human being could manage ... the extraordinary sensation of safety, the abyss held in check, the valley with its life of everyday, bridges, tracks, fields and houses, seen from a narrow ledge which made it exciting and remote ... from now on I became a mountaineer.' Humour was the best way to deflect any anxiety. When Mary Kingsley, tramping through West Africa in 1893, was lost on Mount Cameroon with a single African porter who showed signs that he might be seriously disturbed, she stated simply, 'Nice situation this ... a mad man on a mountain in the mist.'

The women adventurers did not feel threatened by the opposite sex. 'Their apparent defencelessness is a passport, especially among born gentlefolk like the Arab and Druzes,' said one *Times Literary Supplement* commentator in 1907, a sentiment with which Middle East travellers Gertrude Bell and Freya Stark would have concurred. Constance Gordon Cumming wrote to her sister Elisa from Fiji in December 1875: 'Now I am going out to explore some of the trails which lead to higher ridges, that I may see the mountains of the interior ... It makes me laugh now to remember how, the first day I was walking alone on the hills of Ovalua, I hid myself among the bushes from a solitary Fijian, the savage of my imagination. Now, in far wilder country, I walk alone in perfect security, wherever fancy leads me.' The constant, real fear was that they would have to stop moving, that the freedom to wander would come to an end.

Women travellers covered the oceans like pebbles skittering across a pond. Addicted to motion, no sooner had they returned to Britain than they were plotting how to leave once more. 'I always feel dil when I am stationary,' wrote Isabella Bird. 'The loneliness is dreadful often. When I'm travelling, I don't feel it, but that is why I can never stay anywhere.' Nothing animated her as much as planning for another departure. When she met Scottish ship owner Thomas Dunlop, he wrote, 'she astonished me by her energy and her capacity in making arrangements.' Rather than serving as an enticement with its comforts and conveniences, polite society provided further fuel for the women's journeys. Isabella Bird wrote on her return from Japan in 1878, 'After being for two months exclusively among Asiatics, I find the society of English people fatiguing; my soul hankers for solitude and Freedom.' Even the responsibility of editing your own book could be cast off on the excuse that you were very sorry, but you

Dame Freya Stark

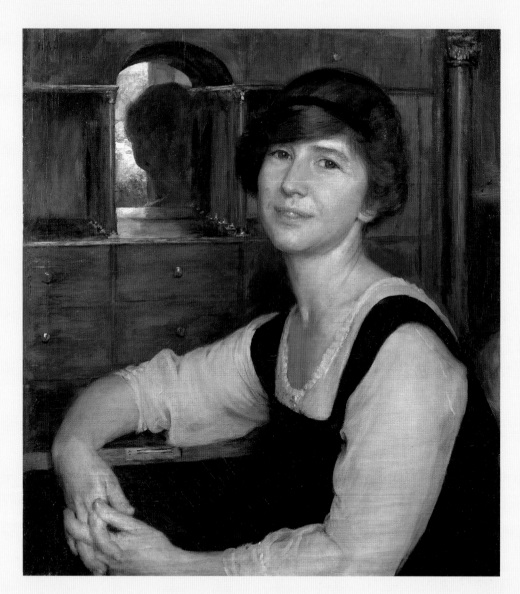

Dame Freya Stark (1893–1993)
Herbert Olivier, 1923
Oil on canvas, 619 x 555mm
(24³/₈ x 21⁷/₈")
National Portrait Gallery, London
(NPG 5465)

Freya's early years were partly spent abroad, where she learned several languages. When her parents separated, her mother set up a factory to make baskets and rugs in Italy. When she was twelve, Freya's long hair became entangled in one of the machines, tearing away her right ear and some of her scalp. She adopted the swept-across hairstyle, seen in her portrait, to hide her injuries. In 1927, she went to Lebanon to learn Arabic and then travelled around the Middle East. In *Letters from Syria* (1942), she wrote: 'I never imagined that my first sight of the desert would come with such a shock of beauty and enslave me right away.' After learning Persian, her book about her Iranian journey, *The Valleys of the Assassins and Other Persian Travels* (1934), established her as a notable traveller, winning her prizes and financial support. A trip to Yemen followed. She was briefly married to the diplomat Stewart Perowne. In her sixties she retraced the footsteps of Alexander the Great, writing a trilogy steeped in her love of Turkey. At the age of eighty-two she was made a dame; she continued travelling until she was ninety.

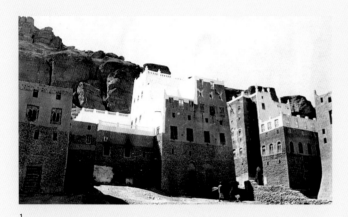

1

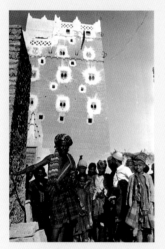

2

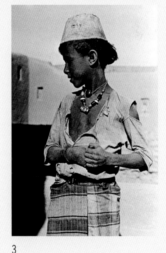

3

Photographs of Yemen
Freya Stark, 1937–8
Gelatin silver prints
John Murray Archive

Freya Stark was a gifted photographer, and recorded her 1937–8 travels in southern Yemen pictorially in *Seen in the Hadhramaut* (1938). A previous journey to this area had almost claimed her life, as she developed severe angina, causing 'indescribable paroxysms'; fortunately, she was given the right medication and flown by the RAF to the hospital in Aden just in time. The dedication in her book *The Southern Gates of Arabia* (1936), which describes this first journey, is to 'The Royal Air Force, and especially those in Aden who made the writing of it possible by carrying me in safety from Shibam.' Shibam, to which she returned, was a place of 'about five hundred houses … in this bee-hive cluster … one of the most beautiful of all the wadi towns, especially at sunrise and sunset, when low shafts of light catch the great walls and make them glow.' This photograph, the only one here that she did not use in the picture book, is inscribed on the back 'our home in Shibam' (1). Another personal image shows her camel being loaded by Bedouin (see pp.30–31) with 'a silver-pommelled saddle lent by the Sultans of 'Azzan, and … therefore much more comfortable to ride than the ordinary baggage camel'. She was fascinated by the architecture including the Sultan's palace at 'Azzan (2), which she photographed with some of his 'retainers'. She particularly noted the 'use of ibex horns around the roof', adding that 'it is the animal most frequently seen carved or painted on the rocks among pre-Islamic inscriptions.' Some of her finest photographs are of people. This boy was 'a small and particular friend – Ali … He used to visit me nearly every day and gave me the pleasure of seeing pure and absolute happiness on the face of a human being – during his first drive in a motor-car' (3).

Freya Stark's Camera
John Murray Archive

Freya Stark used this Leica III camera, which she bought in Berlin in 1933, on her many trips abroad, processing her films at dawn in a black developing bag. She recorded her thoughts on her travels in tiny notebooks, generally in pencil. Freya Stark kept all her passports from her long lifetime as a traveller. The one illustrated on pp.2–3 was issued on 26 November 1934 to 'Miss F. M. Stark'. She used it for her travels to Yemen.

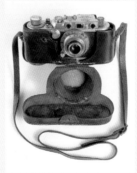

were unexpectedly caught far away from home. Isabella Bird proofread and edited Constance Gordon Cumming's two-volume *From the Hebrides to the Himalayas: A Sketch of Eighteen Months' Wanderings in Western Isles and Eastern Highlands* (1876) 'in the absence of the author, who sailed unexpectedly for Fiji'.

Few married but, if they did, not even marriage could anchor them. When Isabella Bird took Dr John Bishop as her husband on 8 March 1881, who had been gallantly nursing Isabella's sister Henrietta until her death the previous year, it was in the black serge of mourning and there were no guests. Before the wedding, she wrote to her publisher that he needn't fear he would lose one of his most successful authors. 'I shall retain in literature the name under which I have gained a fair success,' she assured John Murray, adding, 'It is an understanding that if I again need change, I am to be free for further "outlandish travelling".' Marianne North liked to repeat a story circulating round all the best soirées: when Mrs Bishop was asked if she would like to go to New Guinea, she replied, 'Oh yes; but she was married now, and it was not the sort of place one could take a man to!'

Dr Bishop was an invalid; he suffered from a painful skin disease. His new wife, also continually unwell while at home, pushed him in a bath chair around the spas of Europe in pursuit of futile cures. After five years of marriage, Dr Bishop died, and Isabella did what she had always done: she sought out far-flung paths, and began to plan a trip to Persia.

Women adventurers did not attract funding from learned societies nor large commissions from newspapers and magazines. They did not inherit the family estate. Without such financial support, they could never hope to match the grand, gesture-filled explorations of their well-financed male contemporaries. (On his first African journey in 1871, Henry Morton Stanley, sponsored by a national newspaper, took eight tonnes of equipment, which required 300 porters to carry.) So while men paraded, women pottered, often travelling simply. Isabella Bird advised would-be travellers to take only the utterly indispensable and to rely upon local provisions. 'I also consider it of importance to discard the many presents which friends are anxious to press upon one, in the shape of folding drinking cups, sandwich boxes, pocket filters, and such-like articles,' she told *Climate* magazine. Instead of a pillow, she recommended a pillowcase stuffed with one's own clothes. In 1876, Marianne North relished the relative simplicity of a Sarawak sojourn without a large retinue: 'The Rajah lent me a cook, a soldier, and a boy, gave me a lot of bread, a coopful of chickens, and packed us all into a canoe, in which we pulled through small canals and forest nearly all day; then landed at a village, and walked up 700 feet of

beautiful zigzag road, to the clearing in the forest ... Life was very delicious up there.'

This difference in scope and style was not lost on commentators at home. One usually sympathetic voice wrote that travellers were made up of two classes: 'those who discover ... and those who simply follow in the track of their bolder or more fortunate predecessors, gathering up fuller, and, it may be, more accurate information. To the latter class ... belong our female travellers, among whom we find no companion or rival to such pioneers as ... Livingstone.' The consensus was clear: the best women travellers could never match the best men. Most of the women travellers, publicly at least, would have agreed, as they were careful to defer to the men's greater achievements. In her first venture into print, in a letter to the *Telegraph* newspaper published on 5 December 1895, Mary Kingsley denied her status as a New Woman and emphasised, 'I did not do anything ... without the assistance of the superior sex.' In private, however, many felt that recognition for their work – travelling and then reporting on their travels – was overdue. 'I think that I have contributed so much to the sum of general knowledge of different countries that had I been a man I should undoubtedly have received some recognition from the Royal Geographical Society,' wrote Isabella Bird to her publisher.

Such sentiments could only be whispered in private between friends. The risks inherent in the women's aberrant behaviour were huge. If any overt identification was made with male antecedents, then a woman adventurer could become de-sexed. Rather than heralded as heroes, they would be branded as freaks. The more free the women's travels, and the less circumscribed by convention, the more they opened themselves up to criticism. When the British traveller Mark Sykes met Gertrude Bell in Jerusalem in 1906, he wrote afterwards to his wife Edith describing Bell as a 'conceited, gushing, flat-chested, man-woman, globe-trotting, rump-wagging, blethering ass!' This was a strong warning to Edith Sykes – and any other woman harbouring secret ambitions – of the dangers of stepping out.

In an attempt to mitigate such disapprobation, women adventurers often emphasised their conservatism in all matters. Despite the many miles they covered, they were, they assured an anxious public, respectable, middle-aged, duty-bound women. They were dedicated daughters and maiden aunts. Gertrude Bell, who happily tramped through Middle Eastern deserts, refused to walk unchaperoned along Piccadilly in central London. Between journeys, she spent her time at home helping to found the Anti-Suffrage League. Flora Shaw, the Colonial Editor of *The Times*, became a member. It was Gertrude Bell's role, as the League's Honorary Secretary, to read out reports at council meetings. Ironically, even at the League's first executive meeting on

25 November 1908, it was announced that 'In the unavoidable absence of Miss Gertrude Bell ...' the report would have to be read by someone else. Miss Bell was busy writing up her archaeological work for her book, co-authored with Sir William Ramsay, *The Thousand and One Churches* (1909).

It was a rare woman adventurer who openly supported suffrage. Lady Florence Dixie was just such a maverick, and a firm believer in causes. Lady Florence had been a war correspondent for the *Morning Post* in South Africa, and was active in the Humanitarian League and the movement to ban the blood sports that she had once so enjoyed. She was also prominent in the Women's Franchise League, producing a pamphlet for them entitled *Women's Position* (1891).

In general, however, women adventurers were overly eager to ensure they did not appear challenging in anything other than their adventures. Their rigorous attempts to seem proper made them girdle any passion. Ship owner Thomas Dunlop noted how Isabella Bird displayed 'a dignity that forbode the slightest approach to familiarity'. They shunned closeness. Some took such paradigms of upright Victorian spinsterhood to the point of parody. Mary Kingsley would appear on the lecture platform dressed as a woman far beyond her years, always in black and with her hay-coloured hair vigorously scraped back inside a tight black sealskin bonnet. She would ask the audience if she reminded them of their maiden aunt.

Of course, away from home it was a different story. In distant lands, they could forge new identities. 'I know all the mysteries of camping life, can find a blind trail with something of Indian instinct, and I have the character of a very expert horseman,' wrote Isabella Bird, the invalid clergyman's daughter, from the Rockies. 'I write horseman, because I have been living for ten months where sidesaddles are not recognised, and if you saw me on my mustang, and a peaked Mexican saddle with great wooden stirrups and Mexican spurs, if you did not say it was "neither brute nor human", you would say "neither man nor woman".' Gertrude Bell also discovered the delights of dressing with some sexual ambiguity. She wrote to her father from Deraa on the joys of using a 'masculine saddle':

Never, never again will I travel on anything else; I haven't known real ease in riding until now. Until I speak the people here think I'm a man and address me as *Effendim!* [The Turkish title of respect applied to officers and professional men.] You mustn't think I haven't got a most elegant and decent divided skirt, however, but as all men wear skirts of sorts too, that doesn't serve to distinguish me.

Gertrude Bell (1868–1926)
Flora Russell, 1887
Watercolour, 254 x 178mm (10 x 7")
National Portrait Gallery, London (NPG 4385)

Gertrude Bell's father was a key influence throughout her life both as her confidant and supporter. Although she twice fell in love, marriage eluded her. She wanted to be 'a Person' – to be treated seriously, like a man. Despite being the first woman to achieve a First in Modern History at Oxford (women then were not awarded degrees), she was a founder member of the Anti-Suffrage League, opposing votes for women. This watercolour is by her friend Flora Russell. After Oxford she went to Tehran, where she stayed with her uncle, the British ambassador, and became excited by the Middle East. Her passion for the region infuses *The Desert and the Sown* (1907) and her other books. She increasingly found that, particularly in Iraq, with her excellent linguistic skills and understanding of complex desert tribes, she could make her mark alongside men such as Lawrence of Arabia (1888–1935). After the First World War, she proposed the present-day borders for Iraq, favouring an Arab government headed by Lawrence's friend Prince Faisal. This she helped to achieve, but there was then less call for her political advice. She returned to an earlier interest in archaeology, and founded the Baghdad Museum. Becoming depressed and disillusioned, in her late fifties she took a fatal overdose.

Gertrude Bell Measuring at Ukhaydir, Iraq
Unknown photographer, March 1909
Modern print from an original negative
Gertrude Bell Photographic Archive, Newcastle University

Gertrude Bell first saw the ruins at Ukhaydir in late March 1909, having ridden out across the desert with 'a young man' named Watts. As she described in her letters (now at Newcastle University): 'We came to the most wonderful building I had ever seen. It is an enormous castle, fortress, palace – what you will … the immense outer walls set all along with round towers and … filled with court after court of beautiful rooms vaulted and domed covered with exquisite plaster decoration … As soon as I saw it I decided that this was the opportunity of a lifetime.' Though dating back to 750–800AD, it was 'almost perfect'. Watts used his surveying equipment to record the outer walls while Gertrude 'set out with a measuring tape and foot rule to plan the whole place'. Watts also may well have taken this photograph of her at work with her Arab assistants. 'I worked yesterday for 5 hours and today 8 … Tomorrow I shall … draw it out,' but felt her effort was worthwhile: 'My plan [of it] is the first that has been made. Thank Heaven I worked at it so carefully and took so many photographs!'

GERTRUDE BELL 1887 BY FLORA RUSSELL

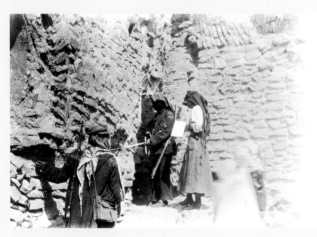

As when Constance Gordon Cumming indulged in her open-air bath, few women willingly submitted to the discomforts of Victorian dress if there were no Victorian eyes to watch them. Unfortunately for Isabella Bird, however, she was spotted. It may not have been compromising for her to wear India rubber wellingtons, 'most useful for riding on horseback when the weather is wet, or wading', but further transgressions in the manner of costume drew less approving comments. It was reported in *The Times* that while making her way over the Rockies she had 'donned masculine habiliments for greater convenience'. Isabella was furious; she inserted a note in the second edition of *A Lady's Life in the Rocky Mountains* (1879) and included a pen-and-ink sketch of the dress that she had been wearing, which, she claimed, had been so misdescribed by *The Times*. It was, she said, the 'American Lady's Mountain Dress' (a title she surely thought up herself), 'a half-fitting jacket, a skirt reaching to the ankles, and full Turkish trousers gathered into frills which fall over the boots – a thoroughly serviceable and feminine costume for mountaineering and other rough travelling in any part of the world.'

On returning to Britain, the women adventurers took up their old costumes – as assumed a role as any of the parts they played far from home. Inevitably, their images in the National Portrait Gallery collections tend to depict them in their British setting. A friend wrote of Gertrude Bell and her contemporary, the far more flamboyant Middle East traveller Rosita Forbes:

> Neither she [Rosita Forbes] nor Gertrude Bell neglected the minor arts of dress. Gertrude, straight from the desert, would meet her London friends looking as if fresh from the hands of Worth. And was it not told of [Rosita] that in a year when hats were certainly large, hers was the most startling cart-wheel that had ever been seen at Ascot?

In the make-believe world of the photographer's studio, a few of them briefly replayed their travelling personae – notably Isabel Burton, in her Arab male costume, and Violet Cressy-Marcks in her leather flying suit. (Conversely, when, in Samoa, the camera was pointed at Margaret Stevenson, she chose to dress as an Edinburgh widow rather than in the native garments and bare feet in which she was far more comfortable.) However, even in the 1920s, Dorothy Mills, Lady Walpole, the first European woman to reach Timbuktu, always took fashionable clothes with her so she could change if she met other Western travellers. Only when unwatched in the forests, jungles and deserts did women disrobe and dress as they wished, unencumbered.

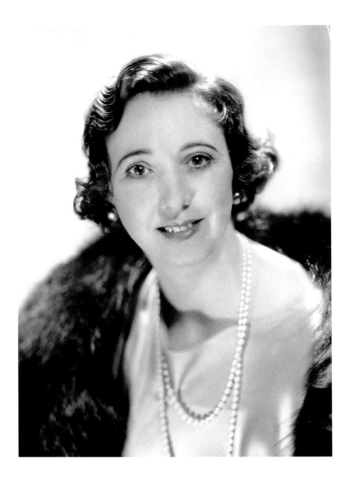

Rosita Forbes (1890–1967)
Howard Coster, 1934
Modern print from an original 10 x 8" negative
National Portrait Gallery, London (NPG x16614)

Crossing deserts in disguise and meeting prominent Arab leaders were just some of Rosita Forbes's specialities. Her first great journey was to Libya in the winter of 1920–1, when she became the first non-Muslim woman and only the second European to enter the closed city of Kufra (or 'Kufara'). She dressed as a Muslim woman called 'Khadija', claiming a Circassian mother to explain away her poor Arabic, and took photographs with a concealed camera. She journeyed by camel-train with an Egyptian explorer, Ahmed Hassanein Bey, but reduced his role in her account, *The Secret of the Sahara: Kufara* (1921). Khadija then visited Yemen. In 1925, Rosita Forbes published *From Red Sea to Blue Nile: Abyssinian Adventures*, recounting her journey through Ethiopia. She met leading figures in the Middle East; they featured in her lectures and books. She visited India and, with her second husband, Colonel Arthur Thomas McGrath (d.1962), went to South America. They settled in the Bahamas and she died in Bermuda.

Women had always been restless, urged on by what the author of *Domestic Manners of the Americans* (1832), Frances Trollope, called (in her 1838 *Vienna and the Austrians*) 'the demon of curiosity'. A young man, meeting Lady Mary Wortley Montagu in Rome in 1740, wrote she is 'one of the most extraordinary shining characters in the world; but she shines like a comet; she is all irregular and always wandering.' Lady Mary, a poet and satirist, had wandered in style. Her husband had been appointed Ambassador Extraordinary to the Court of Turkey in 1716, and she went with him to Constantinople. At this time, well before Victorian sensibilities set in, experimentation with foreign attire was something in which upper-class British men – and occasionally women – could dabble. Lady Montagu's status wasn't threatened when she wrote to her sister

Dorothy Mills, Lady Walpole (1889–1959)
Bassano, 15 May 1911
Modern print from an original negative
National Portrait Gallery, London (NPG x33162)

With a British father, an American mother and a French education, Dorothy Walpole grew up travelling. When her less-than-wealthy husband Arthur Mills (1887–1955) became an author, she, too, turned her hand to writing. Ill health first took her to North Africa and she quickly became fascinated by the continent. In 1923 she became the first Western woman to reach Timbuktu, despite the many difficulties of the journey; she published *The Road to Timbuktu* the following year. Further African journeys and books followed, illustrated with her own photographs. She wrote *Through Liberia* in 1926 and her journey to Senegal was recorded in *The Golden Land* (1929). Everywhere she went, she took fashionable clothes and hats with her, as she never knew whom she might meet. As well as travelling in Africa, she went east as far as Iraq. *Beyond the Bosphorus* (1926) was the result. Her last journey took her west to Venezuela, *The Country of the Orinoco* (1931). This, too, provided a range of terrors and discomforts, which she survived unruffled. Divorced in 1933, she spent her later years in London.

Lady Mar, from Adrianople on 1 April 1717, 'I am now in my Turkish habit', and promised to send her a picture.

Lady Mary was a remarkable observer, and became particularly interested in the life of the women in the harem, to which she was given unprecedented access. (Previous accounts by male travellers had been close to imaginary as, unable to enter and see for themselves, they incorporated every fantasy and prejudice.) Unlike later Victorian accounts, she assured her sister that Turkish women were not enslaved, but 'the only free people in the Empire.' They enjoyed great liberty not despite their veils but because of them. They could move around town and make secret assignations with their lovers unrecognised. If they were discovered, they didn't have to fear the penury of divorce.

Lady Mary Wortley Montagu

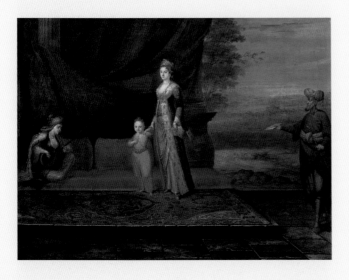

Lady Mary Wortley Montagu (1689–1762) with her son Edward Wortley Montagu (1713–76)
Attributed to Jean Baptiste Vanmour, *c*.1717
Oil on canvas, 686 x 902mm (27 x 35½")
National Portrait Gallery, London (NPG 3924)

Lady Mary Pierrepont was a lively child. She claimed her happiest day was when, aged about eight, her father, Lord Kingston, had her elected to the prestigious all-male Kit-Cat Club. Forbidden by her father to marry the man of her choice, she escaped from home and had a private wedding. Her husband Edward Wortley Montagu was appointed ambassador to the Turkish court in 1716. The couple arrived in Turkey with their young son in May 1717. This portrait was painted in Constantinople (now Istanbul), which can be seen in the background. Lady Mary is shown in Turkish dress with her son and two attendants, one playing the Turkish lute, the other perhaps holding a letter. The country and its people fascinated her; her letters home cover a huge range of topics. Lady Mary's other journey was twenty years later. She went to Europe and settled in Venice for many years, leaving her husband, which caused a scandal. She returned to Britain just before her death.

Lady Mary Wortley Montagu's Travel Letters, 1716–18 (page 95)
Camden Local Studies and Archive Centre

Lady Mary Wortley Montagu's letters from Turkey covered many topics, including clothing, harem life, music, Turkish baths and the fate of Muslim women's souls. She was particularly interested in the practice of inoculating children against smallpox, as she had suffered from the disease, which ruined her appearance. Her son Edward was the first British person to be inoculated, which she called 'engrafting'. Later she also had her daughter Mary, born in Turkey in 1718, inoculated and, on her return to Britain, persuaded Caroline, wife of the Prince of Wales, afterwards George II, to have the royal children inoculated. These letters had an interesting history. Lady Mary entrusted her copies to a clergyman friend. One day, two men visited him and requested to see them. Causing a distraction, they left with the letters, which were returned the next day with apologies. Overnight this copy of them had been made, which led to their unauthorised publication. This greatly upset her family, who had hoped to suppress them altogether.

Elizabeth, Lady Craven (1750–1828)
Ozias Humphry, *c*.1780–83
Oil on canvas, 605 x 506mm (23¾ x 20")
National Portrait Gallery, London (NPG L223)

Elizabeth Berkeley married William, Lord Craven (d.1791), in 1767 and began her
literary career writing plays. After having six children, she and her husband
separated in 1783. Horace Walpole recorded 'she has I fear been *infinitamente*
indiscreet.' She went abroad to France and Italy, then on to Poland, Greece,
Russia and Turkey. She published an account of her travels, *A Journey through
the Crimea to Constantinople*, in 1789. She then went to Anspach in Germany.
She wrote to her husband that the Margrave (a prince of the Holy Roman Empire)
treated her like a sister, but after Lord Craven's death, she married the
Margrave; her six children never forgave her adultery. In Anspach, she translated
plays and wrote her own, while her husband composed music for the
performances. After further travels, she and the Margrave settled in England,
although she was not welcome at court. She continued to write for the stage and
to perform in her own plays at their home in Hammersmith, London. The
Margrave died in 1806 and Elizabeth travelled again. In 1817, she bought a villa
in Naples, where she died eleven years later.

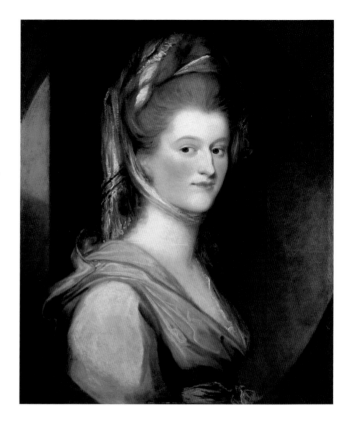

Many Turkish women were independently wealthy, as rich women kept control of their
own income rather than, as in England, surrendered it to their husbands.

Seventy years later, in her *A Journey through the Crimea to Constantinople* (1789),
Elizabeth, Lady Craven also expressed some admiration for the 'so neat and clean'
harem, about which 'our gentleman were very curious to hear'. In 1783, aged thirty-
three, Elizabeth scandalously abandoned her husband and went in search of adventure
of the upper-class kind. She toured the courts of Europe, where her high social status
ensured she was 'protected by sovereigns and ministers, and treated with respect, and
care, and generosity'. Her year-long journey was mapped in the pages of her *Memoirs*
by the titled men and women she met: 'On my arrival at Warsaw, I found my apart-
ments well aired and prepared for me. The Comte de Stackelberg had
bespoken them, by order of Prince Galitzin. The Russian minister, Count de S—,

Caroline Amelia Elizabeth of Brunswick (1768–1821)
James Lonsdale, *c.*1820
Oil on canvas, 762 x 641mm (30 x 25¼")
National Portrait Gallery, London (NPG 498)

Queen Caroline's travels were part of the sorry saga of her marriage to George IV
(1762–1830). George, then Prince of Wales, married her in 1795 in return for a
substantial increase in his allowance from his father. He already had a mistress and a
wife, Mrs Maria Fitzherbert (1756–1837), who was a Roman Catholic and therefore
barred from becoming queen. When Caroline produced a daughter, Princess Charlotte, in
1796, George left her. As Charlotte grew older, her mother was rarely allowed to see her.
Caroline therefore decided to travel, going first to Europe where, in Italy, she developed an
attachment to a young man who joined her court. Her travels took her around the eastern
Mediterranean, including Tunis, Jerusalem, Ephesus and Constantinople, with tales getting
back to Britain about her flamboyant behaviour. Charlotte died in 1817; when George III
died three years later, Caroline returned to England. Her husband wanted to divorce her
and prevent her claim to be queen. He had had her tried in the House of Lords for adultery
while she had been on her travels, but she was acquitted. (The famous picture of the trial
is in the National Portrait Gallery.) Caroline was locked out of his coronation in
Westminster Abbey and, on her death, her body was unceremoniously shipped back to
Brunswick, her birthplace in northern Germany.

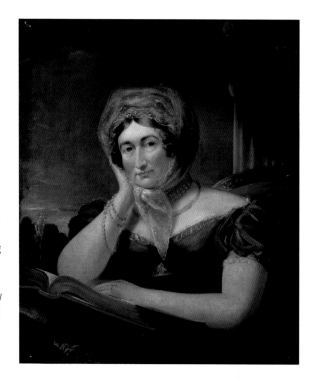

waited on me immediately ... On the evening of the day after I arrived, I was by him
presented to the King ... The Grand Marshal's wife, who was the King's niece,
accompanied me ... I proceeded to St Petersburgh [*sic*]. On my arrival at this city I was
presented to the Empress Catherine ... ' In England, however, she was thought to have
behaved badly and abandoned all sense of sexual decorum on her travels. The one court
where she was not welcome was Queen Charlotte's, as news of her adulterous behav-
iour preceded her arrival. For women whose emotional and sexual lives were frustrated
at home, travel abroad offered untold opportunities. Queen Caroline, the estranged wife
of George IV, fled Britain to find emotional, and probably sexual, satisfaction. She was
rumoured to have worn extremely low-cut dresses on her wanderings and to have
collected young lovers whom she showered with titles. Lady Hester Stanhope – no saint
herself – said of her, 'Oh! What an impudent woman ... How many sea-captains used
to colour up when she danced about, exposing herself like an opera-girl.' Other
women were exiled by their actions. Jane Digby, forsaking her elderly husband, Lord

Ellenborough, and any attempt at conformity, had wandered from lover to lover until, approaching fifty, she fell in love with and married Sheik Abdul Medjuel el Mezrab, a Bedouin. She wrote home to her mother in 1856, 'I would gladly to be as you are, but I cannot change my nature. I am different. How different I hardly realised.'

Even if a woman did not abandon her sexual inhibitions, travel changed her. Harriet Martineau, in *How to Observe Morals and Manners* (1838), an instructional handbook for travellers, noted how, if a traveller looks back over the diary entries of a journey, this shift in perspective becomes clear. 'He laughs at the crudity of the information, at the childishness of the impressions, set down in the opening pages; and traces, with as much wonder as interest, the gradual expansion of his knowledge, education of his perceptions, and maturing of his judgments as to what is before him, as week succeeds week, and each month mellows the experience of the last.' After being in India for only a few weeks, Constance Gordon Cumming noted how she was already beginning to see things differently. 'I frankly confess that there is something startling in the rapidity with which one gets quite at home amongst all this paraphernalia of heathenism,' she wrote. In a letter from Baghdad in 1914 to her distant lover Dick Doughty-Wylie Gertrude Bell echoed, 'You will find me a savage, for I have seen and heard strange things and they colour the mind ... don't ... tell anyone that the me they knew will not come back in the me that returns.' In 1920s Syria, Rosita Forbes pitched her tent, spread her groundsheet, set up her canvas washbasin, and lit some candles to read by. She then turned to her companion with a characteristic flourish and said, 'When we leave the desert, I shall be a Moslem.'

Once Isabella Bird had scaled the Rockies, Mary Kingsley had negotiated West African swamps, and Rosita Forbes had made moving pictures of the Bedouin, where and what was left for the woman adventurer? This anxiety had been expressed long before any of these women set out on their journeys. As early as 1845, Elizabeth Rigby, later Lady Eastlake, had observed,

France, Germany, Switzerland, and Italy no longer *count* in a fine lady's journal. Trieste is their starting-point, not Dover; and Constantinople, Jerusalem and Cairo, the cities they desire to see ... Rides on horseback have now given way to rides on camel-back, dromedary-back, pick-a-back, or any back than can be had ... convents have merged into harems; the Pyramids have extinguished Vesuvius, and St Sophia has cut out St Peter's. Honourable and Right Honourable beauties now listen to howling dervishes instead of Tyrolese minstrels; know more of Arabic than their

Jane Digby (1807–81)
Sir George Hayter, c.1825
Pencil and watercolour, 152 x 114mm
(6 x 4½")
National Portrait Gallery, London
(NPG 883(10))

In her lifetime, Jane Digby travelled further than most women – not just geographically but socially. Born into a wealthy family, she was married to Edward, Lord Ellenborough (1790–1871), who was twice her age. This drawing, a study for a miniature, shows her at this time. She fell in love with an Austrian prince and ran away with him; this led to a scandalous and well-publicised divorce. She then did a tour – moving steadily eastwards – of European countries and titled European men, including a German baron, a Greek count and the King of Bavaria. Reaching Syria, she finally found lasting love with an Arab nobleman, Sheik Abdul Medjuel el Mezrab, who was young enough to be her son. She divided her time between her house in Damascus and his Bedouin tribe in the deserts around Palmyra and beyond, adopting local dress and customs. Jane recorded in watercolours some of these scenes from her life. When she died, Medjuel rode her favourite horse to her funeral in the cemetery in Damascus.

'Tadmor' (Palmyra, Syria)
Jane Digby, n.d.
Watercolour, 381 x 686mm (15 x 27⅛")
Private Collection

Palmyra, which Jane Digby called by its ancient Arab name, Tadmor, played a major part in her life. No other Western woman had made the journey there through the desert since Lady Hester Stanhope in 1813. Jane first visited in June 1853 with Medjuel, who was later to become her husband, as her guide. They arrived at night, wandering together by moonlight through the ruins, under the great arch shown in this watercolour. Medjuel watched her as she sketched, protecting her from over-inquisitive locals. Two years later, Jane spent her honeymoon there. In December 1858, she made the journey on her own, only to find that her husband's tribe had already left the area. However, she chose to live among the ruins for several months, continuing to sketch and paint until Medjuel finally reappeared. When she died, Medjuel placed on her grave in Damascus a block of pink desert limestone brought from Palmyra, on which he carved her name in Bedouin Arabic script.

grandmothers did of French; and flirt with beys and pashas instead of counts and barons, and doubtless find them answer the purpose just as well.

When Isabel Burton reached Syria in the early 1870s, she noted, 'Cook's party had arrived ... They come like locusts into a town ... The natives used to say, "Ma hum Sayyahin: Hun Kukiyyeh." ("These are not travellers: these are Cookii").' When Gertrude Bell made a round-the-world trip with her brother Maurice in 1897, it was on a Cook's tour. By the time she reached the Middle East at the turn of the century, she had the benefit of a *Murray*'s guidebook to use on her desert journeys. When Agatha Christie visited Iraq for the first time in 1928, shortly after Gertrude Bell's death, Baghdad was a popular destination for well-heeled tourists. The Orient Express ran from London to Istanbul, where passengers could join the Taurus Express to take them on to Baghdad.

As the world closed in, increasingly adventure meant a physical challenge. For Penelope Chetwode, faced with a river to cross in her 1974 BBC television film in the Kulu Valley, her choice was to float over by the traditional method on an inflated animal hide. When Amy Johnson took off from Croydon in her Gypsy Moth, *Jason*, on 5 May 1930, she was determined to set a new record for flying solo to Australia, 11,000 miles away. *Jason* had an open cockpit and only four instruments to fly by – a speed indicator, an altimeter, an indicator for turning and banking, and a compass. Throughout the flight, Johnson had to pump petrol regularly from auxiliary containers to the main fuel tanks, and the fumes made her sick. 'The pump was a very old fashioned one, the action being similar to pumping a bicycle tyre,' she explained in a later lecture. 'I had to pump about 50 gallons [at forty pump strokes per gallon] of petrol every day. The only thing that kept me going was the ignominy of giving up the flight.' Her trip took nineteen and a half days, and instantly turned her into a celebrity. Her seemingly off-the-cuff remarks to the papers (such as 'Don't call me Miss Johnson. Just plain Johnnie will do') bolstered her image as a glamorous, daring woman, entering virgin territory – the sky. It was not countries nor customs that interested Johnnie but raw achievement. Encounters where she touched down – whether Istanbul, Baghdad, Karachi, Bangkok or Singapore – were perfunctory, solely for the purpose of refuelling her plane.

'Adventure is my only reason for living,' wrote Alexandra David-Neel, who trekked through the Tibetan highlands in the 1920s. This statement could have been written by any of these women. Travel liberated them. They simply went and saw; they had no

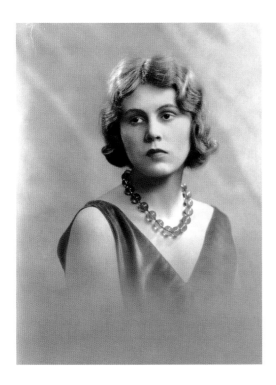

Penelope Chetwode, Lady Betjeman (1910–86)
Lafayette, 19 February 1932
Modern print from an original half-plate negative
National Portrait Gallery, London (NPG x48079)

Penelope Chetwode grew up in northern India, where her father, Baron Chetwode (1869–1950), was Commander-in-Chief of the army. When she met the poet and writer John Betjeman (1906–84) her family disapproved, preferring her to choose 'someone with a pheasant shoot'. The couple finally married in secret, but within a year she was abroad, studying in Berlin, while he was having an affair with their maid. Animals interested her more than humans. When she was pregnant, she said, 'I wish it could be a little horse.' She moved to Berkshire, where goats and chickens roamed freely through the house and her horse appeared at the tea table. Penelope converted to Catholicism, and had an affair with fellow Catholic Evelyn Waugh, the novelist. She published a successful book about a Spanish journey with a donkey called *Two Middle-Aged Ladies in Andalucia* (1963) – one of the 'ladies' was the donkey. In the 1960s, she also revisited the scenes of her Indian childhood. Her trek from Shimla to the head of the Rohtang Pass in Himachal Pradesh was recorded in *Kulu: The End of the Habitable World* (1972). She continued leading treks in the area, finally dying there.

interest in conquering. As one reviewer noted of Freya Stark, she belonged to 'the odd handful who remained not to teach, not to evangelise, not even, broadly speaking, to change, elevate, govern or save but to understand, to interpret, to share the life of the desert.' The women adventurers, each a recalcitrant individual, shared this: they sought a new reflection, not only of the world beyond, but also of themselves.

Companions

We two ladies ... have found out and will maintain that *ladies* alone get on in travelling much better than with gentlemen ... The only use of a gentleman in travelling is to look after the luggage, and we take care to have no luggage.

Emily Lowe, who travelled with her mother, *Unprotected Females in Norway: Or, The Pleasantest Way of Travelling There ...* (1857)

A woman could be a companion to anyone, not just her husband. Margaret Stevenson accompanied her son Robert Louis Stevenson to the Pacific, unmarried sisters Emily and Fanny Eden accompanied their brother to India, and Charlotte Stuart de Rothesay accompanied Queen Victoria wherever she went.

In 1842, Charlotte had been appointed Lady of the Bedchamber to the Queen. On giving up this role in 1855, she married Lord Charles Canning. When he was appointed the first Viceroy of India, she joined him in Calcutta. At the Queen's command, she sent back six-weekly reports all through the 1857–8 'Indian Mutiny'. Victoria told her that, as correspondence from officials and administrators was too guarded and self-seeking, hers was the most useful information to come out of India at that sensitive and crucial time. Lady Canning did not flourish in Calcutta; she suffered under the oppressive heat and equally stifling conventions, which forced her into idleness. Sketching, at which she excelled, was her only joy. Not even two long tours around the country could engage her interest.

Like many female companions, Charlotte was dragged reluctantly along the road. Emily and Fanny

Isabel, Lady Burton (1831–96)
Unknown photographer, *c.*1869
Hand-coloured albumen carte-de-visite, 91 x 53mm (3⅝ x 2⅛")
National Portrait Gallery, London (NPG x76470)

Margaret Stevenson (1829–97)

Margaret Stevenson (1829–97)
(Standing left of centre beside her
son, Robert Louis Stevenson
[1850–94] and his family)
J. Davis, Postmaster at Apia, Samoa,
c.1891
Albumen print, 192 x 234mm
(7½ x 9¼")
National Portrait Gallery,
London (NPG x4630)

Margaret Stevenson (née Balfour)
devoted herself to caring for her
talented but tubercular son, the
author Robert Louis Stevenson. She
travelled with him to the Continent
and to America. When he went to live
at Apia in Samoa for his health, she
swiftly set out for the Pacific in 1891.
By this time, Stevenson was married
to Fanny, an American divorcee ten
years his senior, shown sitting on the
right in the photograph. Fanny was
accompanied by her children from
her previous marriage and their
families; they are pictured on the
steps of their house named Vailima,
meaning 'five streams', on Mount
Vaea. Stevenson went to meet his
mother in Sydney, but fell desperately
ill and required her immediate
nursing. When they arrived in Apia,
the house was incomplete. Margaret
quickly went back to Sydney,
returning only when the house was
habitable. Life revolved around
Stevenson's writing. When he died
suddenly in 1894, forty Samoan
chiefs carried him to burial. Margaret
returned to Scotland to mourn.

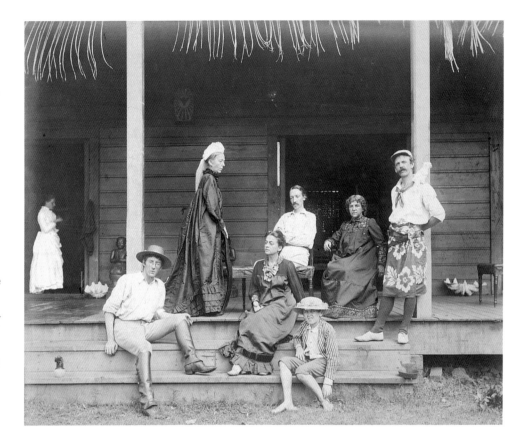

Eden – two sisters in a family of fourteen – had earlier accompanied their brother
George, Lord Auckland to Calcutta on his appointment as Governor General in 1835,
simply because it was inconceivable for him to leave them behind. Emily confessed to
hating her six years in India and counting the days until her return home. She found
the company atrocious; the men had lived in India for so long, she said, their 'manners
are utterly gone – jungled out of them.' She could not, however, complain about the
level of comfort, even though she found it tiresome. Hers was an India of mutton and
cucumber soup followed by sago pudding. The sisters travelled through the country by
palanquin, which Emily accurately described as 'beds in boxes'.

In an article in the *Quarterly Review* of 1845, Elizabeth Rigby (later to marry Sir
Charles Eastlake who, as a young painter in Italy in 1816, had been employed by the

Charlotte, Lady Canning

Charlotte, Lady Canning (1817–61)
Henry Hering, before 1856
Albumen carte-de-visite, 85 x 55mm (3⅜ x 2⅛")
National Portrait Gallery, London (NPG x45082)

Charlotte, Lady Canning arrived in India in 1856 as a flourishing, healthy woman; five years later she looked emaciated and died of malaria. She was born in Paris, the daughter of the British ambassador and was Lady of the Bedchamber to Queen Victoria for thirteen years. When her husband Charles, Lord Canning (1812–62) was appointed Governor General of India, she went with him to Calcutta, where she was 'isolated to a degree I could never have imagined'. She kept a journal and wrote frequently to Queen Victoria, at one point describing 'strange and terrible outbreaks' of violence that were the start of the Indian Mutiny. She also took photographs and painted watercolours, both landscapes and still lifes. She died in her husband's arms and was buried in Barrackpore, West Bengal. He did not long outlive her. His letter to the Queen describing Charlotte's death crossed with hers to him, announcing that Prince Albert had died. Lady Canning's name lives on in Bengal, where a type of sweet called 'ledikeni' is named after her.

View of the Hills near Coonoor
Charlotte, Lady Canning, 1858
Watercolour, 250 x 405mm (9⅞ x 16")
The British Library

Painting watercolours was one way that Charlotte, Lady Canning filled her lonely days in India, particularly when she travelled in great state to cooler parts. Her northern journey deep into the Himalayas was quite gruelling and she produced scenes of plunging ravines and soaring peaks. This watercolour was painted in the aftermath of the Indian Mutiny. She was staying at Coonoor, a hill station in the Nilgiri Hills in southern India. The views in the Nilgiri Hills greatly inspired her and a favourite painting place is still known locally as 'Lady Canning's Seat'. She described how, from that spot, she 'sketched the plains on a fine evening, the colours glowing, and the tanks [artificial lakes] full, like little lines of silver in all directions; hills miles and miles away like distant coasts' (quoted in *A Glimpse of the Burning Plain: Leaves from the Indian Journals of Charlotte Canning*, 1986).

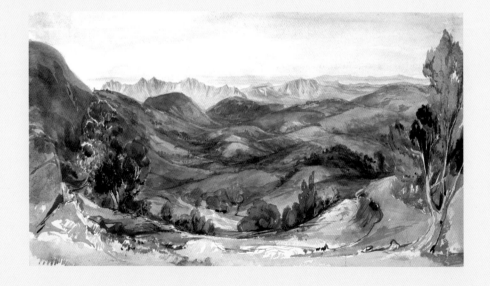

Emily Eden

Emily Eden (1797–1869) and her dog Chance
Simon Jacques Rochard, 1835
Watercolour and pencil, 361 x 261mm (14¼ x 10¼")
National Portrait Gallery, London (NPG 6455)

This drawing was made just before Emily Eden and her sister Fanny (1801–49), both unmarried, accompanied their brother George, Lord Auckland (1784–1849) to India, where he was Governor General from 1836 to 1842. Isabella Fane, whom Emily in her letters called 'not *one of us*', described the sisters as 'both … great talkers … both ugly, and both s[tin]k like polecats' (quoted in *Miss Fane in India*, 1985). Emily was also accompanied by her spaniel, Chance; neither of them greatly enjoyed the voyage. In 1837, Emily travelled to the north and wrote her extremely popular account, *Up the Country: Letters Written to her Sister from the Upper Provinces of India* (1866). The names she and her brother gave to their tents on this journey, including 'Misery Hall' and 'Foully Palace', suggest their sense of humour. She also made a series of drawings of Indian princes, which were later published as lithographs. She was keen to return to Britain, where she published her Indian letters and portraits, and then began to write novels.

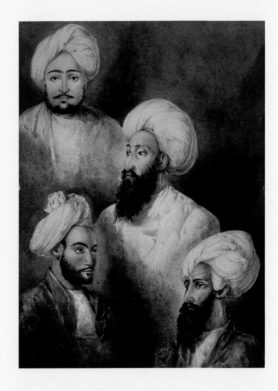

Four Portrait Heads of Afghan Leaders
Emily Eden, June 1841
Inscribed on the back: Hyder Khan, Dost Mahomed Khan, Mahomed Akram Khan, Abdool Ghunee Khan
Watercolour, 350 x 256mm (13¾ x 10")
The British Library

Emily Eden was particularly attracted by the many princes of India, at least one of whom reciprocated by giving her expensive presents. She met this group of Afghan leaders in rather different circumstances. Dost Mahomed Khan (1793–1863), with whom Emily played chess, and his family were enforced 'guests' of Lord Auckland at Barrackpore in 1841. This followed an attempt to replace Dost Mahomed Khan as the Emir (ruler) of Afghanistan by force, an attempt that failed dismally, bringing about one of the worst defeats in British military history. This ignominy led to Lord Auckland being recalled to Britain, which enabled his sisters to return home at last.

painter and traveller Maria Graham) warned that just because a woman was cosseted by comforts and in the orbit of her husband, she should not be dismissed as a traveller:

> for though yachts may be furnished with every luxury – though medical men and air-cushions, and ladies' maids and canteens, and portable tents and Douro chairs, and daguerreotypes, and every modern invention that money can procure, may be included in their outfit – yet the winds will blow, and the waves toss, and the sun beat down, and the dust rise up, and the rain soak through, and hunger, and thirst, and fatigue, and things their delicacy knew not of before, assail.

She may have been describing women like Lady Annie Brassey, who, with her husband Lord Brassey, sailed around in their luxury schooner *Sunbeam*, voyaging through the Pacific, puffed up with pillows and prejudices. But she could as easily have been defending her own travels. Following her marriage in 1849, Lady Eastlake made many trips to Europe with Sir Charles, acquiring paintings for the National Gallery in London, after he had been appointed its first Director in 1855.

The difference between a lone woman traveller and a wife, such as Lady Eastlake, was clear. Anna Stoddart, Isabella Bird's early biographer, wrote:

> Four Englishwomen have, during the last thirty years, established for themselves a well-grounded fame as travellers – Mrs Bishop [Isabella Bird], Miss North, Miss Kingsley, and Miss Gordon Cumming ... Lady Baker and Lady Burton were as brave and as resourceful as any of the four; but it must be remembered that each of them was protected by the presence of her husband against the most powerful of terrorizing influences, namely, the solitude which magnifies peril and weakens resistance.

Young Isabel Arundell's resistance was already weakened when she wrote to her mother: 'I wish I were a man. If I were, I would be Richard Burton, but being only a woman, I would be Richard Burton's wife ... I long to rush around the world in an express; I feel as if I shall go mad if I remain at home.' In 1861, she did, indeed, become Mrs Burton, as dedicated a wife as it was possible to be to the explorer, writer and maverick diplomat. For the rest of her life, she supported and celebrated his varied achievements, and defended him when under attack, utterly entranced. At the same time, she was a dedicated traveller; her attraction to Burton was based as much on what he did and where he went as who he was. When he was appointed Consul to Damascus,

Isabel, Lady Burton

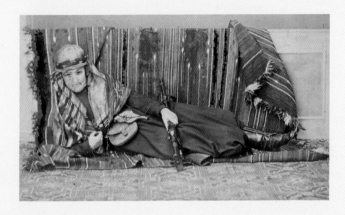

This is how I dress … I wear an English riding-habit of dark blue cloth … I wear a pair of top-boots and for the convenience of jumping on and off my horse I tuck in the long ends of the habit, and let them hang over like native big, baggy trowsers [sic]. Round my waist I wear a leather belt, with a revolver and a bowie [knife]. My hair is tucked tightly up to the top of my head, which is covered with a red Tarbush [fez], and over that the Bedawi Kufiyyeh, the silk and golden handkerchief, which covers the head and falls about the chest and shoulders to the waist, hiding the figure completely, and is bound with the fillet of chocolate-dyed camel's hair. I have a little rifle slung to my back …
(From Isabel Burton, *The Inner Life of Syria, Palestine, and the Holy Land* 1875)

Isabel, Lady Burton (1831–96)
Unknown photographer, *c.*1869
Hand-coloured albumen carte-de-visite, 91 x 53mm (3⅝ x 2⅛")
National Portrait Gallery, London (NPG x76470)

Her husband, the explorer and diplomat Sir Richard Burton (1821–90), was the focus of Isabel Arundell's life. They met in 1851, and married ten years later, despite her parents' disapproval. She helped engineer his posting as British Consul to Damascus in 1869 and accompanied him there. She adored Syria and wild rides in the desert. Richard lacked tact and was suddenly recalled from Damascus to London. He sent Isabel the now famous message 'Ordered off; pay, pack and follow,' which she did. A posting to Trieste followed, again at her instigation. It was less prestigious, but while there they worked together on his translation of *A Thousand and One Nights* (1885–8). On Richard's death, Isabel dedicated herself to his memory, burning his more erotic writings and defending his good name, which was under attack because he had translated the *Kama Sutra*. Isabel was buried beside her husband in Mortlake Cemetery, London, under a marble tent.

Both of the Burtons were fond of dressing-up; Richard famously travelled in disguise to Mecca. In this carte-de-visite, Isabel wears an adaptation of male Arab dress:

I am very much amused, and very much pleased, to learn that all along the road [through the desert] I have been generally mistaken for a boy …

Zamzamiyya belonging to Sir Richard Burton
Donated by Isabel, Lady Burton, 9 November 1893
Metal, in or before 1853
The British Museum

Isabel Burton's veneration of her dead husband involved treasuring his personal belongings, including his cigars, slippers and sewing kit. Richard Burton brought back this metal bottle, used on the Haj (the pilgrimage to Mecca, one of the five pillars of the Islamic faith) to carry holy water. The water comes from the Zamzam, the sacred well in Mecca, and is reputedly health-giving. Some Muslims dip their future burial garments into the water. According to Muslim tradition, this is the well that the angel created to save Hagar and her son Ismail from dying of thirst in the desert, a story also told in Genesis. Other traditions link the

well with Zoroastrian pilgrimages. Isabel donated this bottle of Zamzam water to the British Museum, presumably for some kind of testing, with a letter recording that her husband 'brought it from Mecca in 1853 40 years ago'.

partly as a result of her pressure, Isabel's dream of where married life might lead was realised. 'I am to live among Bedouin Arab chiefs,' she wrote excitedly. 'I shall smell the desert air; I shall have tents, horses, weapons, and be free!' She would also be her husband's 'companion, his secretary and his aide de camp', and would look after 'our house, servants, stables, and animals. I did a little gardening. I helped my husband,' being, as she put it, 'thoroughly English and European' at the consulate. But the opportunities for escape, not from her husband but from domestic responsibilities, were plentiful. The couple took forays into the desert, where Isabel wore Syrian men's robes and smoked a water pipe.

Flora Shaw was also attracted to men of imperial standing. As Colonial Editor of *The Times* (the first woman on staff), she had toured the edges of the Empire and beyond – South Africa, New Zealand, Hawaii, Canada – reporting on economic and political conditions in letters to her newspaper, later published as books. Her job as a *Times* journalist afforded her introductions to political leaders wherever she went, but when she suggested to her editor that she might cross Africa from the River Niger to the Sudan with no one other than an interpreter, he turned the idea down flat.

In line with the paper she worked for, Shaw was a committed colonialist and staunch supporter of British expansion overseas. This brought her into direct conflict with Mary Kingsley, who, although an unquestioning imperialist, favoured informal economic imperialism; the day-to-day administration of a country, Kingsley believed, should be left in the hands of those who lived there, whether they were African slavers or British traders. Despite her politics, Shaw fell for Kingsley's political ally, Sir George Goldie, founder of the Royal Niger Company. When his wife Matilda (to whom Mary Kingsley's second book, *West African Studies* (1899), was posthumously dedicated) died in 1898, and Goldie did not propose, as Shaw had expected, she turned her affections to another emerging imperial giant. Sir Frederick Lugard was the High Commissioner in Northern Nigeria when she married him in 1902, just before her fiftieth birthday.

Her biographer and close friend, E. Moberley Bell, wrote, 'When she ceased to be Flora Shaw she also ceased to be a woman with a career.' It is true that after Goldie's rejection she had resigned from *The Times*, but she continued to have a career, albeit a different one. At first she joined her husband in Northern Nigeria, but finding little to do and no stimulating company, she soon came home and played her supporting role in Britain. This involved writing articles, giving lectures and compiling a long book – all on Northern Nigeria – in order to promote her husband's work. She discarded the black

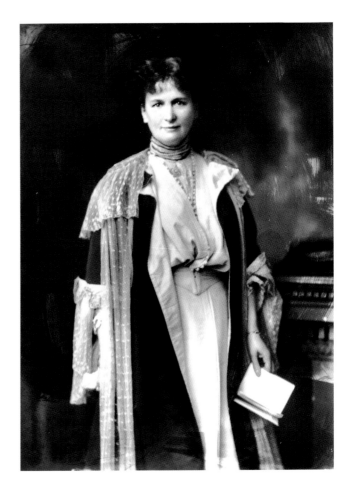

Flora Shaw, Lady Lugard (1852–1929)
George Charles Beresford, 1908
Modern print from an original negative
National Portrait Gallery, London (NPG x6539)

Flora Shaw was born in Dublin, and helped to care for her large family. She began her career in journalism in 1886 and was sent by the *Manchester Guardian* newspaper as the only woman reporter to cover the Anti-Slavery Conference in Brussels in 1888. In 1892, *The Times* sent her to southern Africa. Her belief in the positive benefits of the British Empire infused her writing. Her appointment as Colonial Editor for *The Times* allowed her to travel throughout the Empire. In 1898, she suggested the name 'Nigeria' for the British protectorate on the River Niger. In 1902, she married a colonial administrator, Sir Frederick Lugard (1858–1945), who was then High Commissioner for Northern Nigeria. Next they moved to Hong Kong where he was Governor, before returning to amalgamate the two halves of Nigeria and be its first Governor General from 1914–19. Despite having had a successful career before her marriage, Flora opposed votes for women. Her many admirers included the critic John Ruskin, who commented on her loveliness, goodness, truth and beauty.

clothes she was known to wear for her professional work – a mode of dress other outspoken women, such as Mary Kingsley, also adopted – and took to wearing white gowns. In this new guise, in 1907, she accompanied Sir Frederick to Hong Kong, where he served as Governor for five years. Instead of a professional and independent traveller, her occupation was that of companion and wife to a colonial official destined to hold the highest ranks of office in the British administration.

In other fields, a woman's role as helpmate was a stepping stone towards fulfilling her own ambitions. In Africa in the early twentieth century, the wife of anthropologist Dr Percy Amaury Talbot, author of *In the Shadow of the Bush* (1912), noted how she was

able to travel among 'peoples never studied before' as her husband's companion. 'Unlike Mary Kingsley and the small band of women travellers who followed in her footsteps, my sister and I were not alone. A never-failing watchful care always surrounded us, smoothing each difficulty, and, as far as humanly possible, providing against every discomfort and danger.' Declaring herself the most dutiful of spouses, 'we were naturally anxious to do something in return for all that was done for us, and soon discovered that the chief way in which we could be of use was by making clear copies of rough notes jotted down in spare moments by my husband.' Soon she was writing her own groundbreaking work, *Women's Mysteries of a Primitive People* (1915). Agatha Christie, already a successful writer of murder mysteries, similarly assisted her husband's work during the 1930s. She met archaeologist Max Mallowan in Iraq, where she had gone to see the excavations at Ur. Soon she was joining him on digs throughout the Middle East, filming his excavations and documenting his finds.

Sometimes the women's companions were shadowy figures, and we do not even learn their names. From her books, we do not know who tramped through the Dolomites or sailed up the Nile with Amelia Edwards; we are simply reassured that she did not board the dahabeeyah (a Nile houseboat) on her own. Even a shadowy female presence served to ward off criticism that women were behaving improperly.

Some women had absent companions to whom they would write daily. Many of Isabella Bird's books are based on letters to her sister Henrietta. Isa and Hennie, as they called each other, were two halves of a whole. Hennie was the loyal, dutiful clergyman's daughter; Isa was the adventurer. While Isa wandered, Hennie kept the house in Tobermory warm for her return. Isa knew, wherever she was, Hennie was always there, thinking of and waiting for her. When Hennie died of typhoid in the spring of 1880, her older sister said, 'I feel as if most of myself had gone.' The following year, on the publication of *Journeys in Persia and Kurdistan*, she wrote to her publisher of her lack of enthusiasm for her latest work, 'My sister was the inspiration of my letters and neither Hawaii nor the Rocky Mountains would have been anything without her.' Her next book, *The Golden Chersonese and the Way Thither*, published in 1883, was dedicated to Hennie.

Not all women travellers chose a human companion to legitimise their journeys. Some called upon God. Mildred Cable and the sisters Evangeline and Francesca French, three missionaries known as 'the Trio' as if they were one entity, set out to cross the Gobi Desert in 1926. They had been living in China for over twenty years, and had established a school in the north-west province of Shanxi, but they heard 'the call'

to spread the word of God to the remotest regions, and had been catapulted out on this first of five such journeys.

As a husband or brother might write the itinerary for other companion travellers, for the Trio it was God's unseen hand that determined their route. As they set out, they wrote, 'We climbed a high stony mound, and from the summit came into full view of the plain. Stretching as far as the eye could see was the arid plateau from which the driving winds had swept away all the finer sand and left nothing but dull, grey grit. "It is desolate," I said, "but in the silence and solitude God is still there."'

The Trio reflected the significant number of single women who were following their Maker to remote lands. From the mid-nineteenth century, British missionary societies had been expanding into Africa and Asia. The earliest women involved in mission work had been wives, whose role was seen as assisting their husbands; they had not been granted missionary status. The missionary societies became increasingly concerned about the high death rate among them, often due to childbirth in remote stations. (David Livingstone's wife, Mary, was one of the many women who was buried in the field.) The societies' solution was to replace married with single women, who would be listed as missionaries and who could devote themselves to working with women. The Church Missionary Society, the most significant missionary society in Britain, began sending single women out to the field in greater numbers than they were sending men. By 1900, eight thousand women missionaries were employed throughout the world. Such work never risked being seen as a bold assault on female convention; in fact, undertaking such a mission helped to reinforce a woman's role. 'The especial ways in which women can deal with those of her own sex in heathen lands ... is most womanly,' declared Mrs Emma Pitman in *Heroines of the Mission Field* (1880), one of many similarly titled books that began to appear in the last two decades of the nineteenth century. 'No one who engages in it steps out of her proper sphere in the slightest degree,' continued the author, pressing home the point. 'It would be unwomanly to stand idle in Christ's Kingdom, to refuse to help our perishing sisters.' To many single women, this read as an invitation to travel with purpose and without criticism.

In 1892, Annie Taylor set out on a 1,400-mile march to Lhasa. 'He has sent me on this journey, and I am his little woman,' she wrote of her heavenly companion. Her mission was not to observe but to instruct. As was common among missionaries with the China Inland Mission, including the Trio, Annie Taylor dressed like her Chinese converts. The Mission magazine, *China's Millions*, advised: 'Our sisters will become Chinawomen in dress, custom, speech, and mode of living, in everything save in sin.'

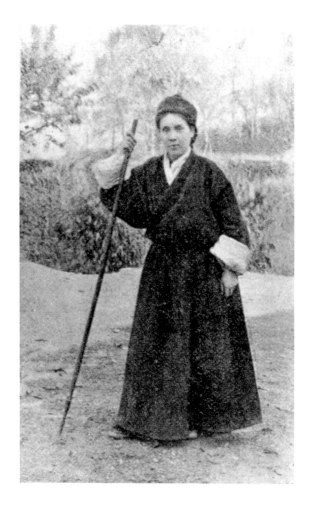

Annie Taylor (1855–1908)
Thomas Charles Turner, published 1893
National Portrait Gallery, London (NPG RN52234)

Annie Taylor was the first European woman to enter Tibet, which was closed to Europeans during the nineteenth century. She arrived in China in 1884 to spread Christianity as part of the China Inland Mission. Annie was an individualist who had set her sights on Tibet, learning Tibetan and writing in her diary that 'the Tibetans respect women and do not even in time of war attack them.' In 1892, she set out for Lhasa. She shaved her head and wore the costume of a Tibetan nun, as in this photograph, which was taken when she was safely back in Britain. She travelled with a Chinese man, Noga, and his wife, a Tibetan convert, Pontso, and two servants. The long journey was horrific – bandits robbed them, horses and even a servant fell dead. She was betrayed to the Tibetans by Noga just three days from Lhasa, and expelled. She remained cheerful throughout, eating Christmas pudding despite the high altitude, and feeling 'quite safe here with Jesus'. When captured, she declared, 'I am English and do not fear for my life'.

Annie Taylor had been living just inside the Tibetan border for eight years when her sister Susette came to visit her in 1903. Susette made the eighty-mile journey from Darjeeling and traversed a pass 14,400 feet (4,389 metres) high, before she saw the valley stretching out beneath her.

> I suddenly become aware of an advancing figure that exactly suits the surroundings. A brick-red gown of native cloth, with a glimpse of fawn silk at neck and wrists pouched up above the girdle, thus displaying blue cloth trousers

Jane, Lady Franklin

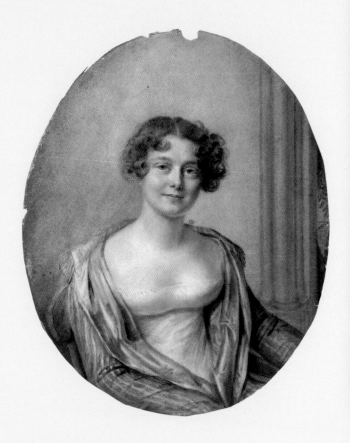

Jane, Lady Franklin (1792–1875)
Amélie Romilly, 1816
Chalk, 159 x 133mm (6¼ x 5¼")
National Portrait Gallery, London (NPG 904)

Jane had travelled extensively around Europe with her father, John Griffin, and her marriage in 1828 to Sir John Franklin (1786–1847), the Arctic explorer and naval commander, took her further afield. They went to Van Diemen's Land (now Tasmania) where Sir John was appointed Governor in 1837. She also visited Australia and New Zealand, where she was the first woman to climb Mount Wellington. In 1845, Sir John set off on his voyage to find the North-West Passage linking the Atlantic and the Pacific, while Jane travelled to the West Indies, North America and Europe. In these and all her later travels, she was joined by her husband's niece, Sophy Cracroft, who had promised her uncle to remain with his wife until he returned. When he and his men failed to reappear in 1850, Jane paid for a succession of ships to search for them, offering a reward of £2,000. To relieve her anxiety, she travelled constantly but, by 1859, it was clear that her husband had perished. She continued to travel, including twice more to North America and to Japan via Hawaii. The monument to both Franklins in Westminster Abbey records that Jane 'after sending many in search of him, herself departed to find him in the realms of light'.

Wooden Rattle, Tlingit People, Alaska
Collected by Jane, Lady Franklin, 1870
Carved wood, handle bound with hide thong
The British Museum

This rattle (left) with its two human faces probably originated with the Tlingit people in Sitka, Alaska, and would have been used in healing ceremonies performed by shamans. In all, Jane Franklin made three visits to North America, two of them to the Pacific North-West. In 1861, she spent some time in Victoria, Vancouver Island, and made a trip up the Fraser River, visiting native Canadian settlements and buying various artefacts. In 1870, she went as far as Sitka, where she purchased this rattle, which she later gave to the British Museum. Her other purchases from Alaska ranged from a man's silver nose ring to a pair of model replica totem poles 3 feet (1 metre) high and 'carved with great skill in grotesque or monstrous figures'. From 1845 onwards, Lady Franklin's thoughts were focused on the Pacific North-West and the Arctic, as her husband struggled through the ice to find the North-West Passage. He failed to find the Passage and then disappeared. The ships sent by Lady Franklin to search for him were unsuccessful. In Sitka in 1870, her niece Sophy recorded that 'it is difficult to believe ourselves to be in this place, so long associated with the search … but there is no one here now who can tell us about our ships.' The loss of her husband, however, did not dampen Jane Franklin's interest in Arctic exploration.

Model of a Birch Bark Canoe
Probably collected by Jane, Lady Franklin in 1860–1 or 1870
Birch bark and porcupine quills
Pitt Rivers Museum, University of Oxford

This canoe seems to have come from the Franklins' collection of model vessels from around the world, which combined their twin interests in boats and travel. It was made by the Odowa (Ottawa) people around the Great Lakes in Canada and the United States (not in Sitka, as it says on it). Jane Franklin was in the region of the Great Lakes in August and September 1860, on a visit that seems to have included Ottawa, as well as a trip to Niagara Falls. This model canoe is decorated with coloured porcupine quillwork and is an early example of tourist art. The eagle design was chosen partly to appeal to the American market. However, the eagle also held a significant place in the Odawa's cosmology, in which powerful spirits called Thunderbirds take the form of large eagles. It is thought to have been donated by Lady Franklin to Eton College Museum, and later passed to the Pitt Rivers Museum in Oxford.

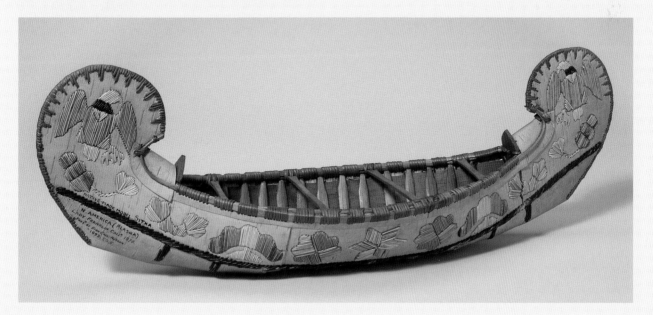

tucked into fur boots the shape of night-socks, drapes a small person with a merry face, much too fair for a native, and topped by a yellow peaked cap. It is my sister!

Annie Taylor's inimitable style and ease with her immediate environment were lost when she returned to Britain. At home, she was 'very unkempt in appearance', according to Isabella Bird, who attended two of her fiery lectures in 1893. Isabella was impressed with Annie Taylor's skills not as a lecturer or evangelist but as a traveller. That summer she wrote to Scott Keltie, Secretary of the Royal Geographical Society, that she had been to see Miss Annie Taylor several times, and even heard her preach on a street corner. 'She impresses me as a woman of very remarkable and powerful individuality, and her journey was the most remarkable of recent years. She is a religious enthusiast. Religious enthusiasm was the *motif* for her journey, and she believes herself to have been Divinely aided.' It was a quiet bid for Annie Taylor to be recognised not for her missionary work but for her remarkable journeys. On 25 July 1893, Isabella Bird also wrote to her friend and publisher, John Murray, 'Miss Taylor's wonderful Tibetan journey, which throws the Central Asian travels of men completely into the shade, will be a new difficulty for the RGS.' The Royal Geographical Society – the most prestigious of the geographical societies to which a male traveller of any standing was awarded Fellowship – had just rescinded the decision to admit women. Fifteen had been elected, including Isabella Bird, before the doors were shut on them. They were not reopened until 1913.

The Royal Geographical Society had recognised the work of one woman, but not for her own journeys. Jane Griffin had already travelled extensively with her father when, in 1828, she made a late marriage to Sir John Franklin, captain of a frigate in the eastern Mediterranean. For the following few years, Jane travelled with her husband before joining him as Governor's wife in Van Diemen's Land, where she took her role very seriously. She campaigned for female convicts and instigated a snake eradication scheme, offering a shilling a head for every snake killed, which ended up costing her £600. Despite Jane's enthusiastic schemes, her husband left Van Diemen's Land under a cloud; Sir John was accused, among other things, of bowing to his meddling wife's 'petticoat government'. Aged fifty-nine, he set about planning his fourth Arctic expedition to discover the North-West Passage, the sea route linking the Atlantic and Pacific Oceans that lies above the Arctic Circle. When Sir John sailed away with his ships *Terror* and *Erebus* in 1845, his wife travelled extensively through North America

and Europe to keep herself occupied. Her husband never returned. Her organisation and financing of several expeditions, over a period of thirteen years, to discover how and why Sir John and his 129-strong crew disappeared, earned her the 1860 Patron's Gold Medal from the Royal Geographical Society; she was the first woman to be so honoured. At the Anniversary Meeting, the Society's President Earl de Grey praised Lady Franklin for 'her noble and self-sacrificing perseverance in sending out, at her own cost, several searching expeditions, until at length the fate of her husband had been finally ascertained'. As women were not admitted to the Society, former President Sir Roderick Murchison accepted the medal on her behalf. Victorian society was far more comfortable with celebrating women travellers as companions than in recognising women as adventurers in their own right.

Despite such opposition, more and more women were venturing into new terrain, redrawing what Freya Stark called 'the map of my life'. It remained for them to find a place and independent purpose there.

By the well and the creeks, sitting in the camps in the firelight, on horse-back and on foot my notebook and pencil were always with me. I would come out sometimes for days, sharing my food, nursing the babies, gathering vegetable food with the women ... until I gained a unique insight into the whole northern aboriginal social system ... Every moment of my spare time was given to this self-imposed and fascinating study.

Daisy Bates, *The Passing of the Aborigines* (1938)

In June 1907, Gertrude Bell was covered in dust, digging at Dā'il. 'You would be surprised to see the scene in the middle of which I am writing,' she wrote to her mother. 'Thirty-one Turks are busy with picks and spades clearing out a church and monastery. At intervals they call out to me, "*Effendim, effendim!* Is this enough?"'

Pencil in hand, she drew plans of the site. Her small sketchbooks show a woman utterly absorbed; her diagrams are smothered in notes, with Arabic transcriptions squeezed in between. As well as writing and drawing, she took photographs. She made rubbings or, when an inscription was too worn, took a cast. The photographs, sketchbooks and detailed notes were her archaeological data. At the same time, she kept two diaries: one for her parents' eyes, the other for the man with whom she had recently fallen in love, Major 'Dick' Doughty-Wylie, nephew of the orientalist Charles Doughty. Doughty-Wylie was a military man who turned to diplomacy; he was also married. All her life, Gertrude Bell found places but lost people, as if she could love only those – family, friends or men – who were unobtainable or absent, and often, like Dick Doughty-Wylie, both.

Beryl de Zoete Watching a Balinese Dancer
Walter Spies, 1935–6. Modern print from an original negative
Horniman Museum, London

Conditions at the site were difficult, as the weather was very unpredictable – great heat followed by thunderstorms – but Gertrude Bell was enjoying herself. She was sorry, she wrote home, but this work was simply so important and pressing that she would be unable to return for her sister Elsa's wedding. It was not too pressing a few months later, however, when she sailed home to take instruction on astronomical observations and surveying from Mr Reeves of the Map Room at the Royal Geographical Society, which still did not admit women as Fellows.

Two years later, at the palace and mosque of Ukhaydir in Iraq, she undertook her most sustained archaeological study. Excavating in temperatures that fluctuated from unbearably hot to freezing, she walked rather than rode across the sands to keep herself warm. She started work before daybreak, yet first the sun, then the frost burnt her face. She wrote home that she had never felt so good, eaten so much nor slept so long. In the evenings, she sat with her guides around the campfire telling stories, drinking coffee and smoking Turkish cigarettes in a long holder. Four years earlier, on the last day of March in 1905, she had written to her mother from Syria, 'I have had the most delightful day today, playing at being an archaeologist.' Now she was no longer playing. In archaeology, Gertrude Bell had discovered a discipline that gave her a reason to be outdoors, in the desert, far from administrative centres. It made use of her gift for languages, and fulfilled her natural bent to record everything in the minutest detail. It also gave her an expertise.

Amelia Edwards was already a successful popular novelist and poet (at seven years old she had had her first poem printed in a penny weekly) and had written two well-received works on travel (one a children's picture book on Belgium) when, in 1873, with no particular interest in Egyptology, she accompanied a few friends on a hired house-boat, known as a dahabeeyah, along the Nile from Cairo to Abu Simbel. The landscape and culture passed her by, but the visible ruins of ancient civilisations captivated her – she called them 'the mummified generations'. It was not the present-day people but the ancient Egyptians she wanted to save from any accusations of savagery, and it was their Egypt of past millennia she recorded from her seat on the deck of the *Philae*. When she arrived at the pyramids, she did not, despite the encouragement of the local guides, clamber all over them; she felt no need to touch. She sat and stared, taking down detailed descriptions and sketching outlines for her watercolours.

On her return to Britain, she immediately set about learning to read hieroglyphs and working on another book. This one would not be popular fiction; it would be about the 'mummified generations'. The voluminous *A Thousand Miles up the Nile* (1877),

with eighty illustrations by the author, was published two years later and was an immediate bestseller. For the first time, there was an accurate and thorough description of the remains of this ancient civilisation. Amelia Edwards gave up all her literary work and dedicated herself to Egyptology, campaigning for the establishment of a fund, as her newspaper advertisements stated, 'for the purpose of conducting excavations in the Delta, which up to this time has been very rarely visited by travellers'. In her next book, *Pharoahs, Fellahs, and Explorers* (1891), composed from a series of fund-raising lectures she had given on an American tour, she wrote, 'The Valley of the Nile is, in short, one great museum, of which the contents are perhaps one third or one fourth part only above the ground. The rest is all below the surface, waiting to be discovered.' Edwards determined that she would enable that discovery. Once she had secured academic and financial support, the Egypt Exploration Fund was established in 1882. From that date, every winter the Fund has sent at least one expedition to Egypt.

The discipline of archaeology had grown out of amateur clubs, often revolving around collections of finds. Collecting – artefacts, rocks, butterflies, insects and specimens of all kinds – had been an activity in which women had long been involved and enjoyed some recognition and success. Constance Gordon Cumming's mother Eliza, who had died in 1842 when Constance was five years old, had collected fossils and had fish named after her. Collecting required no educational qualifications, just a precise eye and a passion for accumulation, considered particularly womanly skills. These feminine qualities could compensate for those it might be necessary to abandon, if only temporarily. Margaret Gatty, in *British Sea-Weeds* (1863), had advised women collectors that those 'really intending to *work* in the matter, must lay aside all thought of conventional appearances,' and wear neither silks nor satins but petticoats that stopped above the ankle to prevent hems dragging in the mud, and boy's oiled shooting boots.

When Mary Kingsley was searching for a reason to tramp around West Africa, she requested a collector's kit – bottles, nets and jars to preserve fish and insects in spirits – from the recently opened British Museum of Natural History. (By her second journey, she was taking 15 gallons of spirits, and had added a copy of the seminal *Introduction to the Study of Fishes* [1880] by the Keeper of Zoology, Dr Albert Günther, to her copious baggage.) On this first journey out, her appearance on board the *Lagos* caused some curiosity among fellow passengers and crew. At first, they presumed she was a missionary; single women were now common in the field. Then, learning she had little faith, they assumed that she must be a collector, a botanist probably – the only other area in which a spinster could conceivably work.

Amelia Edwards

Amelia Edwards (1831–92)
Percival Ball, 1873
Marble bust, 635mm (25") high
National Portrait Gallery, London (NPG 929)

Amelia Edwards had many talents but chose to earn her living by writing. Her life was changed by a holiday to Egypt in 1873–4 when she travelled by local sailing boat up the Nile with her friend Lucy Renshaw (d.1913). She learned to read hieroglyphs and started her own collection of antiquities. Her book *A Thousand Miles up the Nile* (1877) was the first published description of Egyptian sites and made her name. She championed scientific archaeological excavations, and founded the Egypt Exploration Fund in 1882. Another of her interests was women's rights. In 1889–90, she made a highly successful lecture tour of the United States. Her death followed shortly after that of her elderly friend Ellen Braysher, with whom she had long shared a house near Bristol. In her will, she left money to found the first-ever British chair in Egyptology at University College London (UCL), naming the well-known archaeologist Sir Flinders Petrie as professor. She also left her collection to UCL (now housed in the Petrie Museum) and donated this sculpture of herself to the National Portrait Gallery.

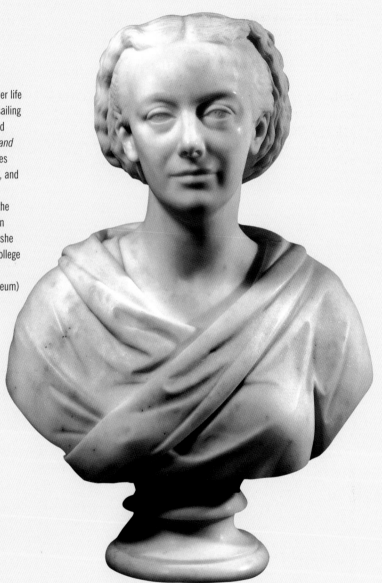

Upper Part of a Sculpture of a Man and a Woman against a Back Slab
Mid-XVIII Dynasty, 1550–1295BC
Painted limestone, possibly from Abydos, Egypt
Petrie Museum of Egyptian Archaeology, University College London (UC15513)

Amelia Edwards left this sculpture, which she collected in Egypt, to UCL in her will. It is not now possible to identify all the items she donated to UCL, but this sculpture clearly appears in a photograph of her study. Originally both of the Egyptian figures were probably seated. This remaining part is particularly well preserved. Both figures wear wigs and the woman has a headband decorated with lotus leaves and a bead necklace. They are presumably husband and wife. The back has seven columns of hieroglyphs. Amelia Edwards was particularly fascinated by the painted portrait sculpture that she saw in the recently opened museum in Cairo (now the Egyptian Museum). Describing 'two marvellous sitting statues' of Prince Rahotep and Princess Nofret in her book *A Thousand Miles up the Nile*, she wrote: 'these people … sit before us, side by side, coloured to the life, fresh and glowing as the day when they gave the artist his last sitting.' Although this example of Egyptian portrait sculpture is much smaller and later in date, it perhaps aroused some of the same feelings in her.

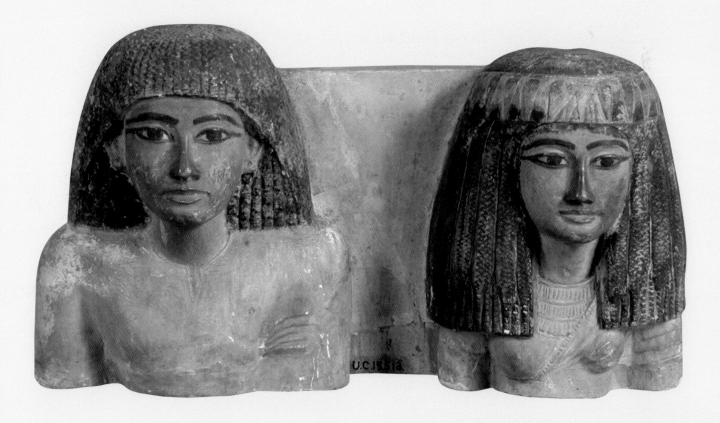

Mary Kingsley

Mary Kingsley (1862–1900)
Arthur King, 1900
Photogravure, 100 x 80mm (3⅞ x 3⅛")
National Portrait Gallery, London (NPG x19155)

Mary Kingsley's father, Dr George Kingsley (1827–92), a traveller and brother of the author of *The Water Babies*, Charles Kingsley (1819–75), was an important influence on her early life. This she largely spent at home, nursing her invalid mother and brother. On the death of both parents in 1892, when she was thirty, she began her travels to West Africa in search, she said, of 'fish and fetish'. Her many adventures included mountain-climbing, fending off crocodiles from her canoe, and, on opening a bag, tipping into her hat 'a human hand, three big toes, four eyes, two ears …'. She emerged from a swamp with a collar of leeches and fell into a pit of pointed stakes – saved by 'the blessing of a good thick skirt'. On her journeys she looked much as she does in this photograph, taken as a publicity shot, except for the hat. She scribbled underneath 'the melancholy picture of one who tried to be just to all parties' on copies she sent to friends. Her travels brought success with her books *Travels in West Africa* (1897) and *West African Studies* (1899). Despite these achievements, she believed that 'no woman equals a really great man.' She died in southern Africa, where she went as a nurse during the Boer War, and was buried at sea.

Mary Kingsley's Hat
1890s
Sealskin
Royal Geographical Society, London

This was the hat that Mary Kingsley brought from Britain and wore while travelling around Africa. As she said in *Travels in West Africa*: 'You have no right to go about Africa in things you would be ashamed to be seen in at home.'

The Tail-spot Climbing Perch (*Ctenopoma kingsleyae*)
Collected by Mary Kingsley, 1895
Fish preserved in glass jar of spirit
Natural History Museum, London

This freshwater fish, which Mary Kingsley collected from Kondo Kondo on the Ogowé River, Gabon, in West Africa, lives in swamps and forest streams and feeds mainly on insects. It has large, rough scales and is greenish brown in colour. It is a member of the family Anabantidae, the climbing perches. These fishes are a group of the so-called 'labyrinth fishes'. This name refers to the labyrinthine air-breathing organs situated above the gills that enable the fish to live in poorly oxygenated waters. Nowadays this fish is sometimes kept in aquaria; one aquarium guide describes it as 'a very predatory and snappish species'.

Dr Albert Günther of the British Museum of Natural History named the species after Mary Kingsley in a scientific account of the fishes that she had collected, published in 1896. Mary Kingsley took Dr Günther's book on

identifying fish and a quantity of spirit jars with her, so that 'an opportunity of collecting the fishes of this mighty river should not be lost. The means of preserving and transporting the specimens were naturally limited, as Miss Kingsley travelled alone with a native crew; besides … the upsetting of her canoe was a matter of frequent occurrence. Nevertheless she succeeded in bringing home in excellent condition … about sixty-five species of Fishes.'

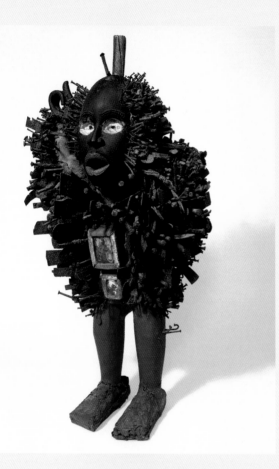

Mavungu, a Power figure or 'Nkisi' from the Congo
Collected by Mary Kingsley, 1890s
Painted wood and metal
Pitt Rivers Museum, University of Oxford

Mary Kingsley collected this power figure or 'nkisi' as part of her interest in what she called 'fetish', a now discredited term used for poorly understood African religious practices. She brought it back and kept it at her London home. This particular figure was the vehicle for a spirit named Mavungu, one of the 'hunters of the night' according to the Kongo people living near the mouth of the Congo River. A diviner, or 'nganga', activated the spirit by hammering pieces of metal into the figure. It would then seek out and punish those who had, by witchcraft, caused his client's illness or misfortune. It could also be used for swearing oaths, ensuring that promises were kept and adjudicating between true and false accusations. Mary Kingsley's explanation of its powers places far less emphasis on its socially useful roles. She describes activating it deliberately to harm one's victim, and suggests that the nganga might then extort money to reverse its malign effects.

Musical Instrument and Carved Ivory Ornament
Collected by Mary Kingsley, 1890s
Wood and cane; ivory
Pitt Rivers Museum, University of Oxford

This musical instrument (left), called an 'mbira', is made of wood with burnt decoration. The eight tongues are made of cane and resonate over the box. Similar instruments, popularly called African thumb pianos, are still used today,

though frequently they have metal tongues rather than wooden ones. The carved ivory ornament (right) is of particular interest as it has Mary Kingsley's signature incised on the back. It is probably an early example of tourist art and was created specifically for her. Unfortunately, it is not clear whether she commissioned it or whether it was made as a gift. The ivory ornament and mbira, like the nkisi and the other West African objects collected by Mary Kingsley, were left to her brother Charles in her will, with the request that on his death they should go to the Pitt Rivers Museum in Oxford. Charles gave them straight to the museum after his sister died.

Women had been contributing to botanical collections for many years. In the 1820s, Maria Graham, later Callcott, a rear admiral's daughter and wife of a sea captain, had been collecting seeds in Brazil for Sir William Hooker, later the Director of the Botanic Gardens at Kew, when it was suggested that she capture the plants in accurate watercolours. Dedicated to her commission, she used a microscope to portray them in more detail. Such contributions led the Royal Botanical Society, established in 1839, to follow the example of the Royal Entomological Society six years earlier, and admit women from the outset.

Mary Kingsley would never have called herself a botanist, but she did return from her first journey with an impressive collection of plants, as well as fish, flies, beetles and rocks. Collecting had been, for Mary Kingsley, a wonderful excuse for 'skylarking' in West Africa. Nevertheless, she was determined that her collection be duly recognised, and asked a cousin to write her a letter of introduction to Dr Günther. He obligingly contributed an appendix on her fish collection to her *Travels in West Africa*. Three freshwater fish that were new discoveries were named after her. The prominent entomologist W.F. Kirby, who also worked at the British Museum, penned another appendix, 'A List of the *Orthopetera*, *Hymenoptera*, and *Hemiptera* collected by Miss Kingsley on the Ogowé River, with Descriptions of some new Genera and Species', including locusts, green ants and an elephant tick.

Although they were rewarded for their collecting skills, the women travellers would, in fact, have gathered few items themselves. Africans whom Mary Kingsley encountered on her route provided her impressive specimens, which she often bought from them in return for tobacco, hairpins or trade alcohol. She did not confine herself (or her guides) to accumulating natural objects. She returned from West Africa with a large number of artefacts, including a dugout canoe and talking drums. (Although she never mentions it, she was able to bring back such hefty items only because she employed porters.) Some of the objects from her collection were donated or sold to the Pitt Rivers Museum in Oxford, then under the directorship of Edward Tylor, who became the first Professor of Anthropology in 1896 and used Mary Kingsley's data in his research. Others, such as a string of whale's teeth (obviously bartered), she used to decorate her Kensington flat. A power figure, 3¼ feet (1 metre) high, named Mavungu (which she called a 'fetish'), stood in the hallway, where it greeted her guests. Friends wrote imaginatively that they could smell the dried blood as they walked up the stairs.

These items were the clues to where her travels could take her. Although 'fish' was the first reason she gave to go off the beaten track, 'fetish' soon took over. She returned from

a trip on her 1893 journey to Corisco Island in the Gulf of Guinea, 'the obtaining of specimens of fish from the lake in the centre of the island being my main objective,' having discovered that 'those wretched fish were nothing and nobody else but an African mud-fish, a brute I cordially hate.' But she still had a good deal to say about the history and inhabitants of the island. Slowly, the naturalist became an ethnologist. She began collecting human customs.

While the women collectors turned their eyes towards other societies, those societies were also looking at them. Even Aphra Behn had recorded how, in seventeenth-century Surinam, 'They had no sooner spied us, but they set up a loud cry that frighted us at first. We thought it had been for those that should kill us, but it seems it was of wonder and amazement.' The local native Indian people set about studying the English party. 'They touched us, laying their hands on all the features of our faces, feeling our breasts and arms, taking up one petticoat then wondering to see another; admiring our shoes and stockings but more our gaiters which we gave them and they tied about their legs ...' The curiosity of the people they travelled among was often as great as that of the nascent ethnologist. Constance Gordon Cumming found in Shanghai that 'in the course of this morning's ramble, I have been the victim of some inquisitive Chinaman's scissors, for a neat small square has been cut from the edge of my new waterproof cloak, evidently with a view to discovering the secret of how to make it. Rather an annoying mode of investigation!' As Isabella Bird sat inside her portable mosquito net, looking out through the lens of her camera and the blur of the mesh at a foreign world, she would have seemed a strange, if not absurd, sight. Unsurprisingly, she complained that she attracted crowds of onlookers whenever she tried to assemble her photographic outfit. The observer enjoyed looking, but did not always enjoy being observed.

Women observers – proto-anthropologists – struggled to be taken seriously. In 1863, debates at the Ethnological Society resulted in a splinter group, the Anthropological Society of London, being formed under the leadership of James Hunt. The catalyst for the division was the ethnologists' decision to allow women to attend meetings. Hunt claimed this resulted in 'practically hindering the promotion of those scientific objects which they continue to claim for their society', in his introduction to Dr Carl Vogt's *Lectures on Man* (1864). He also objected to some sketches in the Society's *Transactions* that accompanied an article on the inhabitants of Sierra Leone, which portrayed them in a soft, sympathetic style, unlike harsher contemporary drawings that had compared them to beasts. It cannot have escaped Hunt's notice that they were the work of a woman – the wife of the author of the article, Robert Clarke, a surgeon in the colonial service.

Maria Graham

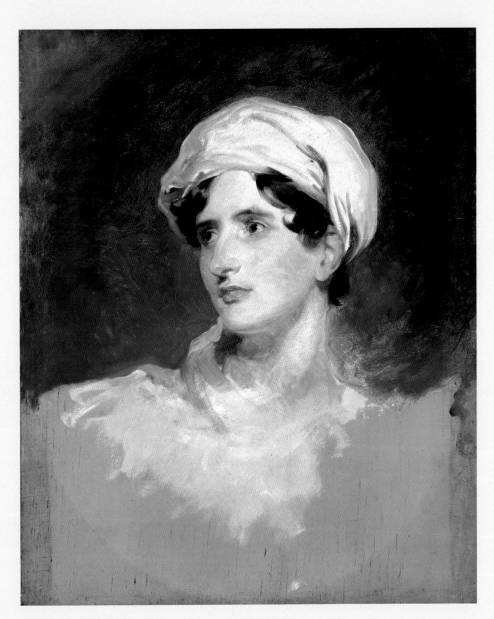

Maria Graham (1785–1842)
Sir Thomas Lawrence, 1819
Oil on canvas, 597 x 495mm
(23½ x 19½ ")
National Portrait Gallery, London (NPG 954)

The daughter of a rear admiral, Maria Dundas married, in 1809, Thomas Graham, the captain of the ship on which she travelled to India. She was painted in just two hours by Sir Thomas Lawrence in Rome, after the Grahams had befriended him there. She journeyed with her husband to Brazil, but he died of a fever in 1822 on the voyage around Cape Horn. Maria settled in Chile for a year before returning to Brazil. While in Brazil, she created her book of botanical illustrations. She also spent time as governess to Donna Maria, the daughter of Dom Pedro (reigned 1822–31), the emperor of newly independent Brazil.

On her return to Britain in 1827, she married the artist Sir Augustus Callcott (1779–1844) and started writing children's books, including *Little Arthur's History of England* (1835). In recognition of her botanical work, the shrub *escallonia callcottiae* was named after her.

2

3

Maria Graham's Book of Botanical Illustrations
Maria Graham, Brazil, 1824–7
Watercolours
Library & Archives, Royal Botanic Gardens, Kew

The impetus for this collection of Brazilian plant drawings came from Maria Graham's correspondence with Sir William Hooker (1785–1865), later the director of the Botanic Gardens at Kew. She wrote to him in 1824, apologising that the seeds she was sending him 'were ignorantly collected'. She continued, 'I do not habitually draw flowers but I could do that … only let me know how to be useful and I will try to be so.' In fact, she was considerably more knowledgeable than she admitted, but wished for 'a better microscope'. She recorded some particularly dramatic specimens such as the 'bromelia' (1). Bromeliads grow in trees, which is why Maria included part of a branch in her drawing. Her interest in seeds is shown in her drawings (2 and 3), sometimes embellished with the occasional insect that crossed her path (3).

1

As long as a pursuit remained non-scientific and amateur, women could participate. The Geologists' Association, whose avowed role was to bring together amateur geologists, had admitted women since its founding in 1858. Its sister organisation, the Geological Society, founded in 1807, perceived itself to be a scientific society, and published a learned journal; it resolutely opposed and deferred the admission of women to its meetings. Women were not admitted as members until 1919.

If an area of study became established as a science, as was happening with botany, geology, archaeology and anthropology, then women's participation was an issue. In the late nineteenth century, the British Association for the Advancement of Science, which had added an ethnology subsection in 1846, the Geological Society, and the Royal Geographical Society all had measures put before their councils proposing the admission of women. These controversies drew larger audiences to their meetings than any other business. Average attendance at a meeting of the Royal Geographical Society during the 1890s was 200. When a motion concerning women's fellowship was scheduled to be discussed, this figure doubled.

Against the background of these heated and long-running debates, the women travellers sought to have their work accepted. They were faced with the dilemma of how to give authority to their work when they lacked the broad academic background of male contributors. A review in the *Archaeological Journal* of Gertrude Bell's *The Thousand and One Churches* (1909), a thorough account of her pioneering archaeological work, complained the book was too narrow, concentrating too much on the simple facts without making 'recognition of a wider principle'. The scholarly women's response was to turn this apparent weakness to their advantage, pleading that an eye for the particular was not a drawback but an asset. Women, said Mary Kingsley, were no good at all on 'abstract things' but 'great on details'. As early as 1845, Elizabeth Rigby had argued that a man's journeys, driving 'a hobby of his own the whole way before him', blinkered him. Women, on the other hand, pick 'up materials much more indiscriminately', and therefore are open to chance impressions. These, argued Rigby, are often found to be far more important than the preconceived goal. Unbound by academic constraints, women could gather raw material without forcing it into a theoretical framework. Some travellers, wrote Gertrude Bell to her mother in April 1907 on her way to dig at Dā'il, 'might as well have stayed behind and read a few big archaeology books', for all the benefit of their observations. 'But I would have you know that is not the way that I have done it ... Here is a world of history that one sees with the eye and that enters into the mind as no book can relate it.'

Women highlighted their first-hand, detailed, on-the-spot knowledge, continually contrasting it to the armchair anthropologists, such as Mary Kingsley's friend Sir James Frazer, author of the multi-volume *The Golden Bough* (1890), whose studies were based on theories not experience. The women scholars trumpeted fieldwork; only then could a people's customs be interpreted properly, in their cultural context. 'Unless you live among the natives, you never get to know them,' Mary Kingsley declared. It was only by engaging in such work that it was possible to 'think in black' and penetrate the African 'mind-forest'. Adopting this approach, Kingsley defended polygamy and the killing of slaves at funerals, arguing that what was inappropriate for West Kensington might be appropriate for West Africa. She rejected the grand, overarching theories favoured by anthropologists and ethnologists of the time. Her advice, in a lecture in November 1897 entitled 'West Africa, from an Ethnologist's Point of View', was to 'say to people interested in Asiatics, Polynesians, and American Indians, "Yes, your information is most interesting, but we won't mix it up with ours, we mean to know Africa as it is, from its back hair to its burial customs ... and we have got our hands full with that."'

From the turn of the century, anthropology as a science developed still further, as universities began to offer courses, and fieldwork was recognised as a necessary element. The debates over what counted as proper anthropological research continued. On her 1910 journey with the Amaury Talbots to Africa, Olive Macleod (1886–1936) noted that Mr Amaury Talbot took instruments to measure the nose, chin, forehead, ears and other facial features for the Anthropological Society, of which he was a member. 'I do hope the Anthropological Society really appreciates the measurements they ask for,' wrote Macleod in *Chiefs and Cities of Central Africa* (1912). 'Mrs Talbot and I often wondered how much they do, for, to our untrained feminine minds, it seemed that general observations were just as effective as measurements.' Like Mary Kingsley, Olive Macleod simultaneously claims special insights and expertise, and, with a deferential nod, denies them.

By the 1920s, women were already getting a name for their anthropological work. In 1928, the American anthropologist Margaret Mead (1901–78) published *Coming of Age in Samoa*, written from fieldwork she had conducted in the Pacific. In Britain, Audrey Richards (1899–1984), after studying anthropology at Cambridge in the early 1920s, went on to do valuable fieldwork in Zambia on marriage, fertility and eating habits – areas that other anthropologists had neglected. Her first book, *Hunger and Work in a Savage Tribe*, was published in 1932. Although spurning academia – 'I have never run a "school" or been a professor,' she boasted, proud of her independence – she was elected President of the Royal Anthropological Institute in 1959, the first woman to hold the post.

Beryl de Zoete

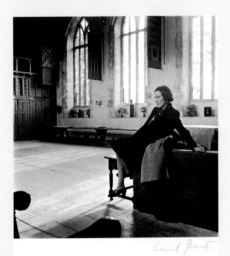

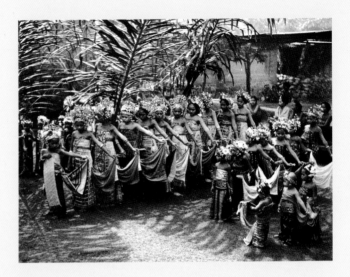

Beryl de Zoete (1879–1962)
Cecil Beaton, 1941
Bromide print, 204 x 196mm (8 x 7¾")
National Portrait Gallery, London (NPG x14058)

Balinese Dancing at Tenganan
Walter Spies, 1935–6
Modern print from an original negative
Horniman Museum, London

Born in London in 1879 into a family of Dutch descent, Beryl de Zoete was passionate about dance. Trained originally in ballet, she became an advocate of eurythmics (rhythmic gymnastics), studying and teaching it for many years. She was particularly interested in dance ethnology, and travelled abroad to see dance in different cultures. From 1935 to 1936, she went to Bali, working with filmmaker and artist Walter Spies (1898–1942). Their joint book, *Dance and Drama in Bali*, was published in 1937. She went on to study Hindu dance in southern India and Ceylon (Sri Lanka).

Married in 1902, she and her husband Basil de Selincourt practised celibacy and vegetarianism. She knew that her marriage had broken down when her husband brought home another woman and began eating beefsteak. Thereafter her partner was the distinguished translator of Chinese poetry Arthur Whaley (1889–1966), whom she met in 1918. She lived with him from 1936 until her death. She produced reviews and articles about different types of dance, and was loosely involved with the Bloomsbury circle.

Beryl de Zoete and Walter Spies collaborated closely in their study of Balinese dance: Beryl made copious notes while Walter took photographs. The photograph on pp.70–71 shows Beryl interviewing an unnamed male dancer in the village of Campuan who demonstrates movements while she watches intently. The most ornate dancers seen by Beryl and Walter were in traditional but wealthy villages, such as Tenganan, shown here. In *Dance and Drama in Bali*, Beryl wrote of this dance: '*Rejang* at Tenganan is danced with linked sashes … Some of the dancers … wear long golden nails fixed to their fingertips. A splendid feature, perhaps peculiar to Tenganan, is that each age dances in a separate file, down to the very tiniest girls, who are minute versions in every respect of their elders, learning gradually by imitation how to perfect their steps.' The dancers hold the linking sashes in their left hand while their right arms undulate slowly, never rising above shoulder level.

With the increasing professionalism of women in anthropology came greater specialisation. Beryl de Zoete, a trained dancer, developed a career in dance ethnology. In the mid-1930s she worked in Bali, watching and recording the dances of different villages for hours, day after day. She noted individual dancers' movements down to the finest details – the movement of a finger or the changing direction of the eyes. Her book *Dance and Drama in Bali* (1937) is a classic and is still in print. In the 1950s, Mary Douglas, whose father served in the Indian Civil Service for twenty-five years, was carrying out extensive fieldwork among the Lele people in the Belgian Congo. Her interests began to focus on taboos and rituals, the subject of her breakthrough book, *Purity and Danger*, published in 1966. She is now considered one of the most distinguished social anthropologists in Europe.

Other sciences, in which women had previously contributed in an amateur capacity, were now accepting them as professionals. Marie Stopes, best known as a pioneering promoter of birth control, was also the first British woman to obtain a doctorate in botany. In 1907, she won a grant from the Royal Society for an expedition to Japan to study the island's living plant fossils, a fan in one hand and a hammer in the other. Her account of her experiences was bravely titled *A Journal from Japan: A Daily Record of Life as Seen by a Scientist* (1910). In 1911, she was employed on another important project by the Geological Survey of Canada to study the plant fossils near St John, New Brunswick.

In archaeology, too, women were no longer 'playing' as Gertrude Bell had once done. When Kathleen Kenyon carried out her first fieldwork in 1929 at Great Zimbabwe as a photographer, she was part of a team led by Gertrude Caton-Thompson (1888–1985). (Privately educated Caton-Thompson had gained an international reputation, particularly in the field of Egyptology.) Kenyon had studied at Somerville College, Oxford, where she had become the first female president of the Oxford Archaeological Society. In 1934, she was one of the founders of the University of London's Institute of Archaeology. But it was not until the 1950s that she attracted serious attention for her work in Jericho, where she made ground-breaking discoveries and re-established the British School of Archaeology in Jerusalem.

From their first trespass into the male professions, women travellers exploited opportunities for greater influence. Many harboured political ambitions, and it was with their newly acquired expertise as anthropologists and archaeologists – those who had 'been there' – that they could wield influence. But their new careers in the corridors of administrative power did not take a conventional path. Much of their politicking was done behind the scenes, in private correspondence, at dinner parties and through seeking

Marie Stopes

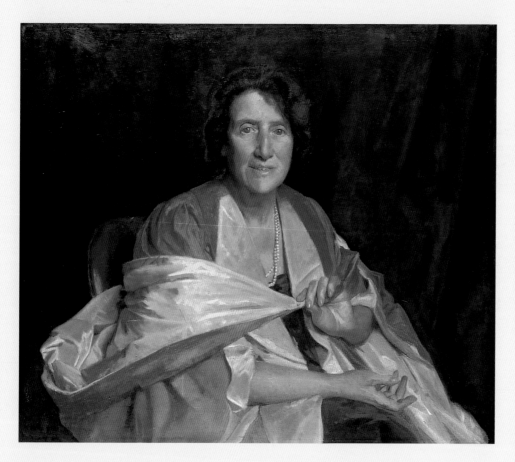

Marie Stopes (1880–1958)
Sir Gerald Kelly, 1953
Oil on canvas, 724 x 857mm
(28½ x 33¾")
National Portrait Gallery, London
(NPG 4111)

Marie Stopes's work as the pioneer of birth control and author of controversial books such as *Married Love* (1918) has eclipsed other aspects of her life, including her journey to Japan. She was originally a palaeobotanist, studying fossilised plants for her PhD in Munich. She then became the first female member of the science faculty at Manchester University and, at the age of twenty-four, the youngest British Doctor of Science. In this portrait she wears her academic robes; the artist Sir Gerald Kelly pronounced it 'strikingly like her'. Her quest for fossils took her to Japan, as did love for a much older Japanese man she had met in Munich. She hoped for marriage, but he failed to reciprocate her feelings. She spent eighteen months, from 1907 to 1908, in Japan, keeping a journal and visiting the island of Hokkaidô for fossils and ethnographic items. She presented her ethnographic collection to the British Museum on her return.

Ainu Crown with Bear's Head Ornament and Velvet Bag from Hokkaidô, Japan
Collected by Marie Stopes, 1907–8
Bark and wood-shaving; silk-embroidered velvet
The British Museum

The Ainu (meaning 'human' as opposed to 'gods') are the indigenous people of Japan who live on the northern island of Hokkaidô, 'a fundamentally different race from the Japanese', as Marie Stopes noted in her *Journal from Japan* (1910). When she visited in 1907 to 1908, they numbered under 18,000 people. She thought them 'very handsome', apart from the 'green tattoo marks on their faces', but could only communicate with them 'in bad Japanese. Aino [*sic*] itself is a curiously hard language, nearly all *k*'s.' The bear, which appears on this headdress, holds particular significance for the Ainu as one of their many gods, 'the god of the mountains'. Some Ainu claim descent from him. In Ainu mythology, the bear god took human form to visit a lonely widow, leaving her with a son, who became a renowned hunter. Bears are worshipped in rituals with dance and song, and are represented, as here, in Ainu carvings. The most important Ainu ritual involves a bear, captured as a cub and raised in captivity, which is killed sacrificially to send its spirit back to the god of the mountains.

The Ainu traditionally lived by fishing and hunting. They traded furs for essentials such as rice and iron, and for luxuries such as lacquerware and fabrics, including silk. The materials used to make this bag – velvet and silk – are Japanese, but the design embroidered on it is pure Ainu.

Mary Douglas (b.1921)
Nick Sinclair, 1993
Bromide print, 318 x 318mm (12½ x 12½")
National Portrait Gallery, London (NPG P564(8))

Mary Douglas is a highly distinguished social anthropologist. Born as her parents
were returning from colonial service in Burma, Mary Tew studied anthropology as
a postgraduate student at Oxford, gaining her PhD in 1951. Her fieldwork took
her to the Belgian Congo where she studied the Lele people. She was Professor
of Social Anthropology at University College London until 1978, and then held
various senior academic posts in the United States until 1988. Her most famous
book, *Purity and Danger: An Analysis of Concepts of Pollution and Taboo* (1966),
reveals the eclectic nature of her knowledge and interests, covering a vast
sweep of topics from adultery to Zoroastrianism. Her lively style makes it highly
accessible, as when she describes gender relations among the Lele: 'Women
were treated … as a kind of currency in which men claimed and settled debts
… A man with no rights over women' was like 'a modern business man with no
bank account'. More recently she has turned her attention to understanding the
Old Testament in its original context in *Leviticus as Literature* (1999).

influence with wives of officials who, they hoped, would forward their views. Mary
Kingsley wrote long, carefully argued letters to the Colonial Secretary, Joseph
Chamberlain, but always addressed to his private rather than to his official residence.
Nevertheless, her petitioning worked, and during House of Commons debates on the
future administration of West Africa, Miss Kingsley's views were frequently quoted. She
soon shifted from arguing that it was necessary to study the African 'mind-forest' for eth-
nological purposes to promoting such understanding as a tool to govern African peoples.

Mary Kingsley agitated against direct British colonial rule of West Africa, devising a
system of councils through which the region could be administered by local people and
British traders. At the same time, she was a staunch imperialist, convinced of Britain's
role as the driving force behind all development and government. This seemingly
contradictory position – both expounding British control and criticising it – echoes earlier
women travellers' involvement in anti-slavery movements. Aphra Behn's *Oroonoko* is
often heralded as the first emancipation novel, but the author did not oppose slavery. Her
hero, although wrongfully enslaved himself, was, in her eyes, a rightful slave owner,

Dame Kathleen Kenyon

Dame Kathleen Kenyon (1906–78)
Jorge Lewinski, 1969
Bromide print, 375 x 300mm (14¾ x 11¾")
National Portrait Gallery, London (NPG x13729)

A student of the famous archaeologist Sir Mortimer Wheeler (1890–1976), Kathleen Kenyon excavated sites both in Britain, including Verulamium (St Albans), and in the Middle East, where she made her name for her work at Jericho. When she first went to the Middle East in the 1930s, she introduced British methods of excavation into the region. The Second World War and its aftermath kept her in Britain, digging and helping to found the Institute of Archaeology at the University of London, where she was lecturer in Palestinian archaeology and acting director. In 1952 she began her excavations at Jericho, which were to change the known early history of the area. She also excavated in Jerusalem, finally retiring from the field in 1967. From 1962, she was Principal of St Hugh's College, Oxford. Her brusque manner was deceptive. Joseph A. Callaway, in the journal *Biblical Archaeologist*, recalled that 'she always had a soft spot for needy students, stray dogs and old vehicles'. This photograph shows her surrounded by archaeological finds.

Pot and Pottery Lamp from Tomb H16, Jericho, Palestine
Excavated by Kathleen Kenyon, 1953
Hand-built buff coarse ware, 2200–2000BC
University of Cambridge Museum of Archaeology and Anthropology

These two items date from before the famous destruction of Jericho by Joshua's troops, when 'the walls came tumbling down', as recorded in the Bible. The wealthy inhabitants of earlier Jericho were buried in tombs cut in the rock outside the city. The body would be laid to rest accompanied by offerings of food or drink to the dead. Unfortunately, it is not now possible to determine what this particular pot once contained. It was found with two other similar ones – a typical set of finds for a tomb of this kind. A lamp was placed in the tomb wall probably for practical purposes during the burial and to provide light for the soul's journey into the afterlife. This lamp would have burnt oil, probably olive oil, or animal fat, with four wicks, one in each spout. Kathleen Kenyon recorded her finds in a series of notebooks with a drawing of each item, as shown here.

Fanny Kemble (1809–93)
Peter Frederick Rothermel, 1849
Oil on canvas, 381 x 305mm (15 x 12")
National Portrait Gallery, London
(NPG 5462)

Frances Anne Kemble was a successful actress from a major theatrical family; her father was Charles Kemble (1775–1854) and her aunt, Sarah Siddons (1755–1831). Following a string of hits in London, Fanny travelled to America to tour with her father. There she married a rich American planter Pierce Butler (d.1867) in 1834. Visiting his estates in Georgia, she was appalled to discover that the source of his wealth was slavery: 'When I married … I knew nothing of these dreadful possessions of his.' She tried to alleviate some of the worst suffering she found on the plantations, but clearly the marriage was doomed. The couple divorced in 1848–9. In 1863, two years after the outbreak of the American Civil War, her *Journal of a Residence on a Georgian Plantation in 1838–39*, detailing the horrors she had witnessed, was published by abolitionists to promote their cause. She continued to live in Britain and in the United States, writing and occasionally giving public readings. She is buried in Kensal Green Cemetery, London.

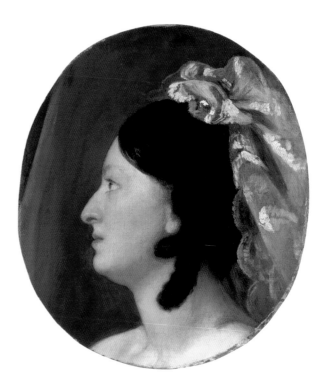

keeping 150 men and women. Aphra Behn's opposition was to the enslavement of members of the noble classes for no other reason than that they were black. For her, rank and status were far more important than race. While insisting ordinary people were treated fairly, she did not object in principle to their enslavement.

Aphra Behn's views would have been coloured by her experiences in Surinam. Later women writers were also affected by what they saw on their travels. When Fanny Kemble became Mrs Pierce Butler in 1834, she did not realise that she was marrying into a family of slave owners until she saw for herself the misery on the Butlers' plantations in Georgia in the United States. Soon she was drawing parallels between the condition of slavery of other races and her own, very different, economic enslavement. Before her marriage, she had achieved fame and fortune as an actor. In *Journal of a Residence on a Georgian Plantation in 1838–39* (1863), she wrote,

For the last four years of my life that preceded my marriage I literally coined money, and never until this moment, I think, did I reflect on the great means of

good, to myself and others, that I so gladly agreed to give up forever for a maintenance by the unpaid labour of slaves – people toiling not only unpaid, but under the bitter conditions the bare contemplation of which was then wringing my heart.

In Britain, Kemble became part of a tight group of anti-slavery campaigners, including Harriet Martineau (who was nevertheless very unsympathetic towards women in the Turkish harem), Anna Brownell Jameson and Barbara Bodichon. Bodichon was one of the few whose political views were constant and broad, covering issues of race, sex and class. Most women travellers wanted to abolish slavery but retain the economic advantages they had gained from it.

Women travellers used their first-hand knowledge to campaign on issues that became important to them. Gertrude Bell had particularly grand political ambitions. During the First World War, she worked as Secretary to the British High Commissioner in Baghdad, Sir Percy Cox, where she was responsible for relations with the Arab population. She knew where her strengths lay. 'I do know these people, the Arabs; I have been in contact with them in a way which is possible for no official, and it is that intimacy and friendship which makes me useful,' she wrote to her brother in May 1916 on taking up the appointment.

Bell believed she could achieve almost anything simply by bringing the different factions together socially. She held up to three parties a week in her back garden hung with lanterns, serving guests drinks, fruit and cake amid the first daffodils ever to bloom in the city. 'There wasn't a moment without quite excellent, sometimes almost brilliant conversation,' she wrote to her father after one such occasion in August 1921. 'And so light in hand, so intimate with us – I must say I went to bed happy. If you can preserve that atmosphere what can't you do?'

What Bell wanted to do was to have Prince Faisal, son of the Emir of Mecca, pro-claimed King of Iraq, a country whose borders she was drawing with a stick in the sand. In 1920 she wrote a White Paper putting forward her point, 'Review of the Civil Administration of Mesopotamia' – the first by a woman. She was not pleased with the response. 'There's a fandango about my report,' she wrote to her father when it was published early the following year. 'The general line taken by the Press seems to be that it is most remarkable that a dog should be able to stand up on its hind legs at all – i.e., a female write a white paper. I hope they'll drop that source of wonder and pay attention to the report itself.' At the 1921 Cairo Peace Conference, where she was the only woman delegate, her ambition was eventually realised, and Prince Faisal's position was affirmed.

She had, she wrote, been engaged in 'creating kings'. Her rewards for such support would be fantastic. Faisal promised her a regiment of the Arab Army, 'The Khatun's Own', she wrote home to her family half in jest, half in hope. 'I shall presently ask you to have their colours embroidered.'

There would be no triumphant parade for Gertrude Bell. When Sir Percy Cox left Baghdad in 1923, she lost her protector. The successfully established government of Iraq, for which she had so long agitated, ironically ousted her from influence. By May 1926, she was writing to her father, 'Politics are dropping out and giving place to big administrative questions in which I'm not concerned and at which I'm no good.' The time and place for a less formal contribution, made under the lanterns in her Baghdad garden, was passing. Her friend Janet Courtney suggested she stand as a Member of Parliament – wouldn't she make an excellent Under Secretary for Foreign Affairs! But this was not the kind of politicking Gertrude Bell, an anti-suffragist, enjoyed. 'No, I'm afraid you will never see me in the House,' she wrote back. 'I have an invincible hatred of that kind of politics … my natural desire is to slip back into the comfortable arena of archaeology.' The Baghdad Museum had been founded, and Bell was appointed its first honorary Director of Archaeology. She drafted Iraq's first Law of Excavation. She hoped the Iraqi government would provide her with a permanent post in the Department of Antiquities, but it was never offered. She said her greatest sense of accomplishment was 'when I came back with the plan of Ukhaidir in my pocket'.

Still, when Vita Sackville-West visited her, she found the house and its owner in good spirits. Her Arab staff's babies were playing in the corner of the garden, a tame partridge hopped about the veranda, and Gertrude was brimming over with enthusiasms, continually jumping up and down from her seat, winding her greying auburn hair about her finger and, as always, chain-smoking. 'She had the gift of making everyone feel suddenly eager; of making you feel that life was full and rich and exciting,' Sackville-West wrote. 'I found myself laughing for the first time in ten days.' Vita, unhappily married to Harold Nicolson, whom she would do no more than visit at his posting in Persia, must have appreciated the enlivening company.

Gertrude Bell was no less than a nation-builder in the Middle East. Amelia Edwards was central in the founding of Egyptology as a discipline. Mary Kingsley's early ethnological studies drew attention to the importance of looking at West African societies from the inside out. These women travellers explored their world. Their scholarship, in many different areas, continues to shape ours.

Vita Sackville-West (1892–1962)
Gisèle Freund, 1939
Colour dye transfer print, 304 x 208mm (12 x 8¼")
National Portrait Gallery, London (NPG P437)

Vita Sackville-West is far better known as a gardener
and a writer than as a traveller. However, from her
teens, she had enjoyed foreign travel. Vita's
birthplace, the great Tudor house of Knole in Kent,
and the fact that as a woman she could not inherit
it, had a major impact on her life. She married
Harold Nicolson (1886–1968) in 1913, and went
with him to Constantinople, where he was in the
embassy. He was posted to Tehran in Persia (now
Iran) in 1925, but Vita chose not to accompany him,
preferring to stay in England with her garden and her
writing. However, two visits to him prompted the
writing of her two reflective travel books, *Passenger
to Teheran* (1926) and *Twelve Days: An Account of A
Journey ... in South-Western Persia* (1928). There
she watched the coronation of the Shah and learned
to love the very different kind of beauty of Persian
gardens. Although their marriage was never easy, in
creating their garden at Sissinghurst in Kent, Harold
and Vita were able to combine their skills. They
produced a masterpiece, which still draws other
travellers from around the world.

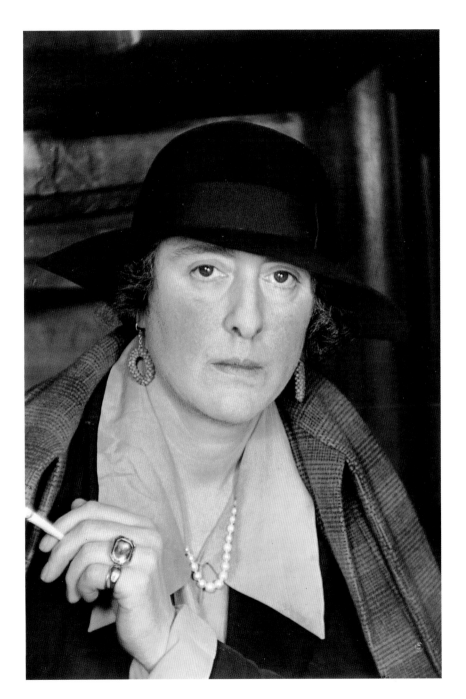

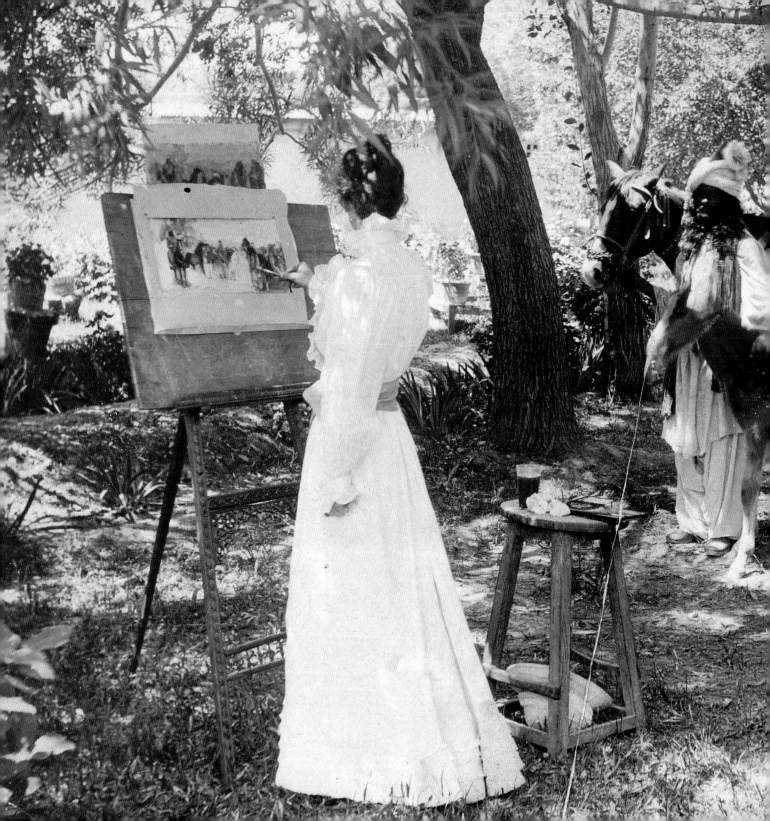

Writers and Artists

The pictures of the pen shall outlast those of the pencil, and even worlds themselves.

Aphra Behn, prologue to *The Luckey Chance* (1687)

Ethel Mannin was destined to be a post office clerk until she discovered writing. Her career was launched at the end of the Great War when, as a teenager, she started to write for the women's pages. Her first novel, *Martha*, was published in 1923, when she was twenty-three years old. That year, abandoning an early marriage, 'with one suit-case, a portable typewriter, a child of three, and six words of French, I realised the dream which had been burning in me since I was twelve, and went South, in search of the sun, violet-fields, olive-groves, vineyards, and orange-trees. Particularly the orange-trees.' As for many other women, her writing and travelling were intertwined. Travelling provided the material for her fiction and non-fiction, and writing provided the reason for her travels.

By the time she reached thirty, Ethel Mannin had made good use of the typewriter, having published six more novels highlighting the lives of working-class women. It was then that she made the promise that writing would be her life; it would save her from her family, her past and her threatened future. She would publish two books a year: one fiction, one non-fiction. She often went abroad to write, hiring a simple room, in Mallorca for example, dragging the table across to the window (her favourite position for a temporary desk), propping up a picture of her absent daughter Jean, and then beginning her latest book, on which she worked for five hours a day.

Her first travelogue, *All Experience*, about her early European trips as a journalist, was published in 1932, the

Ina Sheldon-Williams (*fl.*1900s–50s)
Unknown photographer, 1902. Vintage bromide print, 89 x 104mm (3½ x 4⅛")
National Portrait Gallery, London (NPG x20696)

Ethel Mannin (1900–84)
Paul Tanqueray, 1930
with background jazz design painted
by Ida Davis
Bromide print, 242 x 191mm
(9½ x 7½")
National Portrait Gallery, London
(NPG x14264)

Ethel Mannin was a prolific writer of
novels and travel books, with titles
such as *South to Samarkand* (1936)
and *Moroccan Mosaic* (1953). Born
into a working-class family, she left
school young and began working in
an advertising agency. Encouraged by
her father in her writing, she was
determined to make it her life. When
this photograph was taken, she had
just bought a house in Wimbledon that
she had admired since childhood. She
lived there for nearly forty years. As a
pacifist and anti-monarchist, she had
strong political views, though she
became more right wing as she grew
older. She travelled widely and, not a
specialist, she was as happy
describing Jordan as Japan. She was
very honest about her skills and her
limitations: 'I had too much too soon;
too much facile success, too much
money, too much unassimilated
experience.' Her readers lapped up
her work, encouraging her to produce
more rather than better writing, which
she obligingly did.

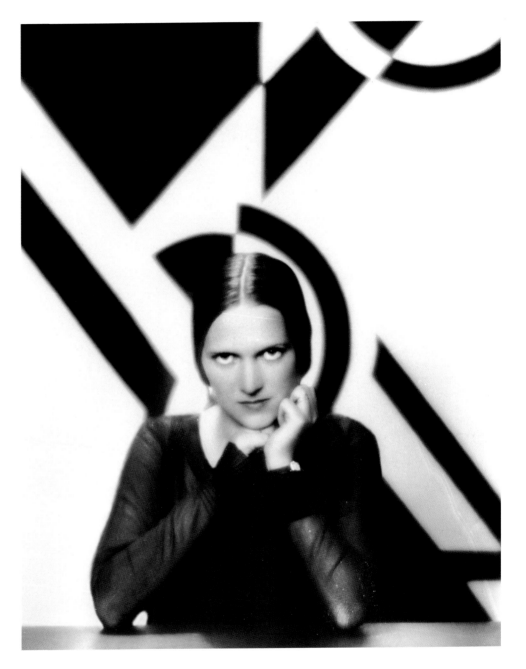

year before she met the poet William Butler Yeats, who was seventy. She is thought to have become his lover, and is credited with curing his impotence. Although she travelled widely, London's Ivy restaurant, the haunt of celebrities and the place where she would dine with Yeats, was her natural habitat – an exotic enough location for a woman from a working-class background. Around the table, she seduced with her cultivated, stylish looks and her strong, diverse opinions; Bertrand Russell was one of many men who fell for her. Mannin, who described herself as 'an emancipated, rebellious, and Angry Young Woman', was known as an advocate of free love and was involved in the World League for Sexual Reform. She promoted nude sunbathing, instant divorce and abortion on demand; she was anti-monarchist, a pacifist, spoke out for the compulsory sterilisation of the mentally ill, and became a communist after returning from the Soviet Union in the mid-1930s. (Her contemporary Clare Sheridan, a traveller, sculptor and cousin of Sir Winston Churchill, had her phone tapped, her mail intercepted and her movements around Europe monitored because of her communist beliefs.) In 1938, Mannin married the Quaker activist Reginald Reynolds, with whom she travelled. In later life, her politics turned to the right, and she renounced the sexual freedom she had so promulgated and practised. She remained faithful to her writing, however, never reneging on the promise she had made to herself. By the time she retired in the late 1970s, she had written over 100 books, fourteen of which were travel accounts.

Writing was one of the few careers that had long provided women with professional status, more so perhaps than other forms of artistic expression. The seventeenth-century author Aphra Behn is often cited as the first professional woman writer; she penned over a dozen plays, numerous poems and five works of prose, including *Oroonoko*. The early nineteenth-century author Fanny Trollope wrote over forty books, but it was her first, the cuttingly critical *Domestic Manners of the Americans*, published in 1832, which was her most successful. Within months she had received over £1,000 in royalties. Its success ensured that her follow-up book, the novel *The Refugee in America*, secured an advance of £400 and was published the same year. At the age of fifty-two, she became her family's breadwinner, rescuing them from penury.

In the following century, Flora Shaw, the third of fourteen children in a prominent military Anglo-Irish family, earned £800 a year as Colonial Editor of *The Times*, enabling her to support her unmarried and widowed sisters. Isabella Bird financed her extensive travels, and all her bulky photographic equipment, entirely through her books, articles and exhausting lecture tours billed as a bestselling author. She found she could live in her own peculiar style for just £10 a month on the Sandwich Islands. Calculating the costs of their

Clare Sheridan

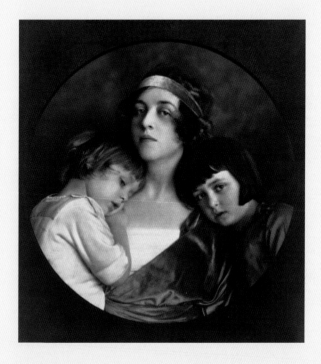

Clare Sheridan (1885–1970) with her children Richard and Margaret
Bertram Park, 1919
Chlorobromide cream-toned print, 276 x 273mm (10⅞ x 10¾")
National Portrait Gallery, London (NPG P333)

Clare Sheridan was a cousin of Sir Winston Churchill, whom she embarrassed with her wild behaviour and belief in free love. She married in 1910 and had three children, one of whom died in 1914. Grief-stricken, she modelled an angel for her child's grave and discovered a talent for sculpture. After the death of her husband in the First World War, she began exhibiting her portrait sculptures, including one of Churchill, created while he painted her. An admirer of communism, she travelled in secret to the Soviet Union in 1920, the year after this photograph was taken. There she sculpted Lenin and Trotsky. She published her diary of the trip in 1921, calling it *Mayfair to Moscow* in America and

Russian Portraits in Britain. She then went to Mexico and the United States, where she settled and became friends with Charlie Chaplin. Next she turned to journalism, interviewing senior European figures for the American press. Her second trip to Russia, in 1923, proved disillusioning. She took her children to live first in Turkey and then on the edge of the Sahara in Algeria. After the Second World War, she became a Roman Catholic. In her later years, she continued to sculpt and wrote her memoirs, *To the Four Winds* (1957).

Blackfoot Moccasins
Collected by Clare Sheridan, 1937
Leather and beadwork, in or before 1937
Hastings Museum and Art Gallery

Clare Sheridan's visit to the United States of America, during which she collected these moccasins, indirectly resulted from another family death. Her son Richard, shown as a boy in her photograph, died in the Sahara in 1937. She carved him a memorial in oak at Brede Church, near her family home in Sussex. Becoming interested in woodcarving, she spent a year on a reservation among the Blackfoot and Blood tribes in Montana and Alberta in the foothills of the Rocky Mountains, developing her skills, collecting Native American artefacts and publishing a book, *Redskin Interlude* (1938). She wrote of her grief: 'I found my medicine – it was living on the Blood Reserve.' Having inherited some Native American blood herself, Clare Sheridan developed, through interpreters, a close affinity with the people and was accepted into the Blackfoot tribe. She was also given many gifts highly valued by the giver 'because according to Indian ideals that is the only reason for giving.'

On one occasion, she visited Crow-Chief on the death of his young granddaughter. 'He wanted to show his appreciation but had nothing to offer – only his moccasins. (They were exquisitely beaded and happened to fit me, I wore them for months.)' The moccasins shown here, made by the Blackfoot, are clearly well worn but their original donor is unfortunately unrecorded.

Fanny Trollope (1780–1863)
Auguste Hervieu, *c.*1832
Oil on canvas, 152 x 127mm
(6 x 5 ")
National Portrait Gallery, London
(NPG 3906)

Frances Trollope, author and mother of the famous novelist Anthony Trollope (1815–82), travelled to rescue the family fortunes. Her husband, Thomas Trollope (1774–1835), succumbed to various speculative schemes, each more disastrous than the last. From 1827 to 1830, Fanny was in North America, where she and Thomas opened a cultural centre in Cincinnati, Ohio, which failed. She also visited a friend's project to assist black slaves near Memphis, Tennessee. This, too, collapsed, but the visit left Fanny with a deep hatred of slavery. She decided to record her experiences as *Domestic Manners of the Americans* (1832): 'What I have written will make it evident that I do not like America.' Describing 'the population in general', she continued: 'I do not like them. I do not like their principles, I do not like their manners, I do not like their opinions.' This portrait of Fanny, painted for the book, was, she pronounced, 'a dreadful consumer of time'. The success of this bestseller, further travel books and a large number of novels allowed the now widowed Fanny and her many children to live in comfort at last.

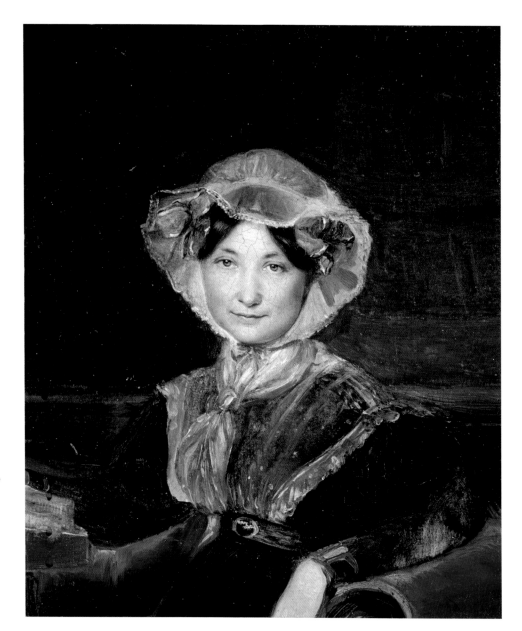

travels was important, and many women travellers were meticulous account keepers. Mary Kingsley budgeted £1 for every five miles in West Africa. Like many women travellers, she moved very slowly, rarely spending more than £5 in a week. The prolific writer Amelia Edwards noted that the running of the *Philae*, including wages and provisions for passengers and crew, was relatively extravagant at £10 per day. Ethel Mannin lived very comfortably, buying her dream home, Oak Cottage in Wimbledon, with the proceeds from the sales of her numerous books.

Although women had to hunt for a sound pretext to leave home, foreign societies were thought particularly suited to the female writer. Women's travel writing, like their anthropological work, was considered important for the insights it could give into domestic life. 'Every country has a home life as well as a public life ... Every country therefore, to be fairly understood, requires reporters from both sexes,' wrote Elizabeth Rigby. In fact, very few writers wrote specifically about women. Lady Mary Wortley Montagu had dined and dressed with the ladies in the Turkish harem, but most women travel writers, anxious not to be pigeonholed, chose to portray a full picture of the society through which they wandered. Rosita Forbes was one of the few who published books concentrating on women abroad. Her *Women Called Wild* (1935), a collection of essays about women around the world, was followed by her edited collection, *Women of All Lands: Their Charm, Culture and Characteristics* (1938).

There were other ways in which women could contribute to travel writing. Men's observations, it was thought, lacked the eye for detail found in women's accounts. (Similarly, women's particular contribution to archaeology and anthropology had been seen as accumulating facts not propounding theories.) In an article in *Blackwood's Magazine* in 1896, it was argued, 'It seems characteristic of the lady traveller to make and record those minute, varied, and vivid observations of life ... No man would be so painstaking and so patient.' In a 1907 review of Gertrude Bell's *The Desert and the Sown*, the *Times Literary Supplement* admitted, 'Women perhaps make the best travellers ... They are unquestionably more observant of details and quicker to receive impressions. Their sympathies are more alert ...' In 1845, Elizabeth Rigby, writing an anonymous review of a dozen books by women travellers in which she recommends Lady Callcott and Anna Brownell Jameson's work, contrasted the 'sweeping generalities' of men to the 'close and lively details' of women writers. (Women travel writers were not always so kind about each other. In her *Letters from Egypt* (1865), Lucie Duff Gordon said of Harriet Martineau's *Eastern Life, Present and Past* (1848), 'there is the usual defect – to her, as to most Europeans, the people are not real people, only part of the scenery.' This, Duff Gordon

**Elizabeth Rigby, Lady Eastlake
(1809–93)**
David Octavius Hill and
Robert Adamson, 1843–8
Calotype, 206 x 156mm (8⅛ x 6⅛")
National Portrait Gallery, London
(NPG P6(124))

Elizabeth Rigby's travels began before her marriage when, in 1838, she went to visit her married sister in Reval in Russia (now Tallinn, Estonia). On the journey, icicles formed on the travellers' eyebrows and eyelashes, and the sherry froze solid. She stayed in Russia until 1841. Her letters home were first published anonymously as *A Residence on the Shores of the Baltic* (1841), and were illustrated with her sketches. The success of this travel book led to her writing for various magazines, including another anonymous piece, 'Lady Travellers', in the *Quarterly Review* in 1845. Elsewhere she attacked Charlotte Brontë's *Jane Eyre* (1847), which she was sure was by a man, for being 'anti-Christian', and wrote various articles on art history. She was fascinated by photography and was the most frequent sitter of the Edinburgh photographers Hill and Adamson. In 1849, she married the painter Sir Charles Lock Eastlake (1793–1865), who became the Director of the National Gallery. She returned twice to see her sister in Reval and made many trips to Europe with her husband to look at paintings. Her wide circle of friends included Charles Dickens and William Gladstone.

believed, had not always been the case. In older travel books, the people were described 'in a far more natural tone, and with far more attempt to discriminate character, than modern ones ... *Have* we grown so *very* civilised since a hundred years that outlandish people seem like mere puppets, and not like real human beings?') There were, Elizabeth Rigby believed, 'peculiar powers inherent in ladies' eyes ... that power of observation which, so long as it remains at home counting canvass [*sic*] stitches by the fireside, we are apt to consider no shrewder than our own, but which once removed from the familiar scene, and returned to us in the shape of letters or books, seldom fails to prove its superiority.' She was also talking about her own strengths; seven years earlier, in 1838, she had visited her married sister in Russia and stayed for three years. The second edition of her edited letters home was published as *Letters from the Shores of the Baltic* (1842), which she recommended, anonymously of course, in her own review.

The discoveries women made on their journeys were not only of distant people, but also of themselves. Inevitably, these inner journeys were often as much the subject of their writing as the landscape and cultures through which they travelled. Elizabeth Rigby remarked how 'inward experiences' and not 'outward impressions' were women's forte, drawing 'most admirable maps of the winding paths of their own hearts'. Rebecca West called it 'the geography within her own breast'. Few women spelt out these inner territories, but could express them obliquely. In 1858, long before she published her first successful travel book, *Untrodden Peaks and Unfrequented Valleys: A Midsummer Ramble in the Dolomites* (1873), and fifteen years before she boarded the *Philae*, Amelia Edwards translated from the French a young woman's stirring adventure. *A Lady's Captivity Among Chinese Pirates in the Chinese Seas* claimed to be a memoir secretly written by the imprisoned author with the tip of her hairpin in the back of an old German book. It is a dashing tale, and the young lady is saved by removing her shirt (secreted under her male sailor's outfit) to flag down her rescuers. 'Still, with all their troubles, my weary wanderings had not been wholly profitless,' the book concluded. 'I had beheld Nature, bountiful and beautiful Nature, under her most varied aspects; and if I had endured fatigue, privation, and even disease, I had, at least, lived that life of peril which hath its own peculiar charm for the imaginative and the young. I have never yet regretted my journey, or its adventures.' For this fictional woman traveller, brought to life by Edwards, the outer and the inner journeys were inseparable.

Amelia Edwards was one of many women writers who used the motif of travel in their fiction. As in *A Lady's Captivity*, the boundaries between truth and make-believe were often blurred. Aphra Behn's *Oroonoko* can be read as a straightforward account of her

Anna Brownell Jameson (1794–1860)
David Octavius Hill and Robert Adamson, 1843–8
Calotype, 203 x 137mm (8 x 5⅜")
National Portrait Gallery, London (NPG P6(112))

Anna Murphy spent some years as a governess before marrying a lawyer, Robert Jameson, in 1825. The marriage was not a success and he went to Canada to pursue his legal career. She remained in London, where she became one of the first women art historians and critics, and earned her living by writing; she also promoted women's rights. Her husband wanted her to visit him in Canada, so she went reluctantly from 1836 to 1838. Her experiences were extraordinary, and included crossing Lake Huron in a canoe paddled by five Native Americans. Of one Native American woman she met, Jameson wrote in *Winter Studies and Summer Rambles in Canada* (1838): 'She lived alone; she had built a wigwam for herself … she could use a rifle, hunt and provide herself with food and clothing … She lived to a great age, and no one ever interfered with her mode of life, for that would have been contrary to all their ideas of individual freedom.' On Anna's return to Britain, her husband granted her £300 a year. This allowed her to write extensively in comfort for as long as he lived; her friends then supported her until her death.

journey to Surinam or as a novella, or both. It must have been as difficult – and perhaps, as unnecessary – for her contemporaries to distinguish fact from fiction as it is for us now. The early nineteenth-century critic Anna Brownell Jameson played with the ways in which journeys could be created. To make her account of an 1821 European tour working as a governess a little more exciting, she created a fictional heroine – a young and passionate invalid who was travelling to escape some unspecified tragedy. In 1826, *Diary of an Ennuyée* was published anonymously. The publisher's preface claimed the manuscript was found by the side of the author's body after she had died from a broken

Dame Rose Macaulay (1881–1958)
Cecil Beaton, March 1958
Vintage bromide print, 239 x 191mm
(9⅜ x 7½")
National Portrait Gallery, London
(NPG P869(19))

Rose Macaulay read history at Oxford
and began writing novels shortly
afterwards. During the First World
War, she did war work in London. In
the Second World War, she was a
volunteer ambulance driver; her own
flat was bombed. Her novel
The World My Wilderness (1950)
reflected her wartime experiences.
She loved foreign travel and wrote
her first travel book about a
Mediterranean journey. *Pleasure of
Ruins* (1953) took her further, to the
Middle East. The best known of all
her books is a novel set in Turkey,
The Towers of Trebizond (1956). Its
characteristic mix of the eccentric,
the exotic and the esoteric can be
gleaned from its opening sentence:
'"Take my camel, dear," said my Aunt
Dot, as she climbed down from this
animal on her return from High
Mass.' The book won Macaulay
literary prizes and other honours.

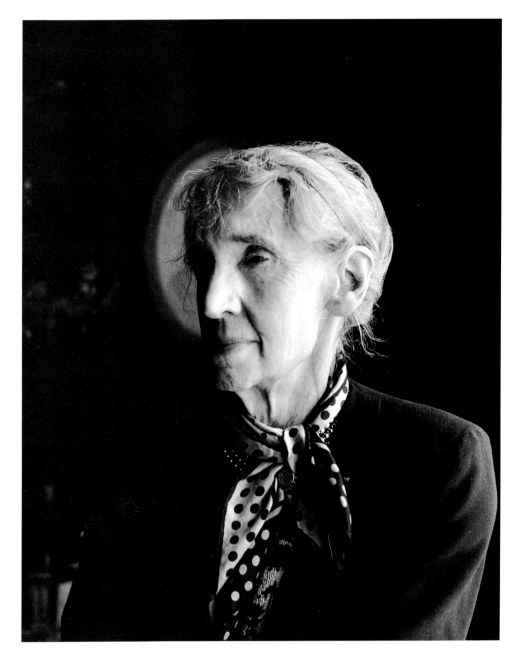

Dame Agatha Christie (1890–1976)
Angus McBean, 1949
Bromide print, 594 x 485mm
(23⅜ x 19⅛ ")
National Portrait Gallery, London
(NPG P294)

Agatha Miller acquired the name under which she wrote on her marriage to Archibald Christie, a young officer, in 1914. She spent the war dispensing medicines. This brought her into contact with refugees from Europe. When searching for a character for a detective story she was writing, she hit upon a Belgian refugee policeman, whom she named Hercule Poirot. Author and detective both shot to fame. In 1926, with her marriage collapsing, Agatha Christie 'disappeared' briefly, triggering sensational newspaper headlines. Her second husband, Max Mallowan (1904–78), was an archaeologist fifteen years her junior whom she met in Iraq at the excavations at Ur. She travelled with him to the sites he was digging, assisting him with photography and conservation (she successfully cleaned the famous Nimrud ivories with her handcream). A range of foreign settings, reflecting the couple's archaeological travels, appears in books such as *Death on the Nile* (1937). One of her most famous novels, *Murder on the Orient Express* (1934), was written while she was staying at the Pera Palas Hotel in Istanbul.

heart. The book was an instant success; it was far better to think a fictional journey real than to suspect a real journey had been fictionalised. Jameson did not acknowledge her authorship, and that the story was a fake, for another eight years.

Since *Diary of an Ennuyée*, other women have used fiction to confuse us. Rose Macaulay wrote the travelogue *The Fabled Shore: From the Pyrenees to Portugal* (1949), which launched the British love affair with Spain. Her novel *The Towers of Trebizond* (1956) has often been taken as a first-hand travel account. While *The Fabled Shore* may illuminate another country, *The Towers of Trebizond*, though set in Turkey, traces another sort of winding path, through the author's loss and discovery of faith.

Material gathered on a journey could be used to give a novel a sense of place. Agatha Christie used her Iraqi experiences in at least two of her mysteries: *Murder in Mesopotamia* (1936) and *They Came to Baghdad* (1951). She even likens her work as an archaeologist to her hero Hercule Poirot's work as a detective. In *Death on the Nile* (1937), Poirot says,

> In the course of excavation, when something comes out of the ground, everything is cleared away very carefully around it. You take away the loose earth, and you scrape here and there with a knife until finally your object is there, all alone, ready to be drawn and photographed with no extraneous matter confusing it. That is what I have been seeking to do – clear away the extraneous matter so that we can see the truth.

But in travel writing, unlike in archaeology, women were not just seeking the truth. They were constructing an enticing traveller's tale.

For some women, the ritual of writing was almost as important as the words on the printed page. In *How to Observe Morals and Manners* (1838), Harriet Martineau gives clear instructions on how to go about collecting and compiling written information. The function of a journal, she said, was 'to reflect the mind of the traveller, and give back to him hereafter the image of what he thought and felt day by day.' She also advises travellers to compose a list of queries. This list should be checked regularly against their diary entries to ensure they had full and ample enough notes on all aspects of the foreign society. Never, she warned, take down this information in full view of your subject.

> The traveller who has the air of taking notes in the midst of conversation, is in danger of bringing away information imperfect as far as it goes, and much

Harriet Martineau (1802–76)
Richard Evans, exhibited 1834
Oil on canvas, 1276 x 1019mm
(50¼ x 40⅛")
National Portrait Gallery, London
(NPG 1085)

Harriet Martineau had a difficult
childhood, dogged by poverty and ill
health. She was well educated, but
while she was still at school her
hearing started to deteriorate.
Undaunted, she set out to earn
money for her desperately poor
family, sending articles, stories and
poems to various magazines. Her
continuing ill health did not stop the
flow of her pen, and some of her
pieces brought financial success. Her
trip to North America in 1834 arose
from her abhorrence of slavery at a
time when abolition provoked
reactions verging on violence. She
travelled around the south unharmed,
but met hostility further north and
had to abandon her visit in 1836. She
wrote *Society in America* (1837) to
describe her experiences, and *How to
Observe Morals and Manners* (1838)
to advise other would-be travellers
about the practicalities and the
benefits of travel. At home she was
ridiculed for her growing interest in
mesmerism (hypnosis). She visited
Egypt and Palestine with friends in
1846–7, again writing a travel book,
Eastern Life, Present and Past
(1848).

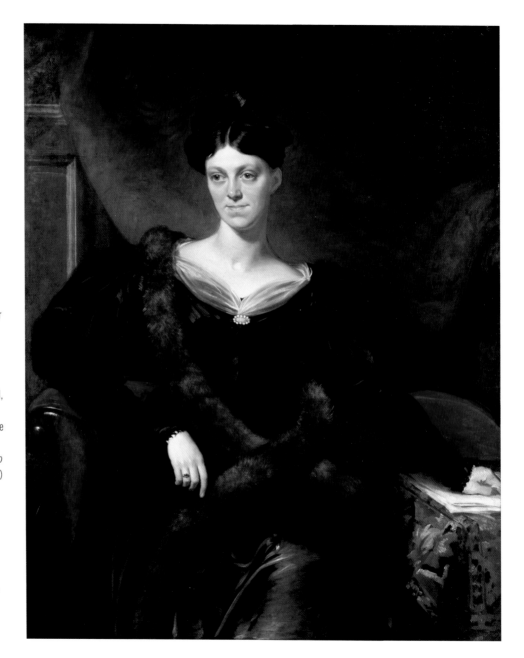

restricted in quantity in comparison with what it would be if he allowed it to be forgotten that he was a foreigner seeking information. If he permits the conversation to flow on naturally, without checking it by the production of the pencil and tablets, he will, even if his memory be not of the best, have more to set down.

Martineau even had strong thoughts on when the journal should be written. Although, she says, it is common to write up notes at night, it may not be the best time, as by then tiredness will have set in. The early morning is optimum for journal-keeping.

Isabella Bird, for whom the ritual of writing was a comfort, did not follow Martineau's advice. In her interview for *Climate* magazine, she described how

> whilst my evening meal is being prepared, I sit in the upright folding chair which I take with me, and which is placed under my special mosquito net. If I am not too tired, I make notes of the day's journey. This I do with a writing board on my knees, the leather case of my camera being employed as a footstool. I have my lamp fixed on to the tripod of my camera, my boots being tied on underneath, and as a rule, I use a photographic lamp, opened so as to give a white light. It is of great importance to have a good light.

Light was also crucial for Constance Gordon Cumming, who not only wrote but also made sketches on her many journeys. As single-minded as she was restless, Constance rose by four every morning to catch the best of the day. She would take her sketchbook and watercolours, swat off the mosquitoes, and set about capturing the new world around her. She was also an assiduous letter-writer, writing home at least once a day, and always precisely placing, as well as dating, her correspondence. Letters to her sister would arrive headed 'Alone in My Wee Boat on the Pei-Ho' or 'From a Tiny Cottage at the Weatherboard in the Blue Mountains, New South Wales', adding, 'You see I have contrived to escape from the reign of fine clothes and prolonged meals!'

Travelling also gave Constance a vocation; having seen a little of the world, she began to write about it professionally. Her first journey into print was an article in *Good Words* magazine. Entitled 'Camp Life in the Himalayas', it was published in 1869 before she returned from her first trip. As soon as her ship had docked, she ceased writing; it was as if there were nothing to report, nothing to see. Her remarkable self-discipline dissolved. Only when Constance set sail again, this time for Ceylon, did her journal and letter-writing resume.

Writing gave lone women travellers a companion in the form of the diary they confided in or of the letters they wrote back to Britain. Most of the women wrote copious letters home – Gertrude Bell to her parents, Isabella Bird to her sister Henrietta, Emily Eden to her sister. Not only were these letters an established literary form for women, and would become the basis for their books, but they were also as good as a conversation with the person they had left behind. Almost every day of her sixty years of travels, Freya Stark wrote no less than ten letters, in addition to working on numerous articles and books. In describing their travels, even if only to family and friends, women were sharing them.

Many of these women's books were illustrated, such as Maria Graham's *Journal of a Residence in Chile, During the Year 1822* (1824), Anna Brownell Jameson's *Visits and Sketches at Home and Abroad* (1834) and Amelia Edwards' *A Thousand Miles up the Nile* (1877). In 1844, the Honourable Emily Eden had her watercolours published in a collection called *Portraits of the People and Princes of India*.

Watercolours were the preferred medium for women; oils – more vibrant, more direct – were for male painters. Marianne North's work in oils broke this convention. Other women travellers recorded aspects of their journeys in even less traditionally female media. The sculptor Clare Sheridan immortalised some of the key people she met on her travels in her portrait sculptures. In Russia in 1920, she sculpted leaders of the revolution to the fury of her cousin Winston Churchill, the War Minister, who raged at her for making him 'look ridiculous when a member of his family flitted off to do portraits of Lenin and Trotsky'. Shortly afterwards, in America, she made a bronze bust of Charlie Chaplin, which he thought made him look like a criminal but she said revealed 'the head of a genius'. During her 1937 visit to Native American reservations in the Rockies, she produced a number of portrait sculptures, including one of Chief Shot-on-Both-Sides, Chief of the Bloods, whom she showed as 'very grave and formal, every inch a Chief'. She moved from modelling to carving, saying that 'clay is too easy, too soft, too pliable, but the hard material fights you, offers opposition' – perhaps a reflection on her attitude to life as well as to sculpture.

In 1879, Marianne North hired a small fashionable gallery in London's Conduit Street for an exhibition of her Indian paintings, organising the extensive publicity herself by printing cards and putting up posters. The exhibition cost her money; only two thirds of her expenses were covered by takings at the door. The further third she had to find herself was worth it, she confided to her diary, for staving off 'fatigue and boredom at home'.

Barbara Bodichon

Barbara Bodichon (1827–91)
'Holmes of New York', 1850s
Ambrotype, 83 x 64mm (3¼ x 2½")
National Portrait Gallery, London (NPG P137)

Barbara Leigh Smith was illegitimate; her radical parents did not marry on principle. From an early age she showed artistic interests, taking lessons from various painters and visiting the artist J.M.W. Turner in his studio. She was passionately concerned about the role of women, particularly their education and their legal position. Her pamphlet *Women and Work* contributed to the passing of the Married Women's Property Act (1857), which gave wives greater financial protection. In the same year, Barbara went on holiday to Algiers, painting watercolours, and met her future husband, Dr Eugène Bodichon (d.1886), a French anthropologist and doctor. They bought a house in Algiers and she divided her year between there and Britain. In London, she had many artistic and literary friends, including Dante Gabriel Rossetti and Mary Ann Evans ('George Eliot'), who based her description of Romola, in her novel of the same name, on her friend. Barbara Bodichon played a major role, with Emily Davies, in founding Girton College, Cambridge, including donating large sums of money. Throughout her life, she continued to paint landscapes, which were frequently exhibited and were admired by critics and artists, such as John Ruskin, Jean Baptiste Corot, with whom she studied, and, more recently, Henry Moore.

The Cactus Grove, near Algiers
Barbara Bodichon, late 1850s
Watercolour and bodycolour, 470 x 345mm (18½ x 13⅝")
Hastings Museum and Art Gallery

This sketch of an Algerian cactus grove with a young goatherd dates from around the time of Barbara Bodichon's marriage, when Algiers began to be her home for half the year. She described in her *Journal* (1859) 'the hills all around the town' covered with 'the queer twisted cactus, chiefly a variety which bears thick prickly leaves, battledoor [*sic*] shaped … All these things are essentially of another phase of nature, of another poetical literature than ours.' This painting was shown in her first exhibition in London in 1859. During her lifetime, her paintings sold well, and it was the proceeds from their sale that allowed her to leave in her will a generous sum to the newly founded Girton College.

In her home town of Hastings, she had met Barbara Bodichon, who had provocatively written 'artist' under occupation on her marriage certificate in 1857. The two women were divided by politics – Bodichon campaigned for women's rights, whereas North said she would be 'bored by the possession of the vote' – but united in their interest in painting abroad. Between journeys with her easel, Marianne North would work on her paintings, filling in the colours where there had been only outlines. In early 1880, she was completing two pictures of the Indian subcontinent, hoping they might be hung at the Royal Academy, when she wrote to Madame Bodichon, 'It is such a delight painting these things, I feel as if I was there all the time, breathing the warm air and talking to the funny people and children. I believe the very idea of it helps to keep the cold out.'

North's Indian sketches drew favourable reviews, encouraging her to lay greater plans for self-promotion. She wrote to Joseph Hooker, the Director of the Botanic Gardens at Kew, asking if she could build a gallery for her flower paintings and offering £2,000 towards the cost. Even such a generous offer was regarded with caution by Kew's Board of Trustees, and they prevaricated at length before eventually agreeing to the scheme. Meanwhile, Marianne North, characteristically impatient with all the delays, left on another journey, this time to Borneo, Australia and New Zealand.

On her return, with little support from Kew, she set about arranging the gallery herself, hanging the 800 paintings by geographical area. If a canvas didn't fit, she cut it down to size. She chose to display only her oils, which were particularly vibrant as she never mixed her paints. She chose to concentrate on her botanical work, leaving out most of her landscapes and street scenes. In this way, she could present herself as skilled at botanical collection. A catalogue drawn up to accompany the exhibition drew attention to the remarkable nature and scope of her finds.

As with the women anthropologists, although Marianne North enjoyed portraying other places and peoples, she did not enjoy being portrayed. When she visited Julia Margaret Cameron at her husband's plantation in Ceylon in 1876, she was a reluctant photographer's subject:

> She dressed me up in flowing draperies of cashmere wool, let down my hair, and made me stand with spiky cocoa-nut branches running into my head, the noonday sun's rays between the leaves as the slight breeze moved them, and told me to look perfectly natural (with a thermometer standing at 96°!). Then she tried me with a background of breadfruit leaves and fruit, nailed flat against a window shutter, and told *them* to look natural, but both failed.

Julia Margaret Cameron

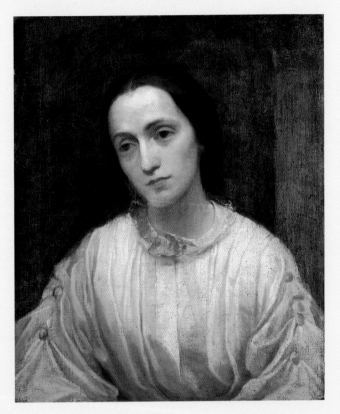

Julia Margaret Cameron (1815–79)
George Frederic Watts, 1850–2
Oil on canvas, 610 x 508mm (24 x 20")
National Portrait Gallery, London (NPG 5046)

Julia Margaret Cameron was born in Calcutta, where her father was a civil servant, but she was educated in Europe. In 1838, she married a lawyer, Charles Cameron (1795–1880), in India. On her husband's retirement in 1848, they moved to Britain, first living in London and then settling at Freshwater on the Isle of Wight. She had a wide circle of friends, including the poet Alfred, Lord Tennyson, the historian Thomas Carlyle and the astronomer Sir John Herschel. In 1863, she was given a camera and within a year was presenting her friends with albums of her photographs. She soon became famous. At the height of her fame she gave up her very successful photographic practice and left Britain for the sake of her elderly husband's health in 1875. They went to live in Ceylon (now Sri Lanka), where they had coffee plantations; she remained there until her death. She still took photographs, using the people working on the plantations as her models, but only a handful of these pictures survive. While in Ceylon, one European visitor was the inveterate traveller and painter of flowers and landscapes in oils, Marianne North. Marianne painted the Camerons' estate and sat to Mrs Cameron for her photograph several times.

Young Woman, Ceylon
Julia Margaret Cameron, 1875–9
Albumen print, 251 x 197mm (9⅞ x 7¾")
National Museum of Photography, Film and Television, Bradford

This image displays the soulful – almost religious – air that infuses many of Julia Margaret Cameron's photographs of women. This unknown young female plantation worker, with lowered eyes, resembles classic paintings of the Virgin Mary. Mrs Cameron enjoyed posing her subjects as biblical or mythological characters. To take her photographs, she used very long exposure times, which required her models to stay completely still. This woman was clearly a good model, as she appears in several other photographs by Cameron.

Marianne North

Marianne North (1830–90)
Julia Margaret Cameron, January 1877
Gelatin silver print, 475 x 350mm (18¾ x 13¾")
The Royal Botanic Gardens, Kew

Marianne North, with her lace head covering, open book and far-away expression, recalls the image of a faithful widow or a female saint. She was unhappy with all Julia Margaret Cameron's photographs of her, finding posing uncomfortable in the heat and the resulting images 'unflattering'. In reality, North was far from peaceful or static; her life was driven by travel to the point that she fell ill if she was not on the move. Having first travelled with her widowed father, after his death she took up a peripatetic life, painting the flowers of the many countries she visited. Wherever she went, she stayed with people in the British community, as she did when she visited the Camerons in Kalutara, Ceylon, in 1876–7. She wrote in her autobiography, published posthumously in 1892, 'I had long known her glorious photographs, but had never met her. She had sent me many warm invitations to come …' In the course of her travels, North crossed every continent and had four new species of plant named after her. Despite this, she opposed women's rights, saying, 'I should be terribly bored by the possession of the vote' and 'how ugly all strong-minded females … were.'

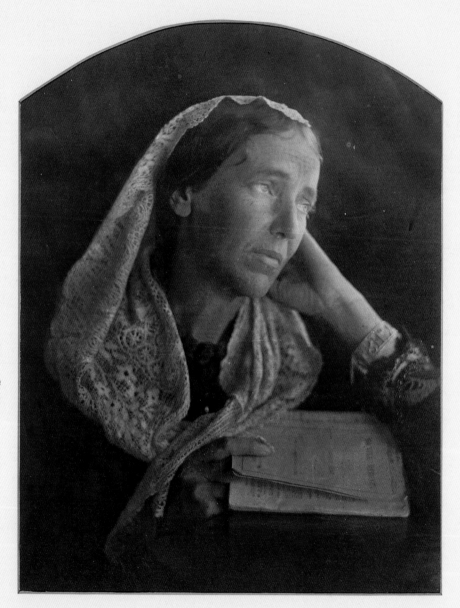

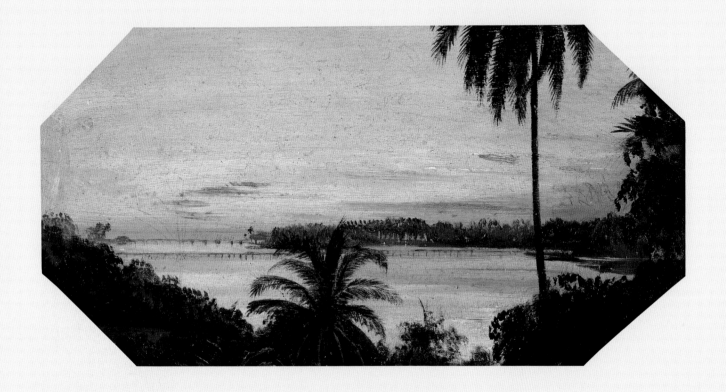

View from Kalutara, Ceylon
Marianne North, January 1877
Oil on paperboard, 430 x 890mm
(16⅞ x 35")
Library & Archives,
Royal Botanic Gardens, Kew

Marianne North painted this picture while staying with the Camerons at Kalutara. She described Julia Margaret Cameron in her autobiography: 'The walls of the rooms were covered with magnificent photographs, others were tumbling about the tables, chairs and floors … The lady herself with a lace veil on her head and flowing draperies. Her oddities were most refreshing … ' She also described the idyllic setting: 'Their house stood on a small hill, jutting out into the great river which ran into the sea a quarter of a mile below the house. It was surrounded by cocoa-nuts, casuarinas, mangoes and breadfruit trees.' In her travels around the world, North created hundreds of paintings recording the flora and the landscapes she visited. These she presented to the Royal Botanic Gardens, Kew; she also paid for a gallery in which to display them. They can be seen there today, covering all the walls from floor to ceiling.

Not surprisingly, Marianne felt 'it was all in vain ... she wasted twelve plates, and an enormous amount of trouble ... she could only get a perfectly uninteresting and common-place person.' Although Marianne North disliked the images of herself because they 'refused to flatter', some of Cameron's Ceylonese sitters proved to be far more compliant models. Cameron produced a number of beautiful portraits of estate workers on her husband's coffee plantations.

The development of photography, in particular the discovery of coating glass plates with a chemical compound called collodion to create permanent negatives, opened up the whole process to amateurs, including women. For twentieth-century travellers, the camera was a standard tool, though in the hands of Freya Stark the resulting images were anything but standard, fully justifying the claim of photography to be a major art form. Fortunately, in its early decades, photography neither came with the historical baggage of 'high art' nor attracted the purely masculine label of a 'science'. There was therefore less inbuilt social prejudice against women taking it up and several women travellers – such as Isabella Bird and Gertrude Bell – became enthusiastic photographers.

The photographs that Julia Margaret Cameron took in Britain gave her lasting fame; she has recently been described as 'the most inventive and imaginative British photo-grapher' of her time. (In contrast, her Ceylonese work has been little appreciated until very recently.) Constance Gordon Cumming admired Marianne North's energy and dedication to building her own legacy, and hoped to imitate her. The two painters first met in the gallery at Kew; in her diary, Marianne North remembered Constance Gordon Cumming as 'a thorough lady: genial and warm-hearted, but so strong and resolute that it might be quite possible she had walked certain limp Anglo-Indians to death before now.' Constance Gordon Cumming was not so impressed with Marianne North. 'She always gave me the impression of being an exceedingly sad woman,' she later wrote in her autobiography.

Gordon Cumming did, however, envy North's gallery, and longed to make a permanent exhibition of her own work, but without North's personal income she was unable to do so. Instead, she made temporary loans of her paintings to different exhibitions, such as the Colonial and Indian Exhibition in London in 1886; 'all this involved a good deal of trouble, especially in re-arranging catalogues, and no advantage whatever,' she complained. Frustrated and with little hope of being able to construct a fitting monument for her work, she decided to donate 250 of her best paintings to her eldest nephew to hang in the family home. The remainder were to be distributed among scattered relations.

Constance Gordon Cumming's concerns were well founded; today, she is far less remembered than her contemporary Marianne North because there is no permanent reminder of her life's work.

Through their enduring words and pictures, we are continually reminded that women have always travelled.

Homecoming

I did not know you were back. I congratulate you on your escape. One heard very unpleasant rumours about what had happened to you somewhere or another.

Secretary of the Royal Geographical Society writing to **Gertrude Bell**, 13 June 1914

That's the trouble with wandering, it has no end.

Gertrude Bell, in her diary to Major Charles Doughty-Wylie, 1914

'Always something new from Africa!' bleated one newspaper, as Mary Kingsley stepped from the African Steam Navigation Company's *Bakana* on 30 November 1893. 'The latest African novelty is seen in the return of an English lady from most surprising and courageous adventures ...'

Ever since Aphra Behn voyaged out to Surinam in the mid-seventeenth century, commentators have heralded the woman traveller as a recent and rather odd phenomenon. In her 1845 *Quarterly Review* essay, Elizabeth Rigby trumpeted the 'early-rising, sketch-loving, light-footed, trim-waisted, straw-hatted specimen of women' that England was now exporting all over the world. Forty years later, this specimen was still rare enough that when Marianne North, Constance Gordon Cumming and Isabella Bird were gathered together in one room it was considered a sensation.

In the summer of 1881, a society hostess had sent out cards 'to meet Mrs Bishop née Bird'. Marianne North wrote how she had found the attraction, 'seated in the back drawing-room in a big arm-chair, with gold-embroidered slippers, and a footstool to show them on, a

The *Sunbeam*
Front cover of *A Voyage in the Sunbeam* by Annie, Lady Brassey, 1878 (detail)

petticoat all over gold and silver Japanese embroidered wheels, and a ribbon and order across her shoulders, given her by the King of the Sandwich Islands ... I was taken up to her the moment I came in.' The hostess grabbed Miss North and Miss Gordon Cumming and, joining their hands with Miss Bird's, exclaimed, 'Three globe trotteresses all at once!' Marianne and Constance, at least, were appalled. 'It was too much for the two big ones,' wrote Marianne in her diary, 'and we retired as fast as we could leaving Miss Bird unruffled and equal to the occasion.'

About the same time as this awkward encounter, a commentator noted: 'A female traveller has ceased to be a rara avis; delicately-nurtured women now climb Mont Blanc or penetrate into the Norwegian forests, or cross the Pacific, or traverse sandy deserts, or visit remote isles, in company with their husbands and brothers, or "unprotected".' In 1907, the *Times Literary Supplement* laid the blame for this trend on one particular late Victorian traveller who liked to wear gold slippers. 'Since Isabella Bird first crossed the Rockies the age of the Lady Adventurer has set in. Girls in the Carpathians were succeeded by wives in Arabia and spinsters in West Africa and Morocco ... ' (The author would have meant Ménie Muriel Dowie, who toured Central Europe in 1890 dressed as a boy, and wrote up her experiences in *A Girl in the Karpathians* [1891]. The spinsters would have been Mary Kingsley in West Africa and Isabella Bird – again, and with some journalistic licence – who had made her last journey, aged seventy, by horse through Morocco in 1901.) Five years later, the same publication was still claiming that women adventurers were something new. 'Until comparatively recently women took part in the exploration of Africa only when they happened to be the wives or daughters of men who had devoted themselves to that fascinating but dangerous pastime,' it commented. The reason this was no longer the case was because it was now so much easier to travel, and so much less was expected of the traveller.

> Within the past few years the safety of travel in the interior of Africa has so enormously increased that feats are now possible to a determined woman which a generation ago would have entailed certain and speedy destruction. Miss Kingsley, Mrs Sheldon and many successors have shown this; though it cannot be said that any piece of actual exploration of the first importance has yet been accomplished by a woman.

(American May French-Sheldon [1848–1936] had travelled through East Africa with an enormous retinue and in very grand style in 1891, publishing *Sultan to Sultan* the

following year.) Women adventurers had arrived, but they had still to have their achievements recognised.

For women who did not draw their own route, the death of a companion could bring a halt to their journeys. After Sir Richard Burton died in 1890, Lady Isabel Burton devoted herself to preserving and restoring his memory, and with it the memory of their itinerant life together. She strove to keep all his works in print, and began to edit a collection of his letters. At New Year 1894, she wrote to Sir Harry Johnston, a prominent colonial official in Africa, 'Thank you one thousand times for calling the Nyassa boat "Richard Burton" ... I know you will be glad to hear that the life book [her own *Life of Sir Richard Burton*, published the previous autumn] has had an immense success. It has had three leaders, over one thousand reviews, of which only about one hundred have been spiteful, and an immense number of beautiful and sympathetic letters, and an immense sale.' The devoted widow could not resist pointing to her own achievements: 'The review I liked best, which was fifteen columns of the "Sunday Sun" said "Richard Burton's widow may console herself, we now know the man inside and out. She has lifted any possible cloud from his memory, and his fame will shine as a clear beacon in all future ages."' His companion till death, she moved to 'the meekest of cottages, close by Dick's grave', in Mortlake, south London, and called it 'Our Cottage'.

For some, Britain would never be home again. For Annie Brassey, the comforts of her luxury yacht proved no protection against the fatal mosquito bite that led to her death from malaria in 1887. Seven years after her arrival in Egypt, Lucie, Lady Duff Gordon, aged forty-eight, succumbed to the tuberculosis that had driven her there and was buried in the English cemetery in Cairo. Frances Trollope died in Florence, her adopted home, a fêted 83-year-old lady. Early one warm morning in July 1926, Gertrude Bell, her role in the new Iraq unclear, took an overdose of the sleeping pills she had been using to help calm her agitated mind. The High Commissioner said, 'At last her body, always frail, was broken by the energy of her soul. Her bones rest where she had wished them to rest, in the soil of Iraq.'

After her friend Amelia Earhart disappeared while flying over the Pacific Ocean in 1937, Amy Johnson's passion for taking to the air cooled, but during the Second World War she made more flights delivering military aircraft. On 5 January 1941, she took off from Blackpool aerodrome heading for an airbase in Oxfordshire. Four hours later, she was spotted hopelessly off course, parachuting out of her plane. Rescuers failed to haul her from the cold water in time, and her body was never recovered. She had once told a

Annie, Lady Brassey

Annie, Lady Brassey (1839–87)
Bassano, 1883
Modern print from an original half-plate negative
National Portrait Gallery, London (NPG x96220)

A hugely popular Victorian author, Annie Brassey (née Allnutt) travelled in comfort with her husband, Thomas, aboard their luxury yacht (see pp.118–19). Their wealth came from his father, who had built railways. The couple's journey around the world in 1876–7 resulted in Annie's book, *A Voyage in the Sunbeam: Our Home on the Ocean for Eleven Months* (1878), which ran through many English editions and was translated into at least five other languages. When in Britain, the Brasseys lived with their five children near Hastings, where Thomas was an MP and Annie did good works, particularly for the St John Ambulance Association. On her travels, she made a large collection of ethnographic and natural history objects. These were originally shown in a museum at her husband's London house, but they were moved to Hastings Museum in 1919. In 1886, she went abroad for her health on her final voyage. She died of malaria and was buried at sea.

Tatanua Helmet Mask from New Ireland, Papua New Guinea
Collected by Annie Brassey between 1876 and 1883
Wood and painted bark with abalone shell eyes
Hastings Museum and Art Gallery

This was among the items collected by Annie Brassey in the Pacific. She simply described such masks as 'old war masks'. In fact, they play an important part in the complex culture of New Ireland funeral rites. The crest along the top is made of bark fibre, representing a local hairstyle for men, with heads shaven apart from a ridge of hair. These masks are linked with the ancestors and represent the most important of a man's three souls – one that resides in the head. Wearing their masks on the top of their heads, young men, who have to be strong to ward off sorcery, dance in pairs or lines. The different designs on each side of the mask have the effect that, when the line turns, new imagery is presented to the watchers. While wearing the mask, the young man must remain totally silent or risk death for himself or a family member. If the ritual dance is correctly performed, however, the community will have pleased the ancestral spirits and will remain vigorous and successful in the future.

Lei Niho Palaoa ('Necklace of the Tooth of the Sperm Whale') from Hawaii
Collected by Annie Brassey between 1876 and 1883
Human hair with marine ivory carving, possibly made *c.*1810
Hastings Museum and Art Gallery

In Hawaii, Annie Brassey saw similar 'most interesting though rather horrible necklaces' in the museum in Honolulu. She recorded in *A Voyage in the Sunbeam* that they were 'made from braids of human hair cut from the heads of victims slain by the chiefs themselves; these braids were suspended from a monstrous hook carved from a large whale's tooth, called a Paloola [*sic*], regarded by the natives as a sort of idol.' For Hawaiians, hair embodied the essence, or 'mana', of a man. During the nineteenth century, walrus ivory, acquired by trading with Europeans, replaced sperm whale ivory, although the name of these necklaces remained the same. Annie Brassey believed that the hair in this particular lei niho palaoa was cut from the heads of enemies killed in battle by King Kamehameha I (reigned 1810–20), founder of the Hawaiian kingdom and a great Hawaiian hero, but she may have been taken in by an unscrupulous sales pitch.

Amy Johnson (1903–41)

John Capstack, *c*.1933–5

Toned bromide print, 200 x 146mm

(7⅞ x 5¾")

National Portrait Gallery, London

(NPG x17127)

For Amy Johnson, it was the distance, the speed and the means of travel that excited her rather than the places where she landed her plane. She grew up in Hull and, after her degree at Sheffield University, went to London as a secretary. She began flying at the London Aeroplane Club in Edgware. When she set out on her first great journey in 1930, the furthest she had flown was across Britain. In a light aircraft, she reached Karachi in six days, beating the world record for the distance. She then went on to Darwin, Australia, but wrecked her plane in Brisbane. The pilot who flew her back to Sydney, James Mollison, became her husband, but they parted some years later. Huge publicity followed her successful flight. Although dressed for flying, her make-up in this photograph emphasises her glamour. She made further long-distance solo flights to Japan and to Cape Town, breaking more records, and in 1939, on the outbreak of the Second World War, she joined the Air Transport Auxiliary. She failed to return from a flight in early January 1941.

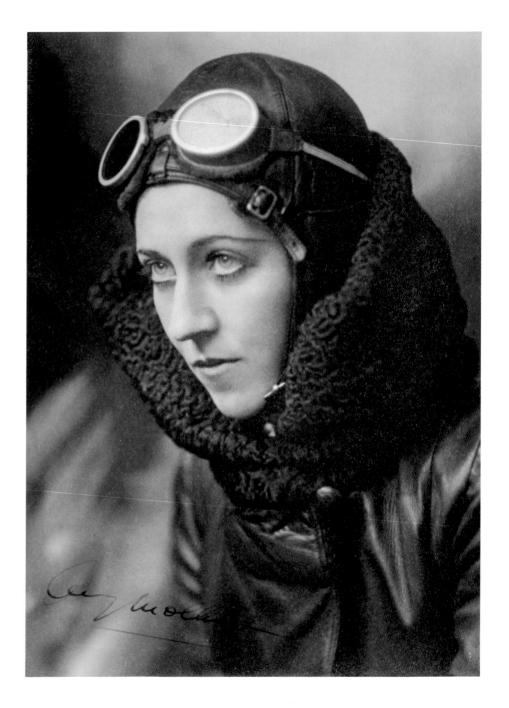

friend, 'I know where I shall finish up – in the drink. A few headlines in the newspapers and then they forget you.'

From Aphra Behn to the present, the women travellers have not been forgotten. Lady Mary Wortley Montagu's letters from Turkey, written almost three centuries ago, are still in print. Sometimes the people among whom the women travellers wandered recall them far better than those at home. Gertrude Bell's friend Janet Courtney remembered how, at her death, 'in the House of Commons tribute was paid to a great public servant. Some people were puzzled. They had known so little about her. She never advertised herself, she appeared so seldom on platforms.' But in present-day Iraq, faint memories of Miss Bell's tea parties linger. 'Her name will come up to evoke, for a moment, an innocent Baghdad of picnics in the palm gardens and bathing parties in the Tigris,' wrote James Buchan, a Middle East commentator, recently.

On the last day of October, 1718, Lady Mary Wortley Montagu returned to England, as so many had left, in a storm. She had had to abandon the packet-boat for a small fishing vessel that had come to her rescue. She hoped that in the squall all images of the East had been washed from her mind. She longed to be happy at home, and for the restlessness to cease. 'I think the honest English squire more happy who verily believes the Greek wines less delicious than March beer, that the African fruits have not so fine a flavour as golden pippins; that the becafiguas of Italy are not so well tasted as a rump of beef; and that, in short, there is no perfect enjoyment of this life out of Old England,' she wrote in Dover. 'I pray God I may think so for the rest of my life, and since I must be contented with our scanty allowance of daylight, that I may forget the enlivening sun of Constantinople.'

Miss Benham did not survive her last voyage. On 26 February 1938, when she was about seventy years old, she perished at sea. In old age she had told a journalist, 'I have no home in the sense that is generally understood and so there is nothing to prevent me enjoying to the uttermost the spirit of wanderlust that has entered my soul. I am never lonely. How can I be when there is so much to see and admire in the world?' This must have surprised Selwyn Grier, whom she had met while crossing Africa in 1912. He had written to his mother from his colonial outpost that Miss Benham travelled through 'sheer loneliness'. But then, as Grier had also noted, nothing is as expected with the women travellers.

We are in for yet more surprises.

Mrs. RICKS, The Queen's Liberian Visitor.

ELLIOTT & FRY Copyright. 55, BAKER STREET. W.
AND AT 7, GLOUCESTER TERRACE. S.W.

Martha Ricks (1816–1901)
Elliott & Fry, 18 July 1892
Albumen cabinet card, 148 x 104mm
(5⅞ x 4⅛")
National Portrait Gallery, London
(NPG x38887)

Epilogue Women Travellers to Britain

Caroline Bressey

Women have travelled to Britain from all over the world for centuries. Their reasons for doing so were as diverse as those of the women who left the safe harbours of Britain – for education, to travel and see new parts of the world, for love, politics and work. Among the women who came to Britain, there were some who were forced to travel, as slaves and domestic servants. These women, who would perhaps have settled among the working-class in Britain, are not often seen in the portraits that are held in national collections. However, several women in the National Portrait Gallery's collections had their lives shaped by slavery, while almost all of those illustrated here were affected by the experience of colonialism. Most of the women whose images we see became famous enough for someone to wish to record their presence, or were wealthy enough to pay someone to ensure that their image was captured.

For some nineteenth-century women, Queen Victoria was the magnet that drew them to Britain. An audience with the Queen was the highlight of quite a few foreign women's visits. Martha Ricks travelled from Monrovia, Liberia, to visit England in 1892. During her trip she met Queen Victoria, who presented her with a signed photograph. She also visited the Mansion House, and *The Times* reported in October 1892 that the Lady Mayoress had received a shawl or quilt 'of native workmanship' from Martha as a souvenir of her visit.

Often, visiting women had their images recorded by the popular studio photographers of the day as personal souvenirs of their stay in Britain. The Princess of Berar came to London in 1931, the year of her marriage, with her father, the deposed last Sultan of Turkey, and her husband, an Indian prince rumoured to be the richest man in the world. The three of them sat to the society photographer Vandyk in his London studio. The archives of several such photographers are now in the National Portrait Gallery's collections and provide superb images of these women during their visits to Britain.

As opportunities for work and further education opened up for women in the nineteenth and twentieth centuries, they travelled to Britain to join educational institutions and to fill political posts themselves. Others, such as Begum Zubeida Habib Rahimtoola (née Chinoy), accompanied their husbands to Britain when they took up political posts. Begum Zubeida was married to Habib Ibrahim Rahimtoola, the first

Princess Dur-i-Shahvar, Princess of
Berar (b.1914), with her father, Caliph
Abdulmecid Khan II of Turkey
(1868–1944), and her husband, Nawab
Azam Jah, Prince of Berar (1907–70)
Vandyk, 19 November 1931
Modern print from an original
10 x 12" transparency
National Portrait Gallery, London
(NPG x129483)

Begum Zubeida Habib Rahimtoola
Bassano, 1948
Vintage print, 206 x 156mm
(8⅛ x 6⅛")
National Portrait Gallery, London
(NPG x84516)

High Commissioner for Pakistan in the United Kingdom following independence in 1947. In 1952, they left Britain when he became the Pakistani Ambassador to France. The most wealthy and cosmopolitan of these women grew up travelling the world. For others, however, their visits to Britain were as much voyages into the unknown as for British women travelling to distant places. Both equally deserve to be called travellers. The biographies of women travellers to Britain are less well known than those of British women travellers, but are just as fascinating.

Pocahontas

Pocahontas (1595/6–1617)
After Simon De Passe, published 1793
Line engraving, 172 x 146mm (6¾ x 5¾")
National Portrait Gallery, London (NPG D5536)

Pocahontas was the daughter of Powhattan, king of about forty Algonquin Indian villages that were located around the shores of the rivers now called the James and the York, which flow into Chesapeake Bay. Among the colonists who settled at Jamestown, Virginia, in 1607 was Captain John Smith (1580–1631), who explored the Indians' country. During his expedition, he was captured and taken to Powhattan's main camp, about eighteen miles from Jamestown. According to the account that he sent to England a few months later, Smith succeeded in convincing his captors of the friendliness of the new arrivals, and was sent back to Jamestown with an Indian escort.

In 1616, Captain Smith wrote to Queen Anne (1574–1619), wife of James I, describing his meeting with Pocahontas. According to his letter, after Smith had been taken prisoner, King Powhattan and his chiefs decided upon Smith's execution. Smith was about to be killed when Pocahontas placed herself between him and his executioners, and, as a result, Powhattan ordered his life to be spared. After this, Pocahontas was a frequent visitor to Jamestown until Smith returned to England in October 1609.

In the spring of 1612, Captain Samuel Argall, another colonist, was trading along the Potomac River, and learned that Pocahontas was staying with the chief of the district. With the help of the chief's brother, Pocahontas was lured on to Argall's ship, where she found herself held hostage. She was kept a prisoner for two years, and was used to manipulate the conduct of the Indians. She was then taken to Jamestown, where she converted to Christianity and was christened Rebecca.

Pocahontas visited England with her husband, the colonist John Rolfe (1585–1622), and their child in 1616. She was the subject of much curiosity, and was presented at the court of King James. Arrangements were being made for her journey back to America when she became unwell. She died at Gravesend in March 1617; her burial is recorded in the parish register of St George's Church, Gravesend.

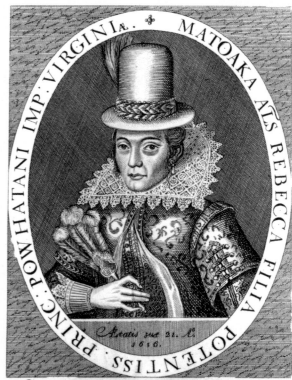

Florence Mills

Known as the 'Queen of Happiness', the American star Florence Mills, whose parents John and Nellie Winfrey had been born into slavery, became one of the most successful entertainers of the 1920s. Appearing on stage as a child, by the age of fourteen she was performing in a song and dance act with her sisters, known as the Mills Sisters, and from then on Florence Mills became the name she used.

In 1922, Mills and a variety of black performers were brought together to form *The Plantation Revue*, which performed on Broadway. Following their success, it was announced that the show was to transfer to London's West End. The news that an all-black cast was going to be performing in London outraged the entertainment unions in Britain, and a letter was sent to the London County Council protesting against the 'importation of coloured aliens' and declaring that there was 'no demand for an all coloured performance' (*The Times*, 17 March 1923). Mills did perform, but the show was called *Dover Street to Dixie*. It had an all-British cast in the first half, with Mills and *The Plantation Revue* cast in a variation of their Broadway show in the second half. Mills returned to Britain in 1926 with *Blackbirds*. A huge success in Paris and Ostend, the show opened at the London Pavilion in September. *Blackbirds* mania gripped the city, with *Blackbirds* parties being held; high society entertained the performers.

Mills retained an awareness of the social problems of life in London. She visited children's hospitals, distributed money to the homeless, and spoke out on racial issues – promoting the work of the American organisation the National Association for the Advancement of Colored People (NAACP).

In April 1927, *Blackbirds* reached its two hundred and fiftieth performance at the London Pavilion. In August, the revue toured the United Kingdom. After performing in Liverpool, the strain of having performed two shows a day, plus matinees and charity performances, took its toll. Exhausted and ill, Mills travelled to Germany to rest, but her condition did not improve, so she returned to America. In October 1927, she entered hospital for treatment of an appendicitis-related illness. She died on 1 November. Over 5,000 mourners attended her funeral in Harlem, New York, and over 150,000 people crowded the streets in tribute. Her memory lived on in Britain through the opening of the Florence Mills, a London nightclub that became a haunt of the city's black intellectuals.

Florence Mills (1895–1927)
In *Dover Street to Dixie* at the London Pavilion
Bassano, 1 August 1923
Vintage print, 202 x 154mm (8 x 6⅛")
National Portrait Gallery, London (NPG x85305)

Florence, Lady Baker

Florence, Lady Baker (before 1845–1916)
Unknown photographer, *c*.1870s
Albumen print, 200 x 155mm (7⅞ x 6⅛")
National Portrait Gallery, London (NPG Ax27707)

Florence, Lady Baker was born Barbara Maria Szász, in
Transylvania. Her Eastern European parents were both killed when
she was about seven. She was apparently about to be sold in an
Ottoman slave market in Viddin (Bulgaria) in 1859 when an English
widower, Samuel Baker (1821–93), aged thirty-eight, paid for her
and rescued her. Together they travelled to Africa in 1861, search-
ing for the source of the River Nile and shooting big game. They
endured many hardships, including deserts, malarial swamps,
mutinies, hostile attacks and sunstroke. As Sam proudly said, 'Mrs
Baker is not a screamer.' The explorers John Hanning Speke
(1827–64) and James Grant (1827–92) had already found the
Nile's principal source, naming it Lake Victoria. In 1864 the
Bakers reached Luta N'zigé, the secondary source of the Nile,
which they called Lake Albert after Queen Victoria's recently
deceased husband.

 In 1865, they made a journey to Britain. This was of great
significance, as it enabled the couple to marry and introduced
Florence to her stepchildren. They greeted her warmly and became
very fond of her. Queen Victoria would never accept Florence at
court because she had lived with Sam before their marriage, but
he was granted a knighthood. Their second African journey, from
1869 to 1873, was to report on the slave trade along the Nile.
Florence's diary reveals the oddness of her life, ranging from
descriptions of eating hippopotamus, helped along by champagne,
to requests for stays and handkerchiefs to be sent out by her
stepchildren: 'We are getting very short of handkerchiefs – in fact
we are getting short of everything' (quoted in *Morning Star:
Florence Baker's Diary*, 1972). They made further journeys abroad,
including to India and Japan, but not again to Africa. Returning to
Britain, Florence outlived Sam by twenty-three years, and was
cared for by her stepchildren.

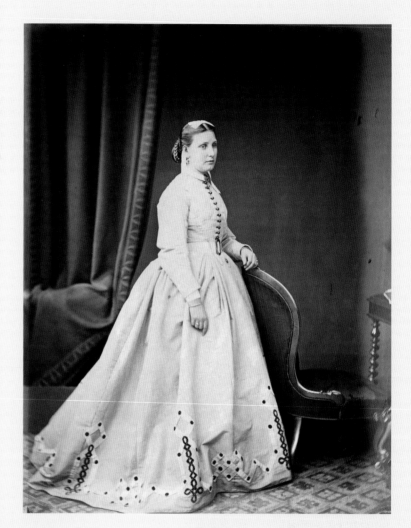

The Maharani of Baroda

The Maharani often travelled to Europe with her husband, Sir Sayaji Rao III, the Maharaja of Baroda (1863–1939). She had been brought up in strict purdah and initially would not eat meals with Europeans (her own Indian cook always accompanied her). When, in 1894, she visited Queen Victoria at Windsor, the crowds lining the streets were all women. The only men present were those essential for running the railway. However, she later became one of the most Europeanised of Indian maharanis. Rosita Forbes praised her for doing 'much to abolish purdah', and for encouraging 'the education of women in every possible way'. The Maharani also visited the United States and Japan.

During her many trips, she was struck by the differences between the position of women in Western and Indian public life. In June 1911, she attended a mass meeting organised by the suffragettes in London. She put her thoughts into a book, which she wrote in collaboration with S.M. Mitra, a well-known and distinguished Hindu writer, who had lived in England for several years. The book, which the *Saturday Review* felt could have done with a little less of Mitra, and a little more of the Maharani, was entitled *The Position of Women in Indian Life* (1911). In the preface, the Maharani asked if Indian women should continue to be isolated from all public affairs and, if not, what was the remedy and how would it be applied? The *Saturday Review* wondered whether the Maharani's vision could ever be realised until the majority of Indian women were sufficiently educated to read and understand it. Moreover, the reviewer questioned whether Indian women would, in the end, be happier and better off. The Maharani herself was well aware that the transplantation of ideas from the West to the East had not always been successful, and that certain questions, particularly those concerning employment, were totally different in Britain and India. Yet she hoped the book, which examined the experiences of women in France, Germany, America and Japan, as well as Britain, would benefit those working to improve the lives of Indian women. She advocated cooperation between men and women, for she saw the characteristic features of both sexes were deeply rooted and that any effort to coerce them would probably mean not evolution but revolution.

Chimanabai Maharani II of Baroda (1872–194?)
Vandyk, 24 October 1911
Modern print from an original 10 x 12" negative
National Portrait Gallery, London (NPG x129478)

Sarah Davies

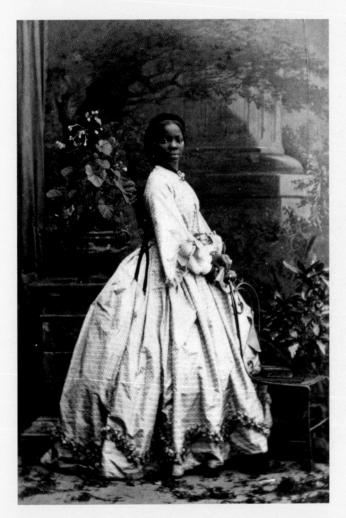

Sarah Davies (d.1880)
Camille Silvy, 15 September 1862
Albumen carte-de-visite sized print, 83 x 56mm (3¼ x 2¼")
National Portrait Gallery, London
(NPG Ax61380)

The story of how Sarah Davies, a young black orphan from Africa, came to England was initiated by Captain Frederick Forbes. Forbes, of HMS *Bonetta*, visited King Gezo of Dahomey in Africa in 1849, in an attempt to persuade him to give up his part in the slave trade. Gezo refused, but gave Forbes some presents as an act of conciliation, among them a young captive girl. Convinced that because of the nature of his mission the government would consider the child the property of the Crown, Forbes accepted the girl, and named her Sarah. On their return to England, Queen Victoria agreed to take financial responsibility for Sarah, and became her godmother. Sarah was an intelligent child, who learned to speak English quickly, and had a wonderful talent for music.

Sarah returned to Africa to be educated at the Church Missionary Society school in Sierra Leone. It is not clear when she came back to England, but she lived for some years in Brighton, and it is thought to be here that she met her husband, James Davies, a merchant from Sierra Leone. Their lavish wedding took place in August 1862 at St Nicholas's Church, Brighton. Despite being held on a wet Thursday afternoon, the ceremony drew large crowds, swelled by those who had come down from London. This photograph of Sarah is among those of the couple taken after their wedding, probably while they honeymooned in London, before their return to Africa, where they settled in Lagos. Sarah became a well-known, popular and important member of Lagos society. An intellectual woman, she was always active, lively and buoyant, full of energy and purpose.

Sarah returned to England on a number of occasions, and in 1867 she visited the Queen with her eldest daughter, Victoria. In 1875, Sarah was in England with her children at a time of severe financial stress. Her husband's business was failing, and eventually he would face bankruptcy hearings in courts in London and Lagos. The case brought against him by Manchester merchants would drag on for over four years. The proceedings seriously affected Sarah's health. In mid 1880, she left Lagos and travelled to Madeira, hoping that the change would help, but on 15 August 1880, she died, not long before her husband was cleared of fraud. An obituary lamented the loss of one of Africa's 'brightest ornaments'.

Cornelia Sorabji

Born in Nasik, India, Cornelia Sorabji came from a reformist Parsi Christian family – her parents were active in educational and social work in Poona and she was deeply influenced by them. Cornelia was always encouraged to share her family's interest in social justice, and this formed the basis for her future vocation. She vowed to fight for the social rights of Indian women through the legal battles of wives, widows and orphans.

The first woman to be admitted to Deccan College, Poona, Cornelia Sorabji gained a First in her degree. In 1889, she became a member of Somerville Hall, Oxford. Originally, she intended to study medicine but by 1890, she had switched to law. She became the first woman ever to read law at a British university. She was given special permission to sit the Bachelor of Civil Law (BCL) examination, which she took in 1892. It was initially proposed that she sit the exam alone, because the examiner refused to examine a woman. She put up great opposition to this obvious display of discrimination. She passed, and continued to read law at a firm in Lincoln's Inn, as her gender prevented her from practising. Sorabji enjoyed life in London, and took great pleasure from visiting the House of Commons and often lunched and dined at the Speaker's House during what she described as 'the thrilling days of the Irish Home Rule Controversy'. She was also presented to Queen Victoria. In her memoirs *India Calling* (1934), Sorabji recalled how she received a message from the Queen to the effect that 'one of my pretty colours (not white) would be permitted: and I wore an azalea *sari*.' She described the event as an exciting experience.

During these years, she returned to India and undertook educational work. She also appeared as a private person speaking in defence of a woman accused of the murder of her husband. The woman was acquitted and, in light of this success, Sorabji appeared in a similar capacity in a number of courts, while seeking to persuade the Indian legal world to accept her and to grant her some professional standing.

In 1922, she was in London again to prepare for her call to the Bar, but she returned to India in 1924, when she was at last able to practise as a barrister. Throughout the 1920s, she travelled between India and England. During the 1930s, her eyesight began to fail and she settled in London, returning to India for the winter. She died in London in July 1954, aged eighty-eight.

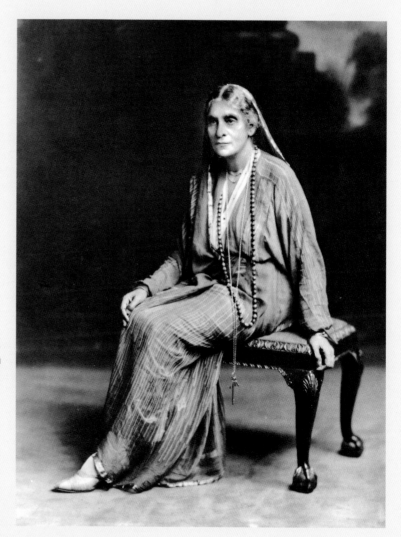

Cornelia Sorabji (1866–1954)
Lafayette, 20 June 1930
Modern print from an original whole-plate negative
National Portrait Gallery, London (NPG x70450)

Queen Emma of Hawaii

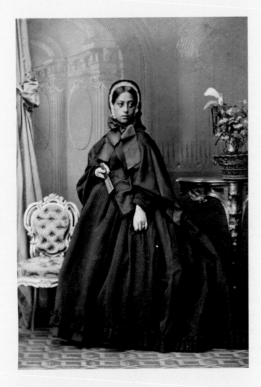

Queen Emma of Hawaii (1836–85)
Camille Silvy, 16 September 1865
Albumen carte-de-visite sized print, 83 x 57mm (3¼ x 2¼")
National Portrait Gallery, London (NPG Ax64561)

Of Hawaiian and English descent, Emma spoke each language perfectly, and was brought up with a knowledge of the customs of both cultures. Queen Emma was the wife of King Kamehameha IV, whom she married in June 1856. She was a popular monarch, highlighting the humanitarian needs of her people and committing her life to philanthropic work.

The Queen travelled to Britain as a young widow in 1865. When she arrived at Southampton in July, among her entourage were two little girls, the daughters of Hawaiian chiefs whom she had brought to England to be educated. When she first went to London, she stayed with Jane, Lady Franklin. One morning in July, while at Lady Franklin's home, Upper Gore Lodge, Emma woke up early, and recorded in her journal that looking out into the garden she could not see beyond the lower end of it because of the fog, which she described as white thick smoke.

In August, Emma drove out, incognito, for a two-hour sightseeing tour of the main London shops. While in London, she visited Trafalgar Square, Westminster Abbey, the Chelsea Hospital, the Crystal Palace, and dined at the Mansion House. She also went to Oxford and Cambridge to see the colleges. She was first presented to Queen Victoria in September and accepted an invitation to stay at Windsor Castle for a night in November. Queen Victoria recorded in her diary that, when she said goodbye to Queen Emma after her stay, she had given her a bracelet with her portrait in miniature.

As the weather grew colder, it was decided that Emma would spend the winter in the warmer climes of southern Italy or France. *The Times* reported that following visits to the principal cities of Europe, the Queen would tour the United States before returning home. Emma returned to the Hawaiian islands in the autumn of 1866, and during the following years became the matriarch of the Hawaiian people.

Worktable
King Kamehameha IV of Hawaii (1834–63)
Presented to Queen Victoria by Queen Emma of Hawaii, 1866
Tropical hardwood, mirror
Lent by Her Majesty The Queen (UK & Commonwealth)

This worktable in Western style was designed by a Pacific ruler. At the age of fourteen, Alexander Liholiho, as he was then called, had travelled to Europe and met, among other dignitaries, Queen Victoria's consort, Prince Albert. During his reign as King Kamehameha IV, Alexander was keen to blend British manners, styles of dress and behaviour with native Hawaiian culture. This worktable similarly combines Pacific materials with British design. In the year of Prince Albert's death, 1863, Kamehameha also died prematurely. The worktable was therefore a personal gift from one widowed queen to another.

Madame Wellington Koo

Madame Wellington Koo (1899–1992)
Bassano, 1943
Vintage print, 193 x 144mm (7⅝ x 5⅝")
National Portrait Gallery, London
(NPG x83698)

Born into a wealthy family of Chinese descent in Java (now in Indonesia), Madame Wellington Koo was used to living a life of luxury surrounded by servants. She first visited Europe with her parents when she was seven, and was educated in France, where she lived with her mother when her parents separated.

Her husband, Vi Kuin Wellington Koo (1887–1987), was Chinese Minister to the United States of America and later Ambassador to Great Britain during the Second World War. When Madame Wellington Koo returned to live in London in the winter of 1943, she was shocked by the devastation that bombs and fires had caused in the city since she was last there in 1939. She remembered the city as bright and full of theatres and lively restaurants. Now the few people she saw looked tired and shabby. The Koos moved into an old house on Portland Place, which served as the Chinese Embassy, and attempted to carry on with diplomatic life as gracefully as possible. Periodically, Madame Wellington Koo's husband would leave Britain on official business and she would be left in London without the distractions of official entertaining. To keep herself busy, she decided to join the Ambulance Corps. Initially the Home Secretary refused her permission, as it was considered too dangerous a job for a foreign official's wife, so she applied directly to the Ambulance Corps itself. For four months, she worked from midnight until 8am in the badly hit East End. Madame Wellington Koo said she never got used to it. She was responsible for ensuring that there was hot coffee for the workers and boiling water for the instruments, and she sometimes held a lantern while the ambulance workers struggled to patch together someone who could not wait for the doctor at the hospital.

Madame Wellington Koo left London in 1946, when her husband was appointed Ambassador to the United States, and they remained in Washington, DC, for ten years. Although Madame Wellington Koo was very fond of Britain, she said that the quarantine regulations for pets prevented her from visiting as often as she might have done.

Vijaya Lakshmi Pandit

Mrs Pandit was the first woman cabinet minister in India, the first woman ambassador for India, and the first woman president of the United Nations when she was elected to the Eighth General Assembly in 1953. The sister of Jawaharlal Nehru (1889–1964), the first Prime Minister of the Republic of India, she was imprisoned three times by the British colonial government for nationalist activities.

In 1955, she became India's High Commissioner in London, and was based in Britain until 1961. In her memoirs, *The Scope of Happiness* (2000), Mrs Pandit described herself as old-fashioned enough to love tradition. One of the reasons she gave for enjoying her time in England was that traditions were kept up in many ways, especially in famous houses, several of which she visited. Though she acknowledged the houses were grand, it was the gardens that she most admired. She also saw the other side of British home life. She visited Indian and Pakistani immigrants who had settled and taken factory jobs in the Midlands. Invited to visit Liverpool and Manchester, she saw a number of dwellings occupied by immigrants, and the situation she found them in distressed her 'beyond words – and also fearful of future consequences'.

While High Commissioner, she was also attached to Ireland and later to Spain. Mrs Pandit felt an emotional bond with Ireland going back to 1916 and the Easter Rising. When she was presented to the President, she was invited to an official lunch. She found everybody at the table exchanged stories about jail life, and she felt that before she left she had been accepted as a comrade.

During her time as High Commissioner, she received honorary degrees from the universities of London, Edinburgh, Cardiff, Nottingham, Loughborough, and, in 1964, Oxford. Before she went to Cardiff, Nye Bevan, Minister for Health during the creation of the National Health Service, coached her in a couple of sentences in Welsh – she felt it was the right thing to do and many people appreciated her attempt.

Vijaya Lakshmi Pandit (1900–90)
Bassano, 1938
Vintage print, 195 x 144mm (7⅝ x 5⅝")
National Portrait Gallery, London (NPG x84424)

Bibliography

All the quotations are taken from the women travellers' published works or published collections of letters as listed below, unless otherwise indicated.

Amaury Talbot, D., *Women's Mysteries of a Primitive People* (London, 1915)

Baker, Florence, ed. Anne Baker, *Morning Star: Florence Baker's Diary* (William Kimber, London, 1972)

Baroda, Her Highness The Maharani of and Mitra, S.M., *The Position of Women in Indian Life* (Neeraj Publishing House, Delhi, 1911, reprinted 1981)

Behn, Aphra, *Oroonoko*, ed. Janet Todd (Penguin Books, London, 2003, first published 1688)

Bell, Gertrude (anon), *Safar Nameh: Persian Pictures* (R. Bentley, London, 1894)

—, *The Desert and the Sown* (Heinemann, London, 1907)

—, and Ramsay, William, *The Thousand and One Churches* (Hodder and Stoughton, London, 1909)

—, *Palace and Mosque at Ukhaidir* (Clarendon Press, Oxford, 1914)

—, *The Letters of Gertrude Bell*, ed. Lady Bell, 2 vols (E. Benn, London, 1927)

—, *The Earlier Letters of Gertrude Bell*, ed. Elsa Richmond (E. Benn, London, 1937)

—, *Gertrude Bell, 1889–1914, 1914–1926, From Her Personal Papers*, ed. Elizabeth Burgoyne, 2 vols (E. Benn, London, 1958)

Bird, Isabella, *The Hawaiian Archipelago: Six Months among the Palm Groves, Coral Reefs and Volcanoes of the Sandwich Islands* (John Murray, London, 1875)

—, *A Lady's Life in the Rocky Mountains* (John Murray, London, 1879)

—, *The Golden Chersonese and the Way Thither* (John Murray, London, 1883)

—, *The Yangtze Valley and Beyond: An Account of Journeys in China, Chiefly in the Province of Sze Chuan and among the Man-Tze of the Somo Territory* (John Murray, London, 1899)

Bodichon, Barbara, *Journal* (quoted in the catalogue of the *Barbara Bodichon Centenary Exhibition 22–30 June 1991*, eds. Frances Gandy, Kate Perry and Peter Sparks [Cambridge, Girton College, 1991])

Brassey, Anna, Lady, *A Voyage in the Sunbeam: Our Home on the Ocean for Eleven Months* (Longmans, London, 1878)

Broad, Lucy, *A Woman's Wanderings the World Over* (Headley Bros, London, 1909)

Brown, Lilian, Lady Richmond, *Unknown Tribes and Uncharted Seas* (Duckworth, London, 1924)

Burton, Isabel, Lady, *The Inner Life of Syria, Palestine, and the Holy Land: From My Private Journal* (H.S. King, London, 1875)

Cable, Mildred and French, Francesca, *The Gobi Desert* (Hodder and Stoughton, London, 1942)

Canning, Charlotte, *A Glimpse of the Burning Plain: Leaves from the India Journals of Charlotte Canning*, ed. Charles Allen (Michael Joseph, London, 1986)

Chetwode, Penelope, *Two Middle-Aged Ladies in Andalucia* (John Murray, London, 1963)

—, *Kulu: The End of the Habitable World* (John Murray, London, 1972)

Christie, Agatha, *Murder on the Orient Express* (Collins, London, 1934)

—, *Murder in Mesopotamia* (Collins, London, 1936)

—, *Death on the Nile* (Collins, London, 1937)

—, *They Came to Baghdad* (Collins, London, 1951)

Craven, Elizabeth, Lady, *A Journey through the Crimea to Constantinople: In a Series of Letters ...* (Robinson, London, 1789)

—, *Memoirs of the Margravine of Anspach* (Colburn, London, 1826)

Cressy-Marcks, Violet, *Up the Amazon and Over the Andes* (Hodder and Stoughton, London, 1932)

—, *Journey into China* (Hodder and Stoughton, London, 1940)

David-Neel, Alexandra, *My Journey to Lhasa: The Personal Story of the Only White Woman who Succeeded in Entering the Forbidden City* (Heinemann, London, 1927)

Dixie, Lady Florence, *Across Patagonia* (R. Bentley, London, 1880)

—, *In the Land of Misfortune* (R. Bentley, London, 1882)

—, *Women's Position, and the Objects of the Women's Franchise League* (pamphlet, Dundee, 1891)

Douglas, Mary, *Purity and Danger: An Analysis of Concepts of Pollution and Taboo* (Routledge and Kegan Paul, London, 1966)

—, *Leviticus as Literature* (Oxford University Press, Oxford, 1999)

Duff Gordon, Lucie, *Letters from Egypt, 1863–65* (Macmillan, London, 1865)

—, *Last Letters From Egypt: To Which Are Added Letters from the Cape* (Macmillan, London, 1875)

Eden, Emily, *Up the Country: Letters Written to her Sister from the Upper Provinces of India* (R. Bentley, London, 1866)

Edwards, Amelia, *Untrodden Peaks and Unfrequented Valleys: A Midsummer Ramble in the Dolomites* (Longmans, London, 1873)

—, *A Thousand Miles up the Nile* (Longmans, London, 1877)

—, *Pharoahs, Fellahs, and Explorers* (Osgood, London, 1891)

Fane, Isabella, *Miss Fane in India*, ed. John Premble (Alan Sutton, Gloucester, 1985)

Forbes, Rosita, *Unconducted Wanderers* (John Lane, London, 1919)

—, *The Secret of the Sahara: Kufara* (Cassell, London, 1921)

—, *From Red Sea to Blue Nile: Abyssinian Adventures*

(Cassell, London, 1925)

Franklin, Jane, Lady, *The Life, Diaries and Correspondence of Jane, Lady Franklin, 1792–1875*, ed. Willingham Franklin Rawnsley (Erskine Macdonald, London, 1923)

Gordon Cumming, Constance, *From the Hebrides to the Himalayas: A Sketch of Eighteen Months' Wanderings in Western Isles and Eastern Highlands*, 2 vols (Sampson, London, 1876)

—, *At Home in Fiji*, 2 vols (Blackwood, Edinburgh, 1881)

—, *A Lady's Cruise in a French Man-of-War*, 2 vols (Blackwood, Edinburgh, 1882)

—, *Wanderings in China*, 2 vols (Blackwood, Edinburgh, 1886)

—, *Memories* (Blackwood, Edinburgh, 1904)

Graham, Maria (later Lady Callcott), *Journal of a Voyage to Brazil and Residence There During Part of the Years 1821, 1822, 1823* (John Murray, London, 1824)

Jameson, Anna Brownell, (anon.) *Diary of an Ennuyée* (Colburn, London, 1826)

—, *Winter Studies and Summer Rambles in Canada*, 4 vols (Saunders and Otley, London, 1838)

Kemble, Frances, *Journal of a Residence on a Georgian Plantation in 1838–39* (Longman, London, 1863)

Kenyon, Kathleen, *Digging up Jericho* (E. Benn, London, 1957)

Kingsley, Mary, *Travels in West Africa* (Macmillan, London, 1897)

—, *West African Studies* (Macmillan, London, 1899)

—, 'West Africa, from an Ethnologist's Point of View', *Transactions of the Liverpool Geographical Society* (1897)

—, 'West Africa from an Ethnological Point of View', *Imperial Institute Journal*, January 1900

Macaulay, Rose, *The Fabled Shore: From the Pyrenees to Portugal* (Hamish Hamilton, London, 1949)

—, *Pleasure of Ruins* (Weidenfeld, London, 1953)

—, *The Towers of Trebizond* (Collins, London, 1956)

Macleod, Olive, *Chiefs and Cities of Central Africa: Across Lake Chad by Way of British, French, and German Territories* (William Blackwood & Sons, Edinburgh, 1912)

Mannin, Ethel, *All Experience* (Jarrolds, London, 1932)

—, *Forever Wandering* (Jarrolds, London, 1934)

—, *South to Samarkand* (Jarrolds, London, 1936)

—, *Land of the Crested Lion: A Journey through Modern Burma* (Jarrolds, London, 1955)

Martineau, Harriet, *Society in America*, 3 vols (Saunders and Otley, London, 1837)

—, *How to Observe Morals and Manners* (Chas. Knight, London, 1838)

—, *Eastern Life, Present and Past*, 3 vols (Edward Moxon, London, 1848)

Mills, Dorothy, *The Road to Timbuktu* (Duckworth, London, 1924)

—, *Beyond the Bosphorus* (Duckworth, London, 1926)

—, *The Golden Land: A Record of Travel in West Africa* (Duckworth, London, 1929)

—, *The Country of the Orinoco* (Hutchinson, London, 1931)

North, Marianne, *Recollections of a Happy Life Selected from the Journals of Marianne North*, ed. Mrs J. Addington Symonds, 2 vols (Macmillan, London, 1892)

—, *Some Further Recollections of a Happy Life Selected from the Journals of Marianne North Chiefly Between the Years 1859 and 1869*, ed. Mrs J. Addington Symonds (Macmillan, London, 1893)

Pandit, Vijaya Lakshmi, *The Scope of Happiness: A Personal Memoir* (HarperCollins, New Delhi, 2000)

Rigby, Elizabeth (later Lady Eastlake), (anon), *A Residence on the Shores of the Baltic: Described in a Series of Letters* (John Murray, London, 1842)

—, 'Lady Travellers', *Quarterly Review*, LXXVI, 1845

Sackville-West, Vita, *Passenger to Teheran* (Hogarth Press, London, 1926)

—, *Twelve Days: An Account of a Journey Across the Bakhtiari Mountains in South-Western Persia* (Doubleday, London, 1928)

Shaw, Flora (anon), *Letters from South Africa by* The Times *Special Correspondent* (Macmillan, London, 1893)

—, *A Tropical Dependency: An Outline of the Ancient History of the Western Soudan with an Account of the Modern Settlement of Northern Nigeria* (James Nisbet, London, 1905)

Sheridan, Clare, *Redskin Interlude* (Nicholson & Watson, London, 1938)

Sorabji, Cornelia, *India Calling* (Nisbet & Co., London, 1934)

Stanhope, Lady Hester, *Memoirs of the Lady Hester Stanhope, as Related by Herself in Conversations with her Physician* (Colburn, London, 1845)

Stark, Freya, *The Valleys of the Assassins and Other Persian Travels* (John Murray, London, 1934)

—, *The Southern Gates of Arabia: A Journey in the Hadhramaut* (John Murray, London, 1936)

—, *Seen in the Hadhramaut* (John Murray, London, 1938)

—, *A Winter in Arabia* (John Murray, London, 1940)

—, *Traveller's Prelude: Autobiography 1893–1927* (John Murray, London, 1950)

—, *The Coast of Incense: Autobiography 1933–1939* (John Murray, London, 1953)

—, *Dust in the Lion's Paw: Autobiography 1939–1946* (John Murray, London, 1961)

Stopes, Marie, *A Journal from Japan: A Daily Record of Life as Seen by a Scientist* (Blackie, London, 1910)

Taylor, Annie, *Travel and Adventure in Tibet: Including the Diary of Miss Annie R. Taylor's Remarkable Journey from Tau-Chau to Ta-Chien-Lu through the Heart of the Forbidden Land*, ed. William Carey

(Hodder and Stoughton, London, 1902)

Trollope, Frances, *Domestic Manners of the Americans* (Whitaker, London, 1832)

—, *Vienna and the Austrians: With Some Account of a Journey through Swabia, Bavaria, with Tyrol, and the Salzburg* (R. Bentley, London, 1838)

Wellington Koo, Madame with Taves, Isabella, *No Feast Lasts Forever* (Quadrangle, New York, 1975)

West, Rebecca, *Black Lamb and Grey Falcon* (Viking, New York, 1941)

Wortley Montagu, Lady Mary, *The Turkish Embassy Letters* (Virago Press, London, 1994), an edited collection from *The Complete Letters of Lady Mary Wortley Montagu*, ed. Robert Halsband, 3 vols (Clarendon Press, Oxford, 1965–7), including correspondence from *Letters of the Right Honourable Lady M—y W—y M—e: Written During her Travels in Europe, Asia and Africa, to Persons of Distinction, Men of Letters, etc. in Different Parts of Europe, Which Contain ... Accounts of the Policy and Manners of the Turks; Drawn from Sources that Have Been Inaccessible to Other Travellers* (London, 1763)

Zoete, Beryl de and Spies, Walter, *Dance and Drama in Bali* (Faber & Faber, London, 1937)

Selected books on women travellers

Allcock, John B. and Young, Antonia (eds.), *Black Lambs and Grey Falcons: Women Travellers in the Balkans* (Bradford University Press, Bradford, 1991)

Barr, Pat, *A Curious Life for a Lady: The Story of Isabella Bird* (Macmillan, London, 1970)

Bell, E. Moberley, *Flora Shaw (Lady Lugard DBE)* (Constable, London, 1947)

Birkett, Dea, *Women and Travel* (Wayland, Sussex, 1991)

—, *Mary Kingsley: Imperial Adventuress* (Macmillan, Basingstoke, 1992)

—, *Spinsters Abroad: Victorian Lady Explorers* (Sutton, Salisbury, 2004)

Courtney, Janet E., *The Women of My Time* (Lovat Dickson, London, 1934)

Cracroft, Sophia, *Lady Franklin visits the Pacific Northwest being extracts from the letters of Miss Sophia Cracroft, Sir John Franklin's niece, February to April 1861 and April to July 1870*, ed. Dorothy Blakey Smith (Provincial Archives of British Columbia, Victoria, BC, 1974)

Davenport Adams, W.H., *Celebrated Women Travellers of the Nineteenth Century* (Sonnenschein, London, 1883)

Ford, Colin, *Julia Margaret Cameron: 19th Century Photographer of Genius* (National Portrait Gallery, London, 2003)

Fox Schmidt, Margaret, *Passion's Child: The Extraordinary Life of Jane Digby* (Hamish Hamilton, London, 1977)

Geniesse, Jane Fletcher, *Freya Stark Passionate Nomad* (Pimlico, London, 1999)

Hall, Richard, *Lovers on the Nile* (Collins, London, 1980)

Hickman, Katie, *Daughters of Britannia: The Lives and Times of Diplomatic Wives* (HarperCollins, London, 1999)

Korn, Alfons, *The Victorian Visitors* (University of Hawaii Press, Honolulu, 1958)

Lovell, Mary S., *A Scandalous Life: The Biography of Jane Digby el Mezrab* (Fourth Estate, London, 1995)

Middleton, Dorothy, *Victorian Lady Travellers* (Routledge and Kegan Paul, London, 1965)

Moorehead, Caroline, *Freya Stark* (Penguin, London, 1985)

Robinson, Jane, *Wayward Women: A Guide to Women Travellers* (Oxford University Press, Oxford, 1990)

—, *Unsuitable for Ladies* (Oxford University Press, Oxford, 1994)

Russell, Mary, *The Blessings of a Good Thick Skirt* (Collins, London, 1986)

Shipman, Pat, *The Stolen Woman Florence Baker's Extraordinary Life from Harem to the Heart of Africa* (Bantam Press, London, 2004)

Slung, Michele, *Living with Cannibals and Other Women's Adventures* (Adventure Press, National Geographic Society, 2000)

Stoddart, Anna M., *The Life of Isabella Bird (Mrs Bishop)* (John Murray, London, 1906)

Tabor, Margaret E., *Pioneer Women* (Sheldon Press, London, 1925)

Taylor, Betty, *Clare Sheridan 1885–1970* (Hastings Press, Hastings, 1984)

Wallach, Janet, *Desert Queen* (Doubleday, New York, 1996)

Winstone, H.V.F., *Gertrude Bell* (Jonathan Cape, London, 1978)

Selected articles on women travellers

'The Work of Women', *Proceedings of the Geologists' Association*, vol. 13 (1893–4)

'Lady Travellers', *Blackwood's Edinburgh Magazine*, vol. 160 (1896)

'The Art of Travelling: An Interview with Mrs J.F. Bishop, FRGS', *Climate*, vol. 1, no. 4 (July 1900)

'Celebrated Women Travellers', *Good Words*, vol. 42 (1901)

'The Desert and the Sown', *Times Literary Supplement*, 25 January 1907

'Across Lake Chad', *Times Literary Supplement*, 9 May 1912

Interview with Gertrude Benham, *Daily News*, 30 January 1928

Rosslyn, Felicity, 'Rebecca West, Gerda and the Sense of Process' in Allcock and Young (eds.), *Black Lambs and Grey Falcons* (1991)

Buchan, James, 'Miss Bell's Lines in the Sand', *Guardian*, 12 March 2003

Index